Deborah Kass

DEBORAH
KASS

The Andy Warhol Museum

One of the four Carnegie Museums of Pittsburgh

BEFORE AND HAPPILY EVER AFTER

Lisa Liebmann + Brooks Adams

Griselda Pollock

Irving Sandler

Eric C. Shiner

Robert Storr

John Waters

Skira *Rizzoli*
NEW YORK

THE
IDENTIFICATION
OF
DEBORAH
KASS

In the arena of art history within which I was educated in the 1990s, identity politics and gender studies reigned supreme, and many of my colleagues and I earnestly set off in pursuit of our subject's core essence as if we might ultimately expose the hidden identity of the artist at hand. With the help of Judith Butler and other feminist theorists and art historians, we championed the subalterns of the art world, striving to give them agency and voice with the goal of tearing down the formal structures of art history. We sought a theory-based path to understanding the art of our age.

Obviously, many artists of that era were engaged in their own identity-based experiments, challenging the limits of the body, experimenting with gender role-play, and blurring the lines between race and national identity. Now, looking back on my initial foray into this most exciting realm, I realize that the one thing we all missed was the simple concept of how the artists we worked on *identified* with their work, their world, and the field of art history. It seems as though we demanded specific examples of a given artist's points of connectivity to gender, race, and identity, forgetting that the subtle act of identification—with that which came before or that which one chances upon in the lived here and now—holds just as much import for where an

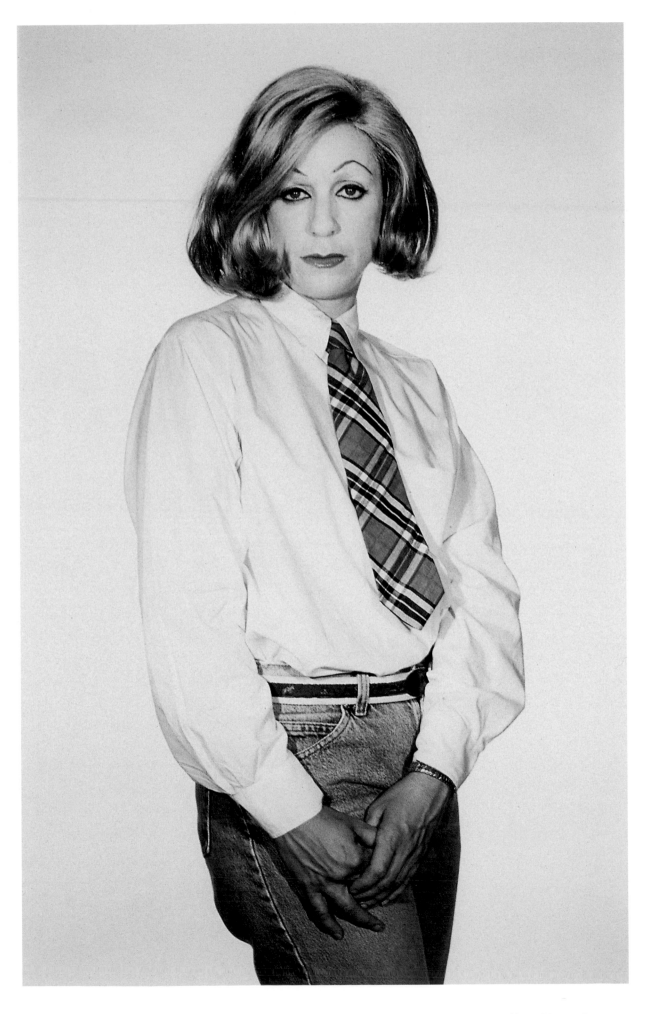

Altered Image 2, 1994–95

artist places herself in the world, how she understands it, and how she writes herself into it.

Thank God I found the work of Deborah Kass to open my eyes to this important give-and-take between an artist and the outside world. Now I know that identification is the key, that in the end, we all strive to connect, to identify with that which we covet, that which we want to know, and sometimes that which we fear and detest. Deborah Kass does all of these things, and in the process has authored a fully formed body of art that not only marks her engagement with art history and the Warholian world of celebrity, but one that also positions her as one of the most critically engaged artists of our age, an artist-cum-theoretician-cum-art historian that riffs on the canon, just as she claims ownership of it, and by extension, confirms her place within it.

In working with Kass closely on the development of this important midcareer retrospective, I immediately came to realize that she has been on a decades-long journey of art-making fueled by equal parts bravado and rigor that allowed her to write herself into the annals of art history not just as a painter (and a damn good one at that), but perhaps more importantly as a *mediator* who is constantly engaged in a conversation between the mostly male-dominated art history of the twentieth century and both the feminist theory of the past and the postfeminist mindset of today. In the nineties, I would have described her work as being critical of the patriarchal art world, or I might have said that she was attempting to insert her female self, her Jewish self, her lesbian self *into* the canon, to somehow make it right, to heal the wrongs of the past. But now, I know that her project is much more than that—it is exactly about her identification with the great male artists of the past, with Warhol, with language, with fame, with Broadway, with Barbra Streisand, with her upbringing, and about 500 other nodes of potential outcomes and identifications. It is about an artist being alive, being engaged, and being real. After all, "you make me feel, mighty real."

And although we can certainly approach Kass's work from a theoretical angle to help place it within its cultural context, we must also factor in the import of identification to help place it within *her* context. For Deborah Kass, like Andy Warhol, is a master of contextualization, of placing the self within a much broader cultural sphere, and in so doing successfully creates variations on self-portraiture that don't always take the self as their subjects. Just as Warhol is reflected in his Marilyn and Elvis paintings through his identification with those luminous stars, so too is Deborah Kass writ large in each and every work included in this exhibition. I am thrilled to watch how visitors to the show will approach the work, not only formulating their own relationships to

the subjects at hand, but engaging with Kass in a dialogue about the things that are important to them and to her, and why. Yes, visitors to the show will identify with Kass, just as she identifies with culture at large; in doing so, a conversation between eras, mindsets, and differing points of view will emerge, one most definitely framed by Warhol, art history, and popular culture. I hope that viewers relate with Kass, her frustrations, heroines, and politics; her icons, dreams, and desires.

Assembling a show of this magnitude takes a village, and I am indebted to Kass and her wife, the artist Patricia Cronin, for allowing me into their lives so that I too could begin to fully identify with Deb and her work. I also thank my amazing team at The Andy Warhol Museum, including my indefatigable assistant, Jennifer Melvin, Director of Exhibitions Jesse Kowalski, Registrar Heather Kowalski, Director of Development Patrick Moore, and the rest of the Warhol family in helping to make this exhibition a reality. I must also extend a huge amount of gratitude to our friends at PNC Financial Services in Pittsburgh for providing the funding necessary to mount this, Kass's first midcareer retrospective. Special thanks go to PNC's Donna Peterman and Sandra Solomon for their stalwart support of Kass and her work. I am also grateful for the assistance of Kass's manager—and before that, the vice president of Andy Warhol Enterprises, Inc.—Vincent Fremont, in helping on all aspects of the exhibition from its very inception. We must also thank the many lenders to the show for parting ways with their treasures so that our visitors can experience Kass's paintings firsthand. We were honored to work with some of the sharpest minds in contemporary art history on this catalogue, and I extend my heartfelt thanks to them for their brilliant essays on Kass and her work. Finally, I would like to thank Paul Kasmin, Kass's gallerist, Director Hayden Dunbar, and their team for their support of this exhibition through loans and introductions to lenders. Working together, we have assembled an exhibition that places the identification of Deborah Kass at its center, and I am certain that the conversations and relationships that radiate from it will be nothing less than astounding.

Eric C. Shiner
Director
The Andy Warhol Museum

Irving Sandler

"Has anyone told you that you paint as well as a man?"
"Not twice."

—Grace Hartigan

In 1992, I saw some pictures at the fiction/nonfiction gallery in New York that looked from a distance like Andy Warhol's grid paintings of Jackie Kennedy, Liz Taylor, and Judy Garland. Up close, I realized that the portraits were of Barbra Streisand, a new subject for Warhol, except that the label informed me they were by a Deborah Kass, a name unfamiliar to me, and that they were titled *The Jewish Jackie Series*. I could have walked away, but I didn't. But why would an obviously post-Warholian artist appropriate the master appropriator? The works looked too serious to be parodies. They had to be an homage to both Warhol and Streisand. Were they? Kass's canvases so intrigued me that I had to learn more about them.

I soon discovered that Kass had developed her painting over two decades by copying images with which she identified. Her fascination with Warhol began when she was around thirteen years old and saw a reproduction of his painting titled *Before and After* (1961), which showed two cartoonlike faces of women in profile, one prior to having her nose bobbed, the other after. Living in a suburban Jewish neighborhood where nose jobs were common, Kass sensed that Warhol's painting parodied this practice and she "took enormous subversive joy in this image."[1] She would not appropriate *Before and After* into her own work until three decades later, but when she did, it would prove a critical move.

(left) Eugène Delacroix, *The Death of Ophelia*, 1853. Oil on canvas. 9 x 11⅞ in. (23 x 30 cm). Musée du Louvre, Paris

(right) *Ophelia's Death (After Delacroix)*, 1973. Acrylic on canvas. 60 x 84 in. (152.4 x 213.4 cm)

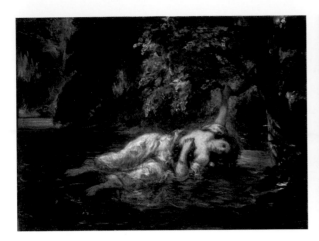 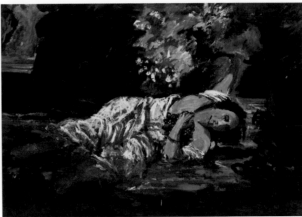

Kass developed as an artist in a conventional manner, studying at the Art Students League of New York, 1968–70, the Whitney Museum Independent Studies Program, 1972, and Carnegie Mellon University, where she was awarded a BFA in 1974. Like most students, she tried this and that in search of a style that she could claim as her own. She experimented with the visual ideas of historic figures, among them Delacroix and Cézanne, and New York School painters whom she greatly admired (and still does), notably Jackson Pollock, Willem de Kooning and Philip Guston, but also Frank Stella and Jasper Johns.

At the same time that Kass was mastering "high art" and its history, she was also enraptured by "low art." She had a passion for popular culture. Her father had a comprehensive knowledge of jazz and taught her about its techniques of sampling or covering, that is, borrowing motifs from other musicians. Her mother had an encyclopedic knowledge of Hollywood movies. Kass recalled, "The first songs I learned were show tunes: 'There's No Business Like Show Business,' 'I'm Gonna Wash That Man Right Out of My Hair' . . . songs written by Jews. . . . By ten I knew practically every line from *Gentlemen Prefer Blondes* and could do wicked Marilyn Monroe and Jane Russell imitations. . . . I inherited [my parents'] taste."[2]

Kass had seen Stella's retrospective at the Museum of Modern Art in 1970 and was strongly impressed by the rigorous logic of his black paintings. In 1976, she encountered a show of Elizabeth Murray's works, which seemed to challenge Stella's rationality. They spoke to her as a woman, as she said:

> A seismic change was occurring in my life as I stood there looking—I had been oblivious to feminism. [I] previously and unconsciously assumed [the] position of all great art to be male. Feminism had no place that I

had recognized in New York School painting Suddenly it all changed. I recognized [that Murray's] paintings clearly had their roots there, but with a different point of view that spoke about something else altogether. The subject was female. . . . I was seeing abstraction turned upside down, inside out, deployed in a completely new way. . . . For the first time ever, I felt that I was the intended audience looking at a work of art. This object had something to do with my experience of the world. It was the first time that I saw my own reflection in a painting. In every sense of the word this was New. . . . It was there, at the intersection of New York School painting and feminism, and that was exactly the place I wanted to be.[3]

What Kass learned from Murray, to put it directly, was to make her painting personal. Her identification with the older artist also had a larger social significance. It led her to join a generation of women, feminist women artists, who were "taking on the difficult task of entering a world that has refused to see [them] as human beings."[4]

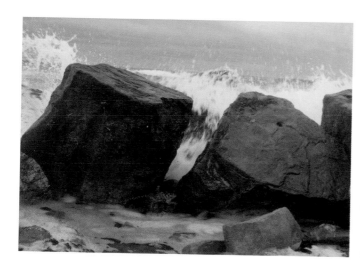

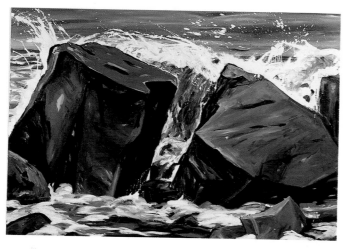

Kass recalled that in the 1970s "It was part of the conventional wisdom of the time that it was impossible to do anything new in painting." Kass who was in "love [with] the language of painting" and its history was determined to try.[5] In 1983, she painted a series of distinctive works she exhibited in a one-person show in New York. They are painterly images of rocks and turbulent water. In *Big Splash* (1983), an anthropoid crag spurts water at a boulder with explosive force, in human terms evoking a tantrum. In *Stormy Weather* (1984), two hulking outcrops confront one another menacingly. The images take on a human aspect, a stormy psychodrama that perhaps reflected Kass's life at the time.

In 1987, Kass began to line up ver-

(top) Photograph by Deborah Kass

(bottom) *Stormy Weather*, 1984. Oil on canvas. 70 x 100 in. (177.8 x 254 cm)

Table of Content (Part II), 1988. Oil, acrylic, and enamel
on canvas. 8 panels: 48 x 96 in. (121.9 x 243.8 cm) overall.
Collection of Barbara Berger

tical canvases to form horizontal paintings in which she introduced a mélange of images, many of them culled from her own earlier works, others new. In two key paintings, aptly titled *Table of Content (Part I)* and *(Part II)* (1988), she appeared to be in search of her own distinctive vocabulary of forms. One of these includes references to her rock and water works, Stella's and Johns's paintings, and *Krazy Kat* comic strips. By 1990, Kass had identified her essential subjects, namely images culled from art history and popular culture. She had also arrived at her primary technique, that is, appropriation. A major painting of that year, *Subject Matters*, combines *Peanut*'s Lucy, a girlhood powerhouse; Johns's eyeglasses; a photograph of a pile of eyeglasses in Auschwitz; and the capital letter I (eye, ego).

Already in the 1970s, Kass was aware that a radical change had occurred in the world, both socially and artistically. As she said, "The years I attended high school from 1967 to 1970 were the most intellectually, politically, and aesthetically charged in postwar history. The rapid change in social consciousness was not lost on a teenager with an interest in the world outside her provincial suburb." Neither were extreme changes in modernist art. All of the avant-garde "isms" that had commanded art world attention and had pushed other styles into the background had become established. Art had reached all of its limits—a limit being defined as the edge where art could be mistaken for non-art. For instance, *Information*, a show of conceptual art at the Museum of Modern Art in 1970 (which strongly impressed Kass), included works that were not objects, or even visible. At the same time, Environments and Happenings broke down all barriers between art and everyday life. It was no lon-

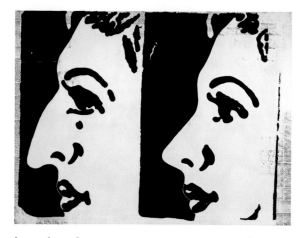

Andy Warhol, *Before and After*, 1961. Casein and pencil on canvas. 54 x 69⅞ in. (137.2 x 177.5 cm). The Museum of Modern Art, New York

ger possible to "make it new" as the great modernists had. However, artists could "*re-make it neo*" by appropriating ready-mades from known styles and presenting them as is or mixing them to forge individual styles that looked fresh and striking.

Kass set out to discover subjects and styles with which she could empathize so strongly that she could just copy them. As she said, her development as a person and as an artist depended on "who and what you identify with in the culture: a song, a star, a character in a book or tv show. As a child that is a way you start identifying yourself and understanding who you are in the world."[6] Kass sought to use borrowings from the vast storehouse of past and present art to create images of herself in her painting, not only traditional representations but self-images configured from her appropriations based on her idiosyncratic desires. Appropriation came naturally to Kass, the legacy of her girlhood absorption with jazz covering. But it also turned out to be the primary technique of postmodern art.

In 1991, Kass introduced two images that would be crucial in her subsequent development. In one, *How Do I Look?*, she "borrowed" Picasso's portrait of Gertrude Stein, the formidable writer, woman, and lesbian. The other work is a copy of Warhol's "nose job" picture, now re-titled ironically by Kass, *Before and Happily Ever After*. She came to view the bobbed nose as the "desire for assimilation played out on the female Jewish body,"[7] and the issue of assimilation would engage Kass in a number of her subsequent paintings.

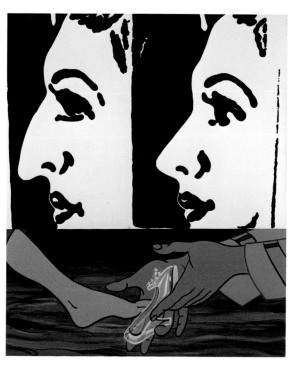

Before and Happily Ever After, 1991. Oil and acrylic on canvas. 72 x 60 in. (182.9 x 152.4 cm)

Kass chose to "collaborate," as she said,[8] with Warhol because "as the sissy son of Czech parents, he became American with an urgency common to immigrants' children that would inspire him to innovate pop art." He chose to depict familiar things identified with his working-class childhood—Coca-Cola, Campbell's soup, money,

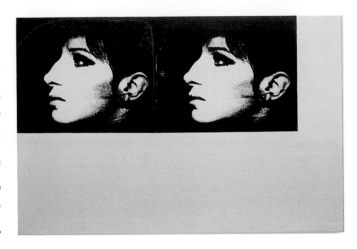

2 Silver Barbras, 1993. Silkscreen and
acrylic on canvas. 28 x 45 in. (71.1 x 114.3 cm)

gay pop stars. Above all, Kass admired Warhol's depiction of "how the world looked through his eyes." This inspired her to use her art to talk about who she was, in her time, in her world—and to speak clearly.[9] Warhol also broke down the barriers between "high" art and "low" popular culture, giving Kass permission to employ subjects and forms from both kinds of art.

Warhol's portraits of Jackie Kennedy, Marilyn Monroe, and Judy Garland led Kass to depict Barbra Streisand, a photograph of whose head in profile, nose held high, was the image of Kass's *Jewish Jackie Series* (1992–93). In these works, she borrowed Warhol's checkerboard-like compositions and inserted in the rectangles repeated Barbras (like the paintings I saw in 1992) in place of his Jackies, Marilyns, or Judys.

When Kass first saw photographs of Streisand, what struck her was that unlike Marilyn, Jackie, or Judy, "She looks like me!" As a Jewish girl growing up in suburban New York, Kass venerated Streisand as "the pop diva who changed my life.The guts it took to just *be* unapologetically, *proudly* herself was positively subversive and radical. Her sense of herself, her ethnicity, talent, glamour, and most importantly her *difference* affirmed my own ambition and identity. . . . If she could make it on brains, talent, and chutzpah, so could I." For Kass, Streisand became a role model, even a surrogate self.[10]

Within Kass's own milieu, to embrace Streisand was a nonconformist act. The generation of her parents, suburban Jews intent on assimilating in American society, hated Streisand. They demanded to know: why didn't she change her name, her nose, HER NOSE? She was *too Jewish*.[11] Moreover, as Kass observed, "Her self-love and self-acceptance coupled with her raging talent, perfectionism, and ambition were utterly radical. Deeply subversive. Most importantly, unlike Andy's women, there was nothing tragic about Barbra."[12]

Kass's muscling of Streisand into Warhol's format in the *Jewish Jackie Series* was at once an homage and a riposte to the pop artist as a man. But Warhol was a particular kind of man. He was gay. So is Kass. She replaced, as she said, "Andy's homosexual desire with my . . . female voice, Jew love, and blatant lesbian diva worship."[13]

As a gay woman, Kass was particularly intrigued by Streisand in the role of *Yentl*. Kass was impressed by the film because it dealt with "Streisand in Yeshiva-boy drag," and themes of cross-dressing, mistaken identities, gender confusion, sex, love, and spirituality.[14] As Kass put it, "Barbra as Yentl, Yentl as Anshel, me as Andy. . . . The image of a woman dressed as a man—in order to study sacred texts denied by law and tradition, a woman whose love for the living history of learning, spirit, and ideas overwhelms propriety and social norms seemed to me to be the perfect metaphor for being a woman artist at this time . . . and precisely what I was doing in this body of work."[15]

In attempting to deal with her identity, Kass confronted an issue that tended to be brushed aside in the art world, even though a debate on multiculturalism, differences, and racial, sexual, and ethnic identities was widespread. Kass recalled that,

> "The cultural politics of difference," to quote Cornel West, were everywhere in the late 80s and early 90s, but not a Jew to be seen! Unless they were queer, feminist, transgender, or black. And the question was always how to bring this into painting, this one big, glaring, capital-O other, that no one was addressing.[16]

Kass did address it. So did the Jewish Museum, which mounted a show in 1996 titled *Too Jewish?*, in which Kass became the poster girl.

From 1993 to 2000, Kass continued to feature female heroines in a series of portraits, including Gertrude Stein, Elizabeth Murray, Cindy Sherman, Pat Steir, Thelma Golden, and the artist herself, as well as feminist males, such as Robert Rosenblum and Robert Storr.

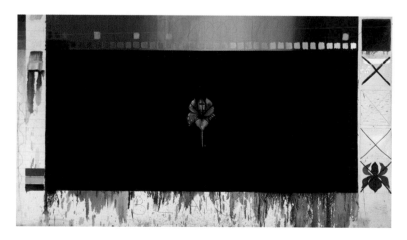

Pat Steir, *Black*, 1973. Oil and pencil on canvas.
72 x 132 in. (182.9 x 335.3 cm). Private collection

In 2002, Kass began to appropriate abstract images by celebrated male artists who were of the generation of her all-male teachers. She chose artists such as Frank Stella and Ellsworth Kelly because she both admired and resented them. Their works provoked her because they

(top) Ed Ruscha. *OOF*, 1962 (reworked 1963).
Oil on canvas. 71½ x 67 in. (181.5 x 170.2 cm).
The Museum of Modern Art, New York

(bottom) *OY*, 2009. Oil on canvas.
71¼ x 66½ in. (181 x 168.9 cm)

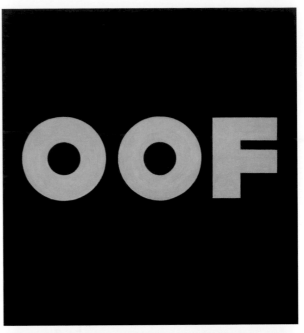

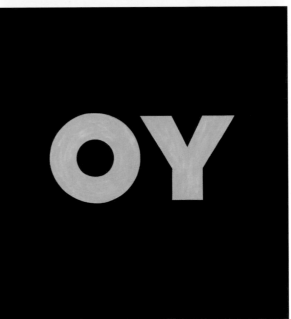

epitomized the dominant "master narratives" in which she had been schooled and which she had come to think were formulated, as she put it, by "white, male, Anglo, Protestant heterosexuals."[17] She set out to challenge and subvert their cultural hegemony by using their paintings in a way that they had "not been used before—to represent herself."[18]

As was her method, Kass accepted the nonobjective images as ready-mades, a postmodern way to treat art associated with modernism. But she also invented her own individual images by mixing up nonobjective styles and introducing words, phrases, and sentences, most of them culled from popular culture—a populist intrusion in elitist styles.

For example, *Frank's Dilemma* (2009), a large, vividly colored painting 78 by 156 inches, consists of two of Stella's square-within-square abstractions fragmented (or exploded) by Warhol's camouflage-like shapes. Superimposed on each square is the printed lyric, "Daddy, I Would Love To Dance," taken from the Broadway musical *A Chorus Line*, a recitative sung only by the women dancers. *Who Will Buy* (2008) is composed of three vertical blocks of red, yellow, and blue in Kelly's style, overlaid with the printed text of its title. Kass added a companion painting the following year titled *Isn't It Rich* (2009).

Kass has titled her two recent shows, *feel good paintings for feel bad times*. And a number of phrases and sentences feel good like the high-keyed yellow, *Let The Sun Shine In* (2006), but a number of the others feel not so good and evoke negative feelings of indignation and frustration—and suggest that Kass's painting is to a degree fueled by these feelings. As she titled one work, *I'd Be Dead Without My Anger*

(2002). Her indignation is also evident in the ethnic, *Hard To Be A Jew* (2003); the feminist, *You Never Really Listened To A Woman* (2002) or *After Louise Bourgeois* (2010), which reads, in neon, "A Woman Has No Place in the Art World Unless She Proves Over and Over Again She Won't Be Eliminated"; and the political, *Save the Country* (2009). Other paintings have more ambiguous messages: the (unhappy?) *C'mon Get Happy* (2010) or the (troubled?) *Forget Your Troubles* (2010).

Kass's *feel good* paintings that most captivated me are *OY* (2009), which consists of two large yellow printed letters O and Y on a blue ground, and a companion piece painted the following year with a Y and O replacing the O and Y. Both paintings were inspired by the text of Ed Ruscha's *OOF* (1962) that Kass saw at the Museum of Modern Art. The conspicuousness of the words prompts the viewer to consider their meanings. The reversal of OY and YO are witty or funny. OY, as in *oy vey*, is a Yiddish moan of pain, resignation, exhaustion, and woe that was once heartfelt but has become an ironic comment on these feelings, like *ohmygod*, the sign of its assimilation into American popular culture. *Yo*, as a good-natured greeting, is identified with African American slang. What complicates the coupling of these terms is that *yo* seems to have originated in Italian Philadelphia and is identified with Rocky Balboa, whose "Yo, Adrian, I did it!" has become a pop catchphrase. Then there is the *yo* in Spanish meaning "I," as in the title of a painting, *Yo, Picasso* (1901). I believe that Kass could well have titled her body of work, *Yo, Kass*.

Although Kass has revised and undermined abstraction associated with male artists and added pop elements to it, her imitation of sources signifies her esteem for them. Nonetheless, she has also competed with the boys, meeting them on their own turf and matching them in quality. This in the long run counts more than gender difference.

1. Deborah Kass. "The Legacy of Andy Warhol." Panel discussion at the Brooklyn Academy of Music, October 2003.

2. Deborah Kass. "Jewish Jackies, Jewish Barbies, Jewish Princesses: Exploding the Myths." Dialogue with Rabbi Avis D. Miller, Contemporary Museum, Baltimore, 1997.

3. Deborah Kass. "The Seventies." *The Brooklyn Rail*, September 2007.

4. Kass was not only moved by the works of Elizabeth Murray but by Joan Snyder, Mary Heilmann, Louise Fishman, Susan Rothenberg, Lois Lane, Denise Green, Harriet Korman, Harmony Hammond and Dora Nelson who produced "a receptive cultural climate" for younger women artists.

5. Terry R. Myers and Deborah Kass. "In Conversation." *The Brooklyn Rail*, September 2010.

6. Deborah Kass, e-mail to Irving Sandler, April 3, 2012.

7. "The Legacy of Andy Warhol."

8. "In Conversation."

9. "The Legacy of Andy Warhol."

10. Irving Sandler. "Deborah Kass." *Bombsite*, September 2010.

11. "Jewish Jackies. . ."

12. "The Legacy of Andy Warhol."

13. "The Legacy of Andy Warhol."

14. Maurice Berger. "Seeing Myself Seeing Myself," *Deborah Kass The Warhol Project* (New Orleans: Newcomb Art Gallery, Woldenberg Art Center, Tulane University, 1999), p. 20.

15. "The Legacy of Andy Warhol."

16. "In Conversation."

17. Deborah Kass. Typescript, title, and date unknown.

18. Ibid.

nature

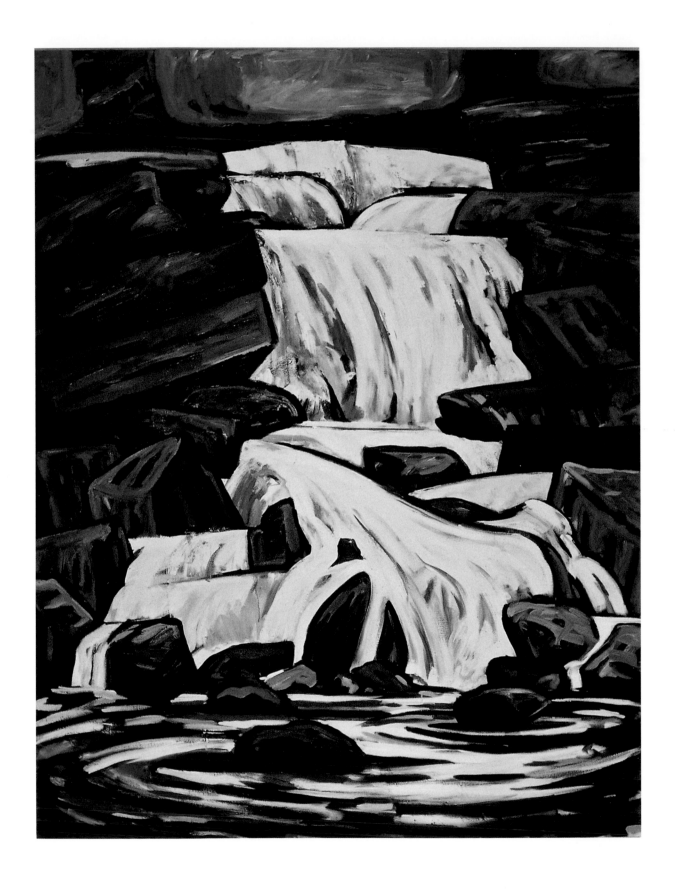

Glendale Falls, 1983

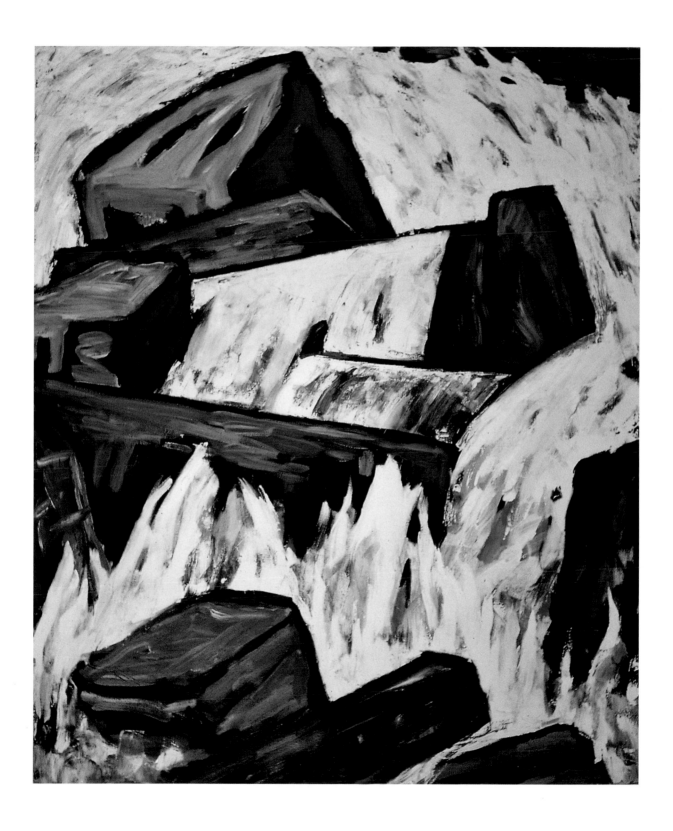

Rushing Water, 1983

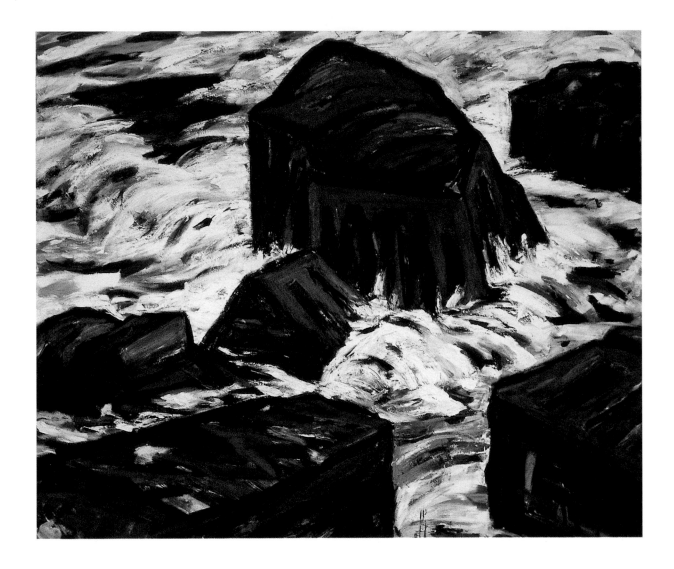

The Monitor and the Merrimack, 1983

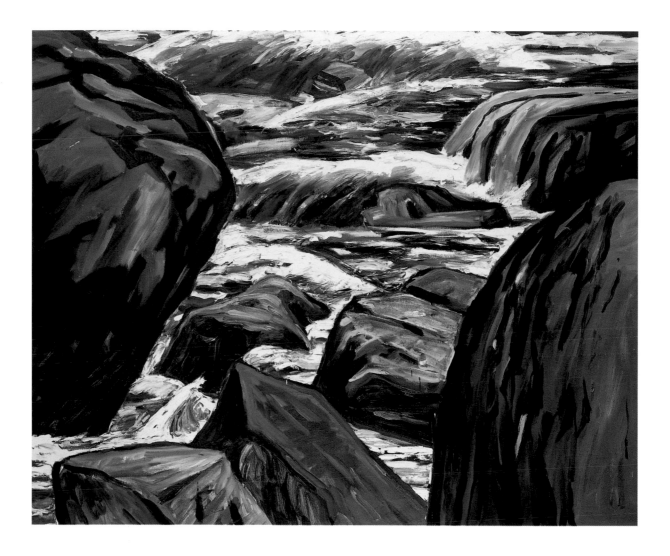

Maine Squeeze, 1983

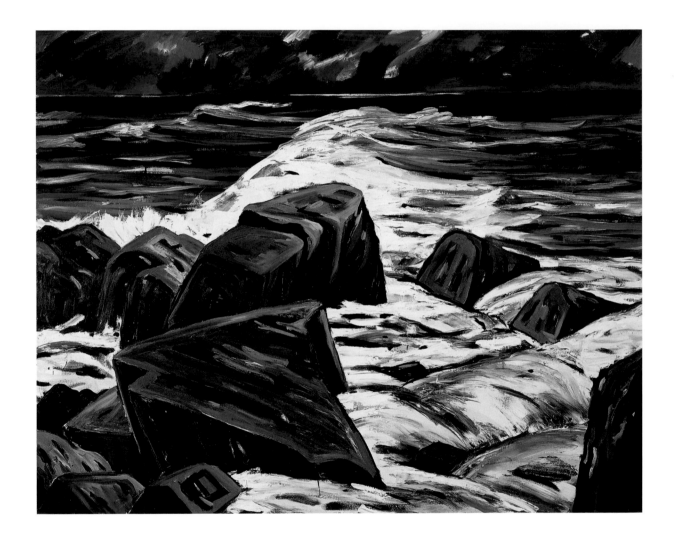

Full Moon, 1984

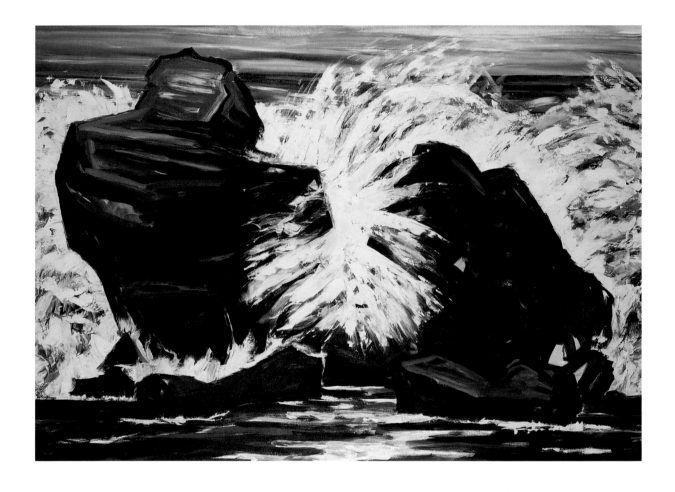

Big Splash, 1983

Lisa Liebmann and
Brooks Adams

Deborah Kass says she first met us "with Joan Stern in about 1977," in a former bar and hamburger joint called Barnabas Rex, on Duane Street, in lower Manhattan. (The term Tribeca was just being coined then.) "Susan Rothenberg lived around the corner," she added—perhaps for additional period flavor. "Joan Stern" could probably use some explaining, but let's just say that she was a friend of ours from Sarah Lawrence College, from which we had recently graduated. Deb had graduated from Carnegie Mellon University a couple of years earlier and had spent a semester in the Whitney Museum's Independent Study Program. She had gotten to know our friend Joan through assorted and, with hindsight, rather sweetly inchoate artistic and/or Sapphic circles in the city. (The term "dyke-o-drama" was another new coinage of the day.) We were all in our early twenties more or less.

This epochal meeting wasn't exactly what you'd call an art world gathering, though Deb was very much the young painter, one whose studio, on lower West Broadway, we would soon visit. No, we, along with Joan, had been "theater people" at Sarah Lawrence, weaned at birth on musical comedies, schooled in both the Beatles and Barbra Streisand, then trained to perform sexually provocative cabaret acts in a Weimaresque, neoBrechtian style by the late, great, absolutely mephistophelian John Braswell. (Braswell, in collaboration with Wilford Leach, who had joined Joseph Papp

at the Public Theater by 1977, conceived and directed some very exciting experimental productions earlier in the decade at LaMaMa E.T.C., which sometimes functioned as a Sarah Lawrence theater department annex. Both directors died of AIDS in the late 1980s.)

So our creative beginnings, if you will, were all singing, all dancing. By the time we met our present subject, however, our carefully programmed inhibitions had got the better of us, and Brooks was enrolled at NYU's Institute of Fine Arts, and Lisa was applying to Columbia University's Graduate School of Journalism. Who can remember if we discussed Sondheim with Deb that evening at Barnabus Rex? The truth remains that we recognized one another as Broadway babies at a time when that was widely considered to be extremely uncool—queer, in a sense yet to be formally addressed—at least not in the machos- and Marxists-serving hangout we found ourselves in. Deborah Kass has over the years sometimes appeared to us as a beacon, like a signal sent downtown from the bright lights of Times Square.

Deborah is clear. Her mane of thick dark hair undulates with definition. Her direct, unflinching gaze—light blue in a pale, strong-featured face that has changed very little over time—seems to emanate from an ancient source, and is always, ineffably, serious, despite the humorous mobility of the mouth below. Her head would look right on a plinth, in a forum of Caesars, or on a platter, like John the Baptist or Medusa in a symbolist painting. Although usually in jeans, often with boatnecked striped T-shirts, she is nevertheless a long-standing devotee of the Little Black Dress, and always seems to have an occasion coming up for which to wear one. It is difficult to remember visiting her without the vision of some nifty little designer number sneaking into one's mind's eye, hanging up somewhere in plain sight, in a transparent plastic bag bearing the logo of an expensive "French" dry-cleaner. When we've run into her on such occasions (our wedding, for one), she projects the gestalt of a modern-day kore sculpture, and the aerobic silhouette of a female figure at a cocktail party in an Alex Katz painting.

It is now early March 2012, and we are in Kass's studio in a postindustrial section of Brooklyn (she and her spouse, the artist Patricia Cronin, whose studio is next door in the same building, live not far away on a pretty, tree-lined street of brownstones). There are *feel good* paintings around, but she has been rifling through her flat files, pulling out such relevant, antique tidbits as a sketch, circa 1966, of Angela Lansbury (*Mame*), and another from the same period, more fully realized, of and autographed by Pearl Bailey (*Hello Dolly!*), who, she adds cheerfully, "talked about it on Merv

Letter from Charles Shulz to Deborah Kass, 1961

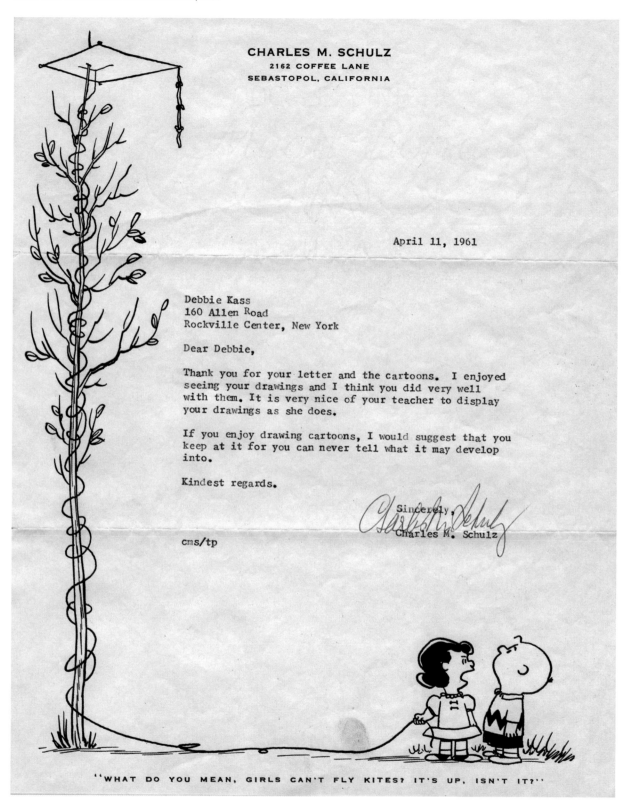

CHARLES M. SCHULZ
2162 COFFEE LANE
SEBASTOPOL, CALIFORNIA

April 11, 1961

Debbie Kass
160 Allen Road
Rockville Center, New York

Dear Debbie,

Thank you for your letter and the cartoons. I enjoyed
seeing your drawings and I think you did very well
with them. It is very nice of your teacher to display
your drawings as she does.

If you enjoy drawing cartoons, I would suggest that you
keep at it for you can never tell what it may develop
into.

Kindest regards.

Sincerely,

Charles M. Schulz

cms/tp

"WHAT DO YOU MEAN, GIRLS CAN'T FLY KITES? IT'S UP, ISN'T IT?"

Griffin." Not one to destroy the evidence, Deb has kept all of her report cards. She brandishes one from kindergarten with the comment that she "is very good at art and Phys. Ed." There is also a letter from Charles Schulz, dated 11 April 1961, and

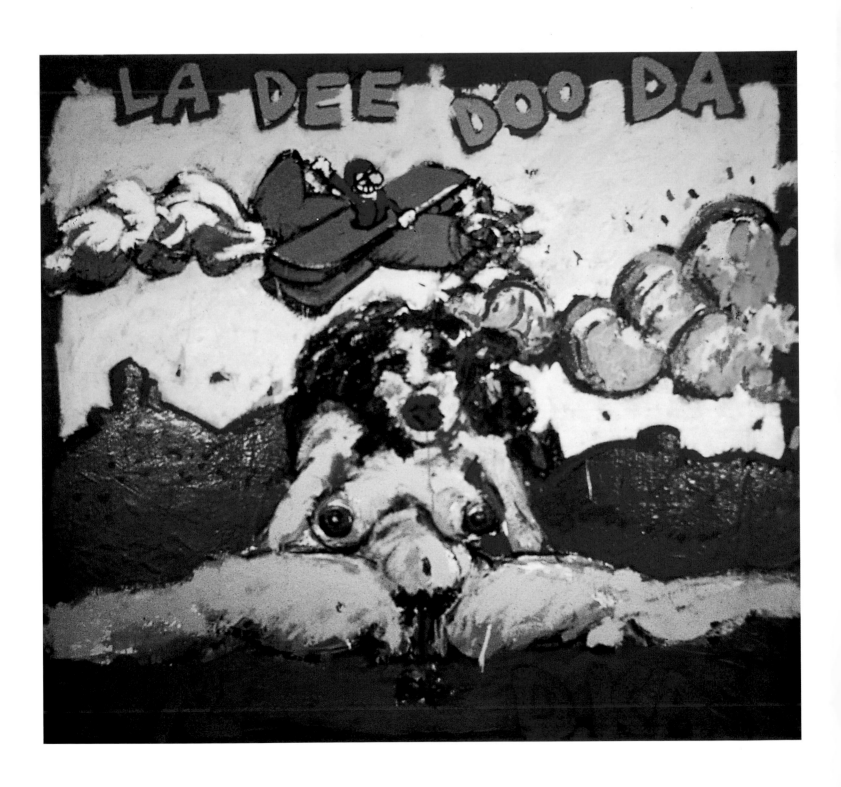

La Dee Doo Da (In the Field), 1972

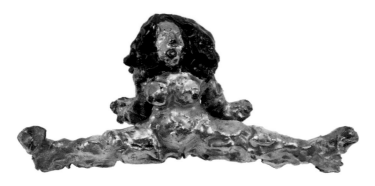

Mona Lever, 1972. Glazed ceramic.
Approx. 13 x 6 x 5 in. (33 x 15.2 x 12.7 cm)

on *Peanuts* stationery—the response to a drawing she had sent him while in third grade. The letter urges her to "keep at it, for you can never tell what it may develop into."

Here's Deb at twenty, spread-legged and gleefully naked on paper—a psychedelic fertility goddess! It's *La Dee Doo Da (In the Field)*, from an eponymous series she made in 1972, while at Carnegie Mellon University and, evidently, having fun. "I'm having sex for the first time," she explains, "and tripping a lot. . . The influence of drugs on the aesthetics of the time should not be underestimated." (Kass is among those interviewed in Ken Johnson's *Are You Experienced?: How Psychedelic Consciousness Transformed Modern Art*, published in 2011, which among other things establishes a causal relationship between "liberated" psychedelic sex imagery of the 1960s, and "second wave feminism" of the 1970s.)

At one point she rustles around a shadowy, shelved area off to the side of where we've all been standing. Wheeling around suddenly, she announces, "I failed ceramics," and plunks a smallish, breakable-looking object down on top of one of the metal files. It is a small ceramic sculpture, quite rococo, in glazed gold. It's from that bumptious *La Dee Doo Da* series, aforementioned, and it looks a bit as if the title figure in one of Willem de Kooning's *Woman* paintings from the early 1950s had popped a happy pill and tumbled off the canvas, Jack-and-Jill style. "We were all looking at R. Crumb and underground comics," she says.

By 1972, Kass had seen a good bit. Two years earlier, she had undertaken a Ken Kesey*esque* voyage—in two vans, with ten classmates and two "youngish hippie cowboy" instructors from Carnegie Mellon—to the West Coast, to visit Allan Kaprow and check things out at "the very new and very hip CalArts." Accompanied by her much older boyfriend, a sculptor, she had also begun to spend time in New York, in Soho, then a frontier zone for artists "where at night they kept the windows dark and took the trash out when no one was around."

They often stayed with the artist John Torreano, a friend of her boyfriend's from Ohio State University, "home of the very influential professor, Hoyt Sherman." The idiosyncratic Sherman, whose best-known student was Roy Lichtenstein, had devised a

Jasper's Dogs, 1973. Acrylic on canvas.
60 x 96 in. (152.4 x 243.8 cm)

teaching method he called a "Flash Lab," wherein images were quickly projected on the wall of a darkened room. Students were afterwards required to draw what they had seen from memory. (Working with the US Navy and Army Air Corps during World War II, he also devised a "camouflage room" as a means of teaching pilots and gunners to quickly identify enemy aircraft.) The semiotic fluency of a work such as Kass's *Jasper's Dogs*, from 1973, wherein staccato cross hatches *à la* Jasper Johns morph into a camouflage pattern *à la* Andy Warhol, all the while suggesting a jigsaw puzzle, would argue that she absorbed Sherman's lessons by osmosis.

"My subjects were always charged and art historical—very sexual and transgressive, before anyone talked about it. . .To me it seemed as if painters in New York in the early 1970s were splitting formal hairs, dancing on the head of pins." Kass, unlike many of her exact contemporaries, had developed traditional skills. She learned anatomy and how to draw from the model while in high school in Rockville Centre, Long Island, and on Saturday mornings in the city at the Art Students League of New York—classes she paid for herself with babysitting money. But her "real" education took place on Saturday afternoons at MoMA.

"I contemplated the Modern's masters, Cézanne through Pollock to pop. I had my favorites. I studied with reverence. I fell deeply in love with de Kooning, Oldenburg, and Cézanne. But I couldn't help but wonder: what in God's name did any of this have to do with me?" Kass's first big epiphany, also courtesy of MoMA, did not take long in coming: "It was the [Frank] Stella show in 1970 that blew me away. Even though I always wanted to be an artist, I wasn't sure what that meant. Seeing Stella, and being able to follow his logic through each series to the next, meant to me that I could do this with my life . . . Stella's work changed my life for good."

Frank Stella, *Single Concentric Squares*, 1974.
Acrylic on canvas. 69 x 69 in. (175.3 x 175.3 cm).
Collection of the artist

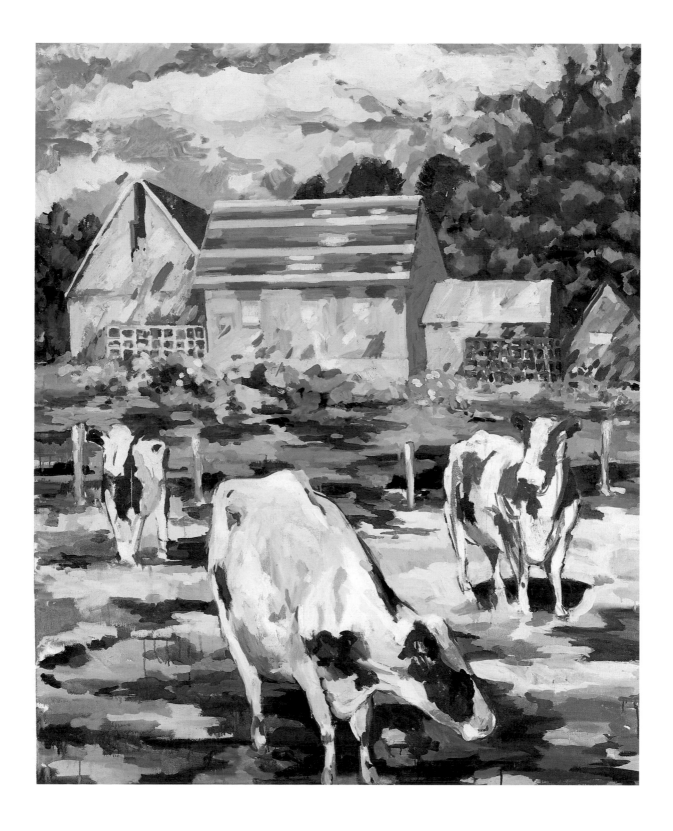

Cows, 1976

(top) *Rose Goes to Niagara*, 1973. Acrylic on canvas. 96 x 72 in. (243.8 x 182.9 cm)

(middle) *Poet's House*, 1975. Watercolor on paper. 14 x 14 in. (35.6 x 35.6 cm)

When we first visited Kass's studio in the late 1970s, however, the Stella factor was not discernible. There were placidly realistic paintings of cows on the walls. Made in 1976, they were based on photographs taken in and around Cummington, Massachusetts, home to an artists' colony where Kass spent a few summers. The most striking—the *oddest*—thing about the cow paintings was what one might describe as their in-your-face normalness. Kass's work was and—for all the more recent odes to queerness—is essentially normative. Kass and her work speak in a "WE" voice, of matters that are at once intensely personal and all but universal, like popular music. The cow paintings had a dilute pop quality, almost regional in feeling, like the cows on Ben & Jerry's ice cream containers, which in fact originated from roughly the same period (1978) and area (Burlington, Vermont).

No one has ever accused Kass of being unduly effete, as a person or as an artist. Her cows, along with a number of other animals, nudes, and landscapes, as well as nudes in landscapes, were by-products of full-on groping, stoned and not, with some of the canonical masters of nineteenth and early twentieth century art history, particularly French, including Delacroix (Kass painted a skittish, but lushly romantic version of *Death of Ophelia* in 1973); Duchamp (a very big *Rose Goes to Niagara*, from 1973, that may owe something to the artist Red Grooms—not to mention *Gypsy!*—but was nonetheless Kass's can-do response to the Duchamp-mania that was gripping New York in the wake of the Duchamp 1973 retrospective at MoMA); Courbet (a failed *Woman with*

Monet's Turkeys, 1976.
Oil on canvas. 46 x 44 in. (116.8 x 111.8 cm)

a Parrot, in 1974); Monet (*Turkeys*, 1976; definitely stoned); Cézanne (a disciplined, formally insightful series from 1975 called the *Poet's House*, doubly based on an actual house once belonging to the poet Richard Wilbur, down the road from the Cummington Community of the Arts, and the French master's *House of the Hanged Man*, from 1873). Her energy, ambition, and good old-fashioned painting know-how were all apparent, despite her rather surprising disregard of almost everything that seemed to us then to be formally relevant, or indeed politically charged.

Here is Deborah at twenty-seven, from the neck up and looking lucid, in *Self-portrait*, from 1979. This is a larger-than-life-size, square format painting whose raw surface and plainspoken affect—the painter's answer to Method Acting—denotes considerable interest, on the artist's part, in the work of Alice Neel (1900–1984), which was then enjoying enormous belated acclaim. "We were all infatuated with Alice Neel and seeing deeply," she confirms. Kass's self-portrait, along with her portrait of Julian Schnabel, a former Whitney Program classmate, found its way into *Heads*, an exhibition that Brooks curated at P.S. 1 in 1981, just as New York was in the birthing throes of a new figurative movement that was being dubbed neo-Expressionism by unhip critics, and of which Schnabel was of course a protagonist. (Brooks's P.S. 1 show also included works by Leon Golub, Al Calderaro, Austé Pečiura, Lilly Brody, Lil Picard, Douglas Ward Kelley, and the performance artist John Kelly.)

But Kass (along with the others in that show) remained at a distance from this new, emphatically male-dominated tidal wave in painting. The early 1980s zeitgeist, with its coquettish relationship to money and power, came as a slow-building shock to many who had come of age during the period just past, and had experienced it as a funhouse of blurring boundaries and multiplying definitions of the self. "The men of my generation saw their paths very differently," she said. "Art was business and business demanded a kind of ruthlessness I don't think any woman artist at the time, younger or older, could even imagine. Their vision presaged what the art world was to become." In retrospect the 1970s were something of a golden age for women painters, even as the relevance of the very medium was continuously being put to question. Those years, says Kass, were "the only decade in which women painters got their due... in the tiny art market of the time."

Elizabeth Murray's first solo show, at the Paula Cooper Gallery in 1976, had occasioned Kass's second epiphany: "The earth moved," she has said, *à la* Hemingway. "Along with Elizabeth, there was Pat Steir, Joan Snyder and Mary Heilmann. . . .

Snyder's operatic emotional and physical intensity led to a lifetime of formal invention and, perhaps, made the same impression on Julian Schnabel as it did on me. . . . Carroll Dunham's work seems simply unimaginable without Murray's precedent. . . . Pat and Elizabeth taught at CalArts and their influence was clearly felt. Content was eventually *de rigueur* in the paintings of their male students, Ross Bleckner, David Salle, Eric Fischl, and Lari Pittman among them."

"Deborah Kass's first solo exhibition in New York was a strong one." These unambiguous words are Lisa's, from a review she wrote for *Artforum* (May, 1984). The paintings, shown earlier that year, were of rocks, mostly within the context of seascapes, and seemed to be imbued with some of the ruggedness and fervor of early twentieth century American masters of landscape (Winslow Homer, Albert Pinkham Ryder, Marsden Hartley). But they also declared allegiance to some of Kass's living paragons, especially to Pat Steir and that artist's sensuous, extravagantly painterly art historical exegeses from that period. Several of their titles furthermore betrayed an authorial consciousness that embraced pop as well as a certain campiness: *Big Splash* (1983), *Maine Squeeze* (1983), *Stormy Weather* (1984).

Over the next few years, Kass continued to make and exhibit paintings in theme-and-variations series—explosively perspectival geometric works, for instance, in brilliant jewel tones—that allowed her to practice and more overtly incorporate the formal as well as anti-formalist "lessons" of Stella and Murray, along with assorted passing interests and influences, including that of John Torreano, her former host. These were, invariably, "strong" and technically accomplished works, resolutely uncool, sometimes almost insanely vigorous, and ultimately a little tiresome. Kass, it seemed to us, was proving something, perhaps mainly to herself, and there was a somewhat embattled, "Annie Oakley" mood about her studio: *She could do anything better than. . . .*But her work, for all its declarative thrust, had not yet found an emotional identity or a visual language it could absolutely call its own.

At this point we exit from Kass's "prehistory," as most of what has been discussed so

Elizabeth Murray, *Can You Hear Me?*, 1984.
Oil on canvas. 106 x 159 x 12 in. (269.2 x 403.9 x 30.5 cm).
Dallas Museum of Art

Emissions Control, 1989–90. Oil, acrylic, Flashe, and
enamel on canvas. 63 x 135 in. (160 x 342.9 cm)

far now appears to be. At the close of the 1980s, she embarked upon a new phase of work grouped under the rubric *Art History Paintings*. These canvases, segmented into discrete picture planes and sometimes involving palimpsests—very much like slightly earlier work by David Salle—constitute a cornucopia of references and appropriations, ranging from Robert Motherwell to Walt Disney. They are more lighthearted and have a lighter touch than all but her earliest works, and are much more pointedly critical than anything she had done before; they are, essentially, open-ended satires. In one of the first of these paintings, *Emissions Control* (1989–90), a composition in five sections whose central image is of sea-splashed, jewel-encrusted rocks, she spoofs herself. In the later and more assured *Portrait of the Artist as a Young Man* (1991), there is a male nude in grisaille on the bottom half of the canvas—headless, with what may be an ebbing erection—that splits the difference between an academic life-drawing subject and homoerotic porn. On top against a black ground, there is a large, white, ersatz-Pollock drip, here magnified and looking cartoonish, among other things. And, as if floating portentously over both of these sultry planes, are the sketchily painted outlines of a face that can only be Picasso's: bullseye!

Neither of us liked these *Art History Paintings* all that much back then, though Brooks held a fond memory of seeing one of them in a three-artist show, *Painting Culture*, curated by Kass in 1991 (at the former fiction/nonfiction gallery), through which he discovered the work of Sue Williams and of Jane Hammond. Over the long, fraught course of the 1980s, we had gotten a little sick of strategic "appropriation." Plus Lisa, who had written enthusiastically about Salle's work—the compositional portemanteau for the entire series—and who was about to begin

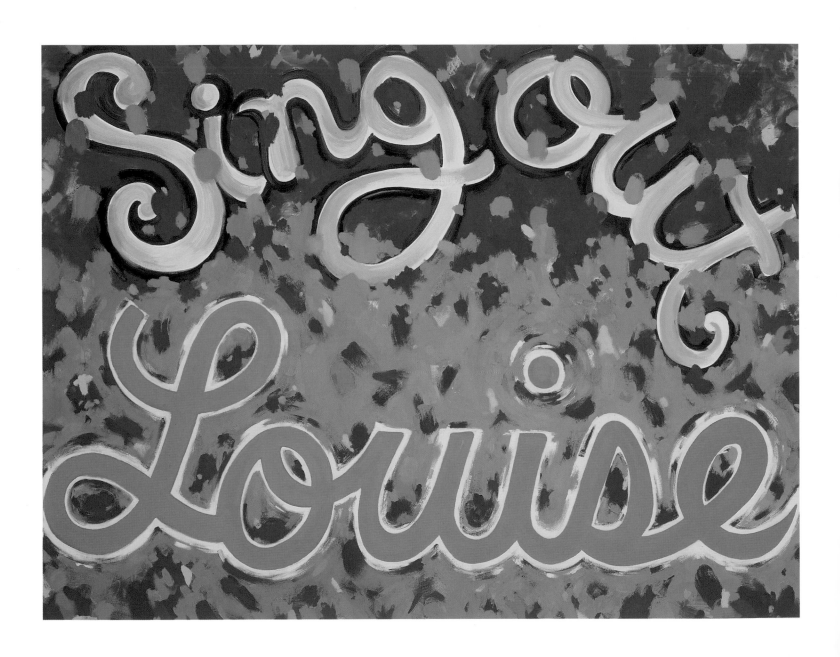

Sing Out Louise, 2004

writing a monographic text about him, was . . . well . . . sort of grumpy about this latest development.

They look a lot better to us now. In any event, they were without doubt Kass's watershed. Out of a work such as *Before and Happily Ever After* (1991), wherein the appropriated image of Warhol's famous "nose job" painting is combined with an image of Cinderella successfully being shod, Kass's great 1990s series, *The Warhol Project*, was spawned. Starting in 1992, when the *Jewish Jackies* and *Yentl (My Elvis)* paintings began to appear, cries of pleasure could be heard ringing in our house. These continued intermittently throughout the decade as specimens from Kass's inspired, utterly Warholian yet wholly personal taxonomy—*Celebrities*, *Most Wanted*, *Self-Portraits*, and of course *Commissions*—rolled out of her studio.

The long-running vitality of Kass's *Warhol Project* is a tribute to what does really appear to be Andy's inexhaustible greatness, as well as to Kass's skill, vision, and voice—all fully and seamlessly integrated, at last. With *feel good paintings for feel bad times*, a series begun in 2002 with the drawing *Sing Out Louise* and still going strong—you may notice a large cast of supporting players, but the curtain call is hers and hers alone.

All quotations are from an interview with the artist on 4 March 2012 or from "The Seventies," the transcript of a talk given at the National Academy of Design as part of a panel discussion moderated by Katy Siegel on the occasion of *High Times, Hard Times: New York Painting 1967–1975* in 2007 (also published as "The Seventies" in the *Brooklyn Rail*, Sept. 2007).

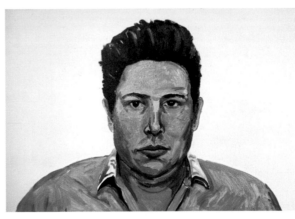

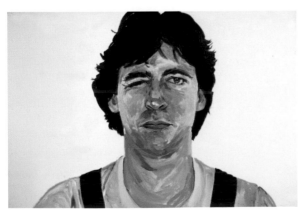

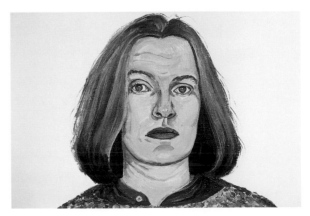

(top to bottom)

Self-portrait, 1979. Oil on canvas. 22 x 32 in. (55.9 x 81.3 cm)

Aladar Marberger, 1979. Oil on canvas. 22 x 32 in. (55.9 x 81.3 cm)

Dickie Landry, 1979. Oil on canvas. 22 x 32 in. (55.9 x 81.3 cm)

Judd Nelson, 1979. Oil on canvas. 22 x 32 in. (55.9 x 81.3 cm)

(top to bottom)

Karen Gunderson, 1979. Oil on canvas. 22 x 32 in. (55.9 x 81.3 cm)

Peter Bradley, 1979. Oil on canvas. 22 x 32 in. (55.9 x 81.3 cm)

Julian Schnabel, 1979. Oil on canvas. 22 x 32 in. (55.9 x 81.3 cm)

Helen Wilson, 1979. Oil on canvas. 22 x 32 in. (55.9 x 81.3 cm)

(top to bottom)

Ingrid Sischy, 1979. Oil on canvas. 22 x 32 in. (55.9 x 81.3 cm)

Charlemagne Palestine, 1979. Oil on canvas. 22 x 32 in. (55.9 x 81.3 cm)

Julia Hayward, 1979. Oil on canvas. 22 x 32 in. (55.9 x 81.3 cm)

Helen Winer, 1979. Oil on canvas. 22 x 32 in. (55.9 x 81.3 cm)

(top to bottom)

Jeannie Kaufax (Grandma), 1979. Oil on canvas. 22 x 32 in. (55.9 x 81.3 cm)

R. M. Fischer, 1979. Oil on canvas. 22 x 32 in. (55.9 x 81.3 cm)

Stuart Hitch, 1979. Oil on canvas. 22 x 32 in. (55.9 x 81.3 cm)

Jim Welling, 1979. Oil on canvas. 22 x 32 in. (55.9 x 81.3 cm)

Untitled (Sky), 1988

Sense and Sensibility I, 1987

Sense and Sensibility II, 1987

Untitled (Pollock), 1987

Something of Value I, 1988

Second Nature, 1988

Table of Content (Part I), 1988

Short Story II, 1989

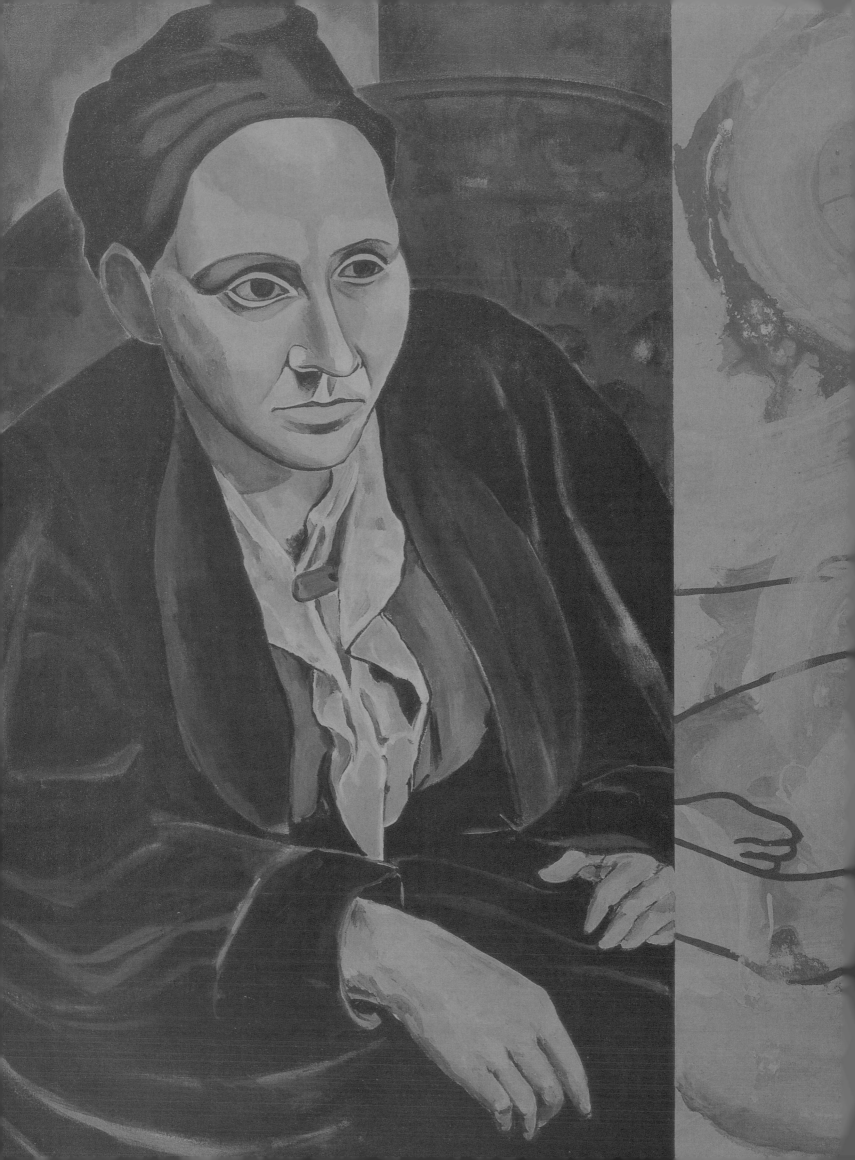

art history

THE END

Emissions Control, 1989–90

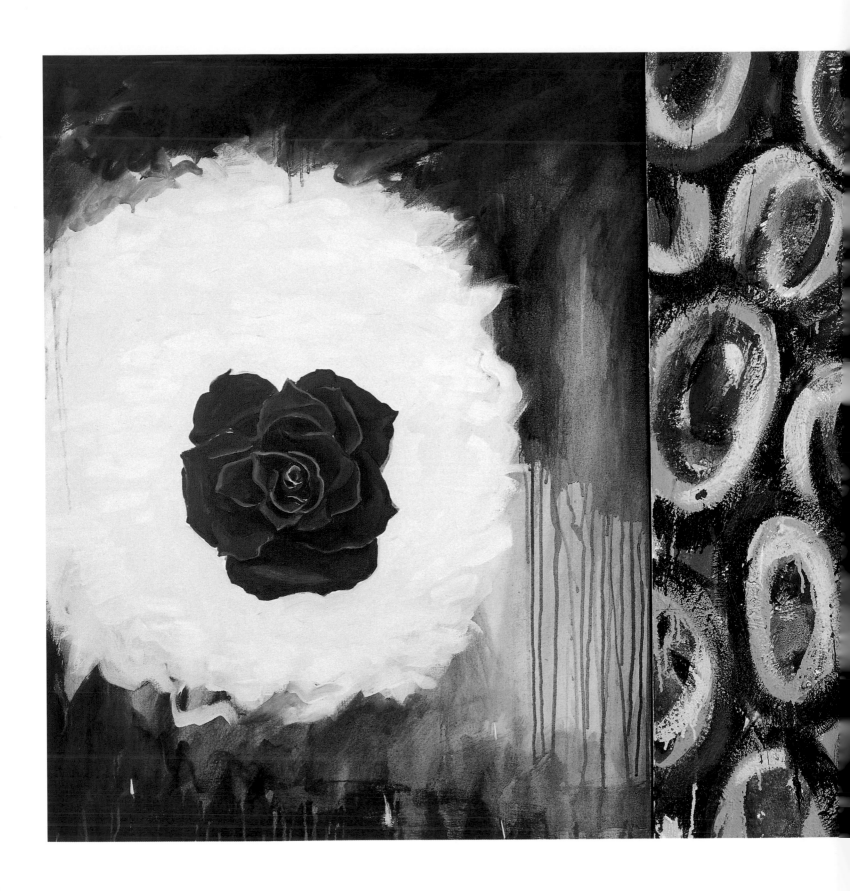

Call of the Wild (for Pat Steir), 1989

My Spanish Spring, 1991

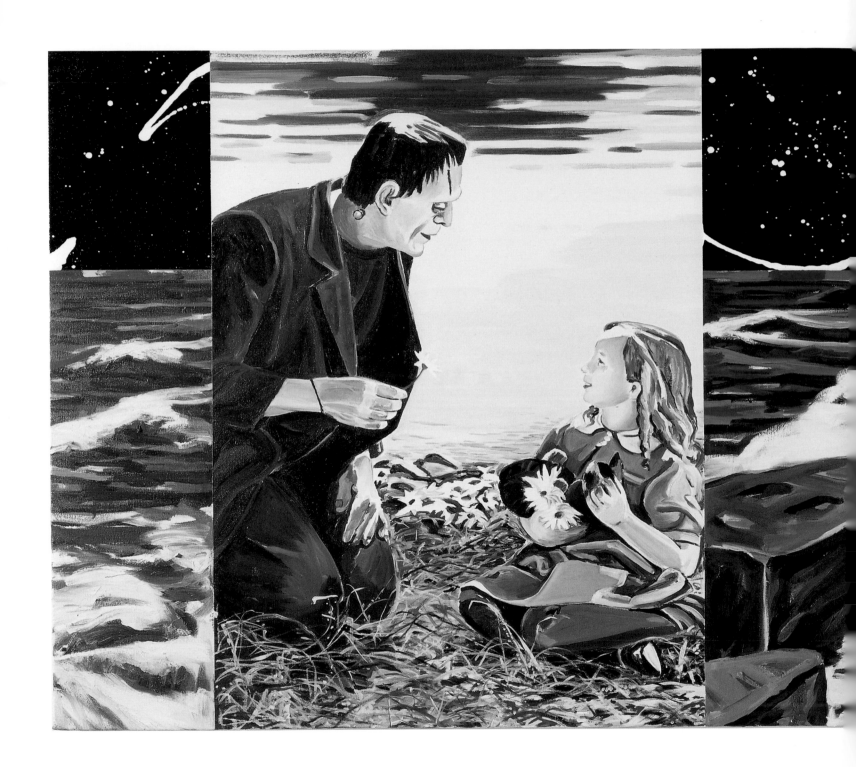

Nature Nature II, 1991

Untitled (First World Third World), 1990

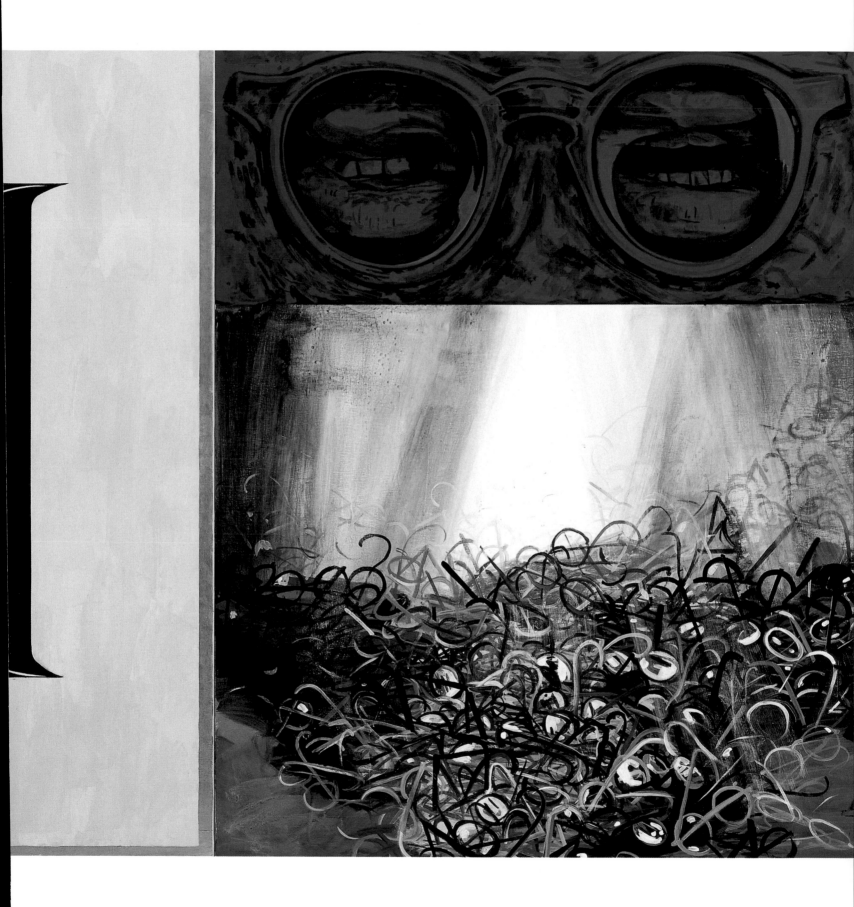

Subject Matters, 1989–90

Nature Morte, 1990

Portrait of the Artist as a Young Man, 1991

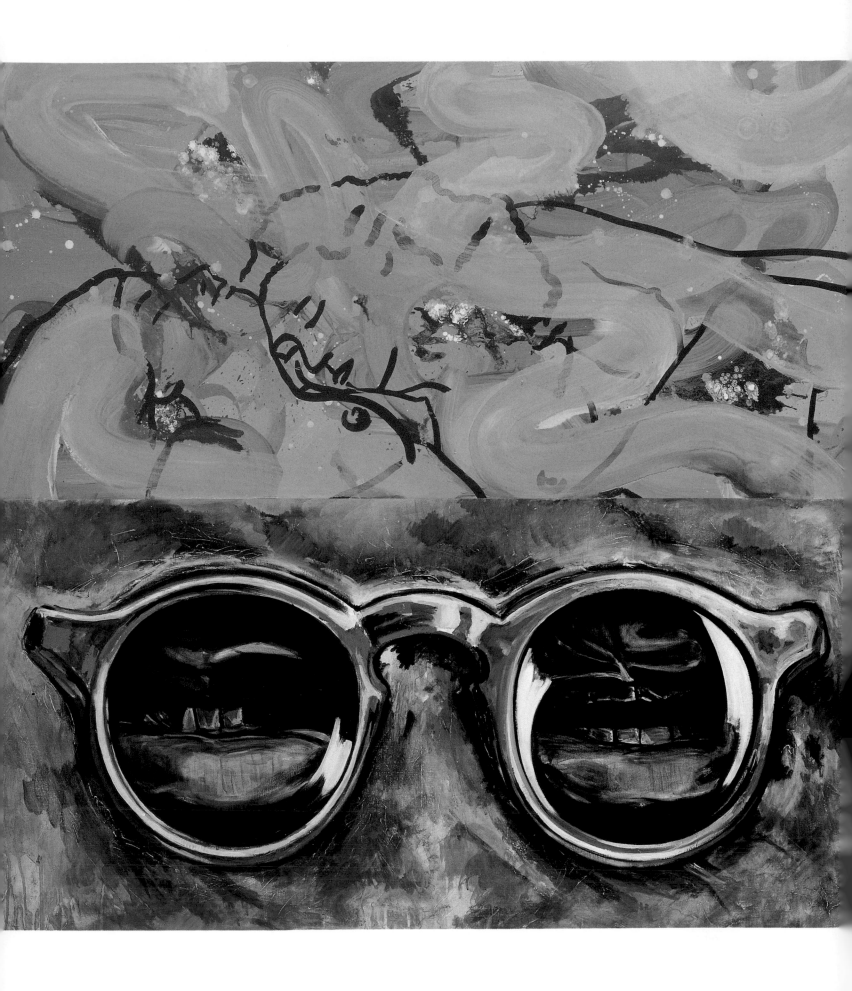

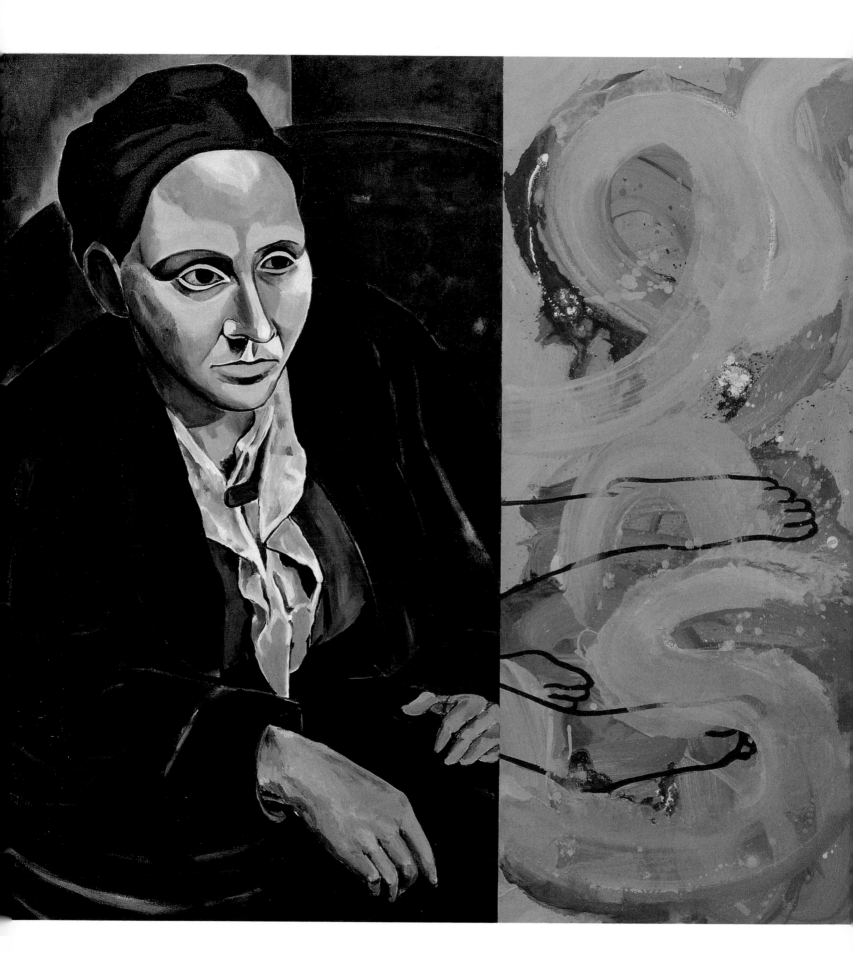

How Do I Look?, 1991

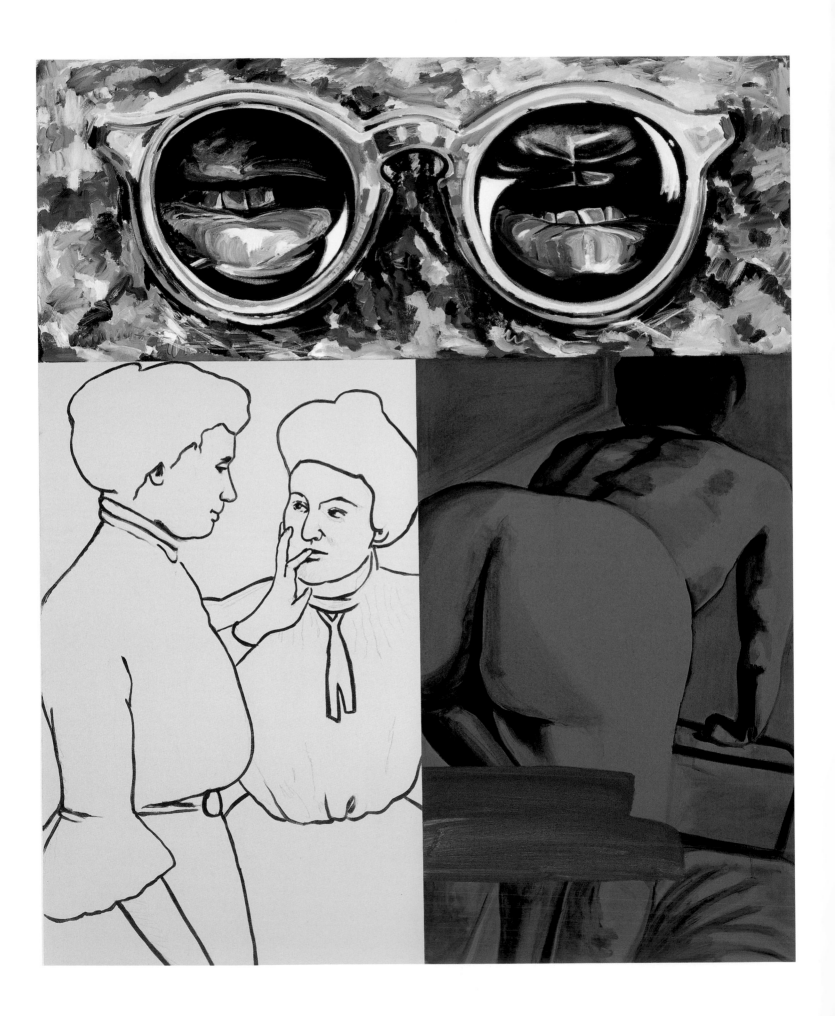

Read My Lips, 1990

Making Men #4, 1992

Making Men #3, 1992

Making Men #2, 1992

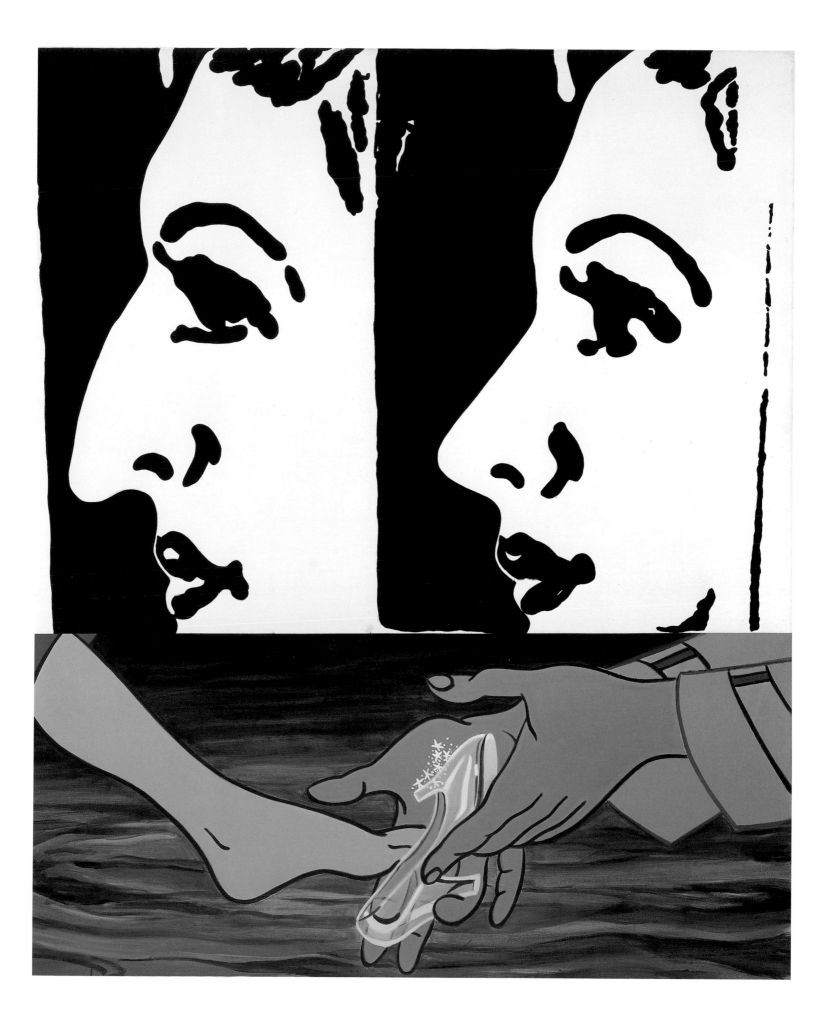

Before and Happily Ever After, 1991

Puff Piece, 1992

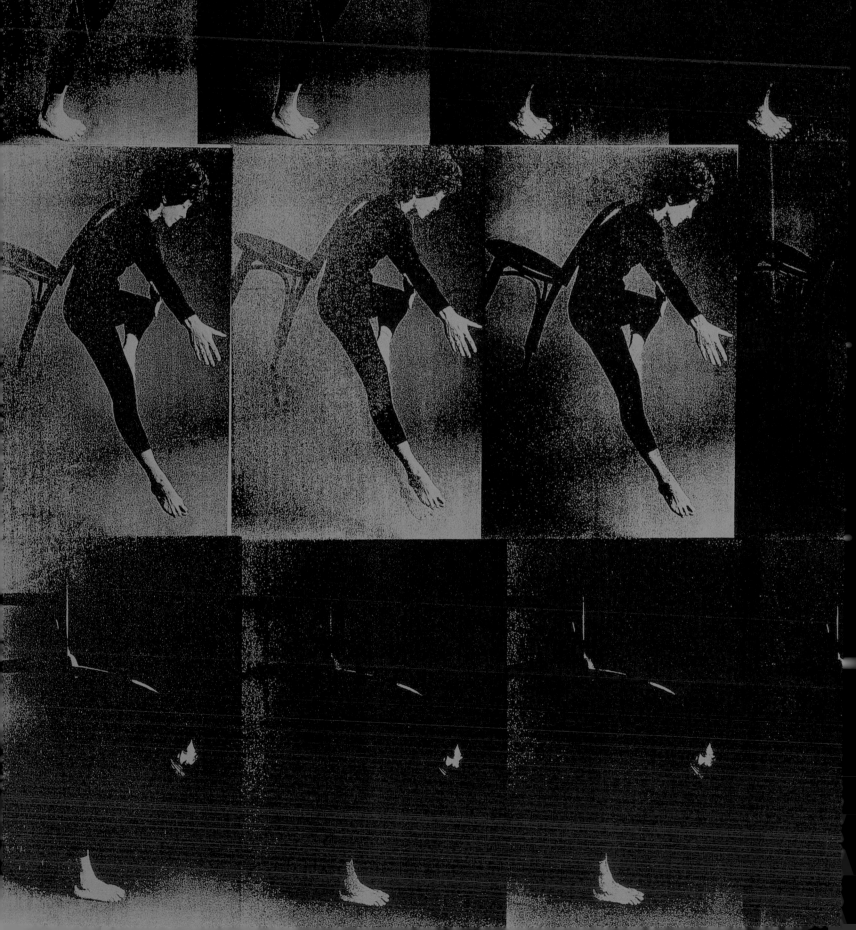

KASSQUERADE

Robert Storr

for
Gertrude and Alice,
Peggy and Shelley,
Lyn and Kate,
Evelyn, and all my
Other mothers
and sisters.

So how do you queer the queerest artist who ever made it into the "main-stream" of American culture? Well, first it is necessary to note when and on what terms he got there, since the artist in question is obviously Andy Warhol. The moment was the 1960s when the rebellion against the patri-archal, Anglo-Saxon old order erupted on all sides and the counterculture was born. But as everyone now knows and those with the biggest stake in the matter were even more acutely aware of then, the latitude that was granted to truly "different" con-stituencies—much less the rights to uncensored self-assertion—was far from equal across the board. Insofar as Warhol was concerned the terms were not initially in his favor, nor were they in the favor of other men like him, Jack Smith and other compa-rably flaming creatures among them. By the time "Andy" became a bankable art star, mass media celebrity, and household name, gay artists had already hit the big time, but almost all of them had done so at the then current price of allowing or insisting that their sexuality be left fundamentally obscure.

Warhol braved the prejudicial compromises requiring carefully managed public suppression of overtly homosexual traits or tropes by playing the sissy to the hilt. For doing this he deserves a posthumous medal or two: the Presidential Medal of Freedom for starters and a Congressional Medal of Honor for courage in the face of overwhelming odds during the opening salvos of the Culture Wars of the 1980s and after for good measure. Allen Ginsberg should be awarded the same decorations in honor of the declaration made in his genuinely patriotic McCarthy-era national ode—genuine because he persisted in loving the best that his country represented despite its contempt for him and his kind—"America, I'm putting my queer shoulder to the wheel." If the first medal is ever bestowed, we will know that we finally have a commander in chief in no need of evolution. If the second should by some miracle

be voted by a legislative branch that demagogues have so frequently exploited as an amplifier for their ignorance and bigotry, then the Culture Wars will finally be over.

Yet with all the credit that is due him, Warhol spoke for only a portion of the LGBT community in the decades before that acronym was invented and before general recognition of the actual spectrum of sexual identities and preferences was anywhere near as broad or as nuanced as it has since become. While Warhol hosted many shades of gay at the original Factory and in his post-Factory entourage, the one that got by far the least attention given its demographic proportions was the L in that lineup of abbreviations: lesbians. True, America had long ago embraced the only other proudly nationalist poet of queerdom prior to Allen Ginsberg, Gertrude Stein, and it had gone so far as to extend its bemused affections to her dour partner Alice B. Toklas. But until recently—and arguably even now—women have had a second place status in homosexual circles just as they have had in heterosexual ones. The fault does not for the most part issue from conscious or unconscious misogyny, though traces of hostility to or disregard for women are constantly evident on and never far below the surface of our cultural, social, and political lives. And, as Warhol insisted, surfaces count as much or more than depths. Rather it results from myopia, an ingrained unwillingness or actively cultivated inability to see what is there to be seen. Unless it is directly addressed to men, female desire has by tradition been all but invisible, and when addressed to men in obvious ways it has more often than not been condemned as unseemly. Moreover, sex has always been such a serious matter in our Puritan-corrupted ethos that playfulness in the service of desire is worse than overt lust. So the simple answer to the question posed at the outset, "How do you queer the queerest artist ever to dent the carapace of America's 'shared' values?" is: grant a funny lesbian the license afforded to Warhol. Better yet, watch her spontaneously claim it outright.

"Footlights up!" and cue Deborah Kass. When she takes her bow it is not as an Andy understudy, mind you. And certainly not as a straight one-to-one substitution for the greatest sissy of them all, since, to paraphrase Søren Kierkegaard's wondrously suggestive maxim, nothing straight is ever made from the bent timber of Woman. Not this woman anyway. Or, writing in drag while taking the same liberties with Mae West's dictum, one might just purr, "straightness has nothing to do with it." And neither do most of the other shibboleths of entrenched White Bread America.

For starters, Kass's Warhol re-personations are a drag act doubled by that of her chosen protagonist: torch singer and gay icon, Barbra Streisand. Of all the divas and divos of Warhol's era, Streisand was among the few who declined the offer to have

a portrait painted by the record angel of Big Money and Big Fame, thereby leaving Kass the opportunity to play the Warhol game without appropriating an actual work by him, while faithfully glossing the attributes of his signature manner. It also meant that Kass was in a position to select her own paradigmatic likeness of Streisand and take full possession of all the connotations of the image. Although she had her pick of Barbra as the gamin, Barbra the glamorous chanteuse, Barbra the droll facsimile of Fanny Brice in *Funny Girl*, or any other of her numerous stage and screen incarnations, Kass had her eureka moment in settling on Barbra in the movie version of Isaac Bashevis Singer's short story "Yentl the Yeshiva Boy," a Victor/Victoria fable of sexual semiotics and mores in the Shtetl. The intricately enlaced plot concerns the pious daughter of a rabbi who assumes a male identity after her father's death in order to pursue her own "masculine" intellectual passions as a Talmudic scholar. The decision affords her the chance to avoid her "feminine" fate as a conventional wife and mother in her strictly gendered orthodox community. So successful is her deceit that she marries the woman whose hand had been denied to the fellow Yeshiva student she truly loves. In the end, Yentl confesses her subterfuge to her inaccessible male soul mate, but none of the essential complications are resolved, nor can they be in the static community that gave rise to them.

Nominally modeled on Warhol's portraits of the King of Rock and Roll, Kass's numerically various renditions of *My Elvis* as *Quadruple Yentl (My Elvis)* (1997) and *Double Double Yentl (My Elvis)* (1992), play fast and loose with their pop template. Portrayed with a Talmud in one hand and the other tucked into her hip pocket like the capped and cloaked, bookish and bespectacled boy affecting a manly strut that she pretends to be, Streisand—with Lee Van Cleef of Sergio Leone's spaghetti westerns hovering in the wings somewhere—effectively mirrors and culturally warps the stance of the rugged cowboy Presley drawing a gun in Warhol's 1962 paintings. However, as every American who saw him for the first time in 1956 on the Ed Sullivan show knows— I did and I knew even then—Presley's swivel hips caused a sensation not merely because the overtly erotic gyrations were "vulgar," as Sullivan claimed off camera, but because "real men" don't move their hips like that. Women and blacks do. With "Elvis Pelvis" being too pretty by half and not white enough from the waist down, the paradigm that Kass pushes off from is already loaded with subversive ambiguities. The one thing that could be said for Elvis by those most inclined to find such uncertainties intolerable was that he was a Southern Baptist who loved his mother. Yet as mama's boy Warhol demonstrated, filial piety can itself be suspect. Meanwhile, in an era that struggled to elect John F. Kennedy as the first Catholic president, Warhol's middle-European devotion to the Church was another count against him.

In any case, Barbra was nobody's mother and she was Jewish. Indeed, alongside the Yentl series Kass delighted in dropping Streisand's profile into the iconic formats occupied by Kennedy's grieving widow in her extended *Jewish Jackie Series* (1992), created just shy of thirty years from the Warhol originals. Making the most of how Streisand's majestically "Jewish nose" replaces Jackie's upturned Bouvier bud—in passing Kass thus nods to the several *Before and After* (1961) "nose job" paintings Warhol made just prior to his first Marilyns and in her own *Before and Happily Ever After* (1991) she quotes them directly—Kass's ethnic reconfiguration supplants or better enhances gender-bending. And so with every sideways step beginning with Warhol's sly sixties sashays to the left and right, and continuing with Kass's latter-day parodies of classic pop, we veer further from the straight and narrow, one "minority" identity trumping the next at the expense of the illusion that the "majority's" inherent nature is in any sense universal. Alas, my words cannot match the mordant, pictorially efficient mischief of Kass's paintings, but my purpose here is merely to signal how many layers her "surfaces" add to Warhol's, how gleefully abysmal Kass's hall of mirrors is when set into his.

Never one to ignore an iconographic opportunity or to leave art market money on the table, Warhol played the Jewish card himself in a suite of lithographs titled *Ten Portraits of Jews of the 20th Century* (1980). With three of the Marx Brothers squeezed into a single sheet—Groucho, Chico and Harpo—Warhol was in fact able to honor a dozen Jews, the others being Franz Kafka, George Gershwin, Martin Buber, Louis Brandeis, Golda Meir, Sarah Bernhardt, Albert Einstein, Sigmund Freud and, naturally, Gertrude Stein. Not one to miss a trick either, Kass doubled down on her original homage to Stein in *How Do I Look?*, a 1991 appropriative mash-up of Jasper Johns's sculpture *The Critic Sees* (1964) and Picasso's canonical 1905–6 likeness of the salon sphinx, Gertrude Stein, by conjuring her own silkscreen variation on Warhol's group

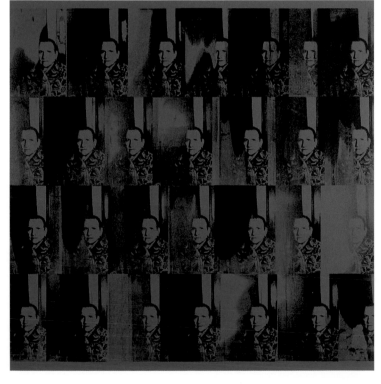

Parisian, Portrait of Gertrude Stein, 1997.
Silkscreen ink and acrylic on canvas. 77 x 77 in.
(195.6 x 195.6 cm)

portrait of Robert Rauschenberg and his family, here with Stein as its centerpiece with her brothers Leo and Michael, their wives, her nephew Allan, and her lover and surrogate "autobiographer" Alice B. Toklas serving as the chorus. For his homage to Rauschenberg, Warhol borrowed the title of James Agee's biblical report on the life of sharecroppers in Depression-era Alabama in part because Rauschenberg's Texas origins were almost as humble and hardscrabble. For her purposes, however, Kass renders Warhol's ironic title *Let Us Now Praise Famous Men* as *Let Us Now Praise Famous Women*, and in her second homage to Stein she re-genders Warhol's images of Chairman Mao as "Chairman Ma." There she—Kass—goes again. In yet another chain reaction of semiotic switcheroos, Agee's profoundly Catholic account of the suffering of Southern Baptist farmers caused by American capitalism run amuck becomes the tagline to a painting celebrating Warhol's discreetly gay but heartland-American predecessor in pop, Rauschenberg, only to morph into the Big Sister-like visage of a stern-looking Jewish dyke. Slipping her own face into the thin silk-screened laminates of Warhol's late camouflage self-portraits, Kass caps the lesbian infiltration of his multiple masquerading work by usurping his place altogether with the slightest trace of teasingly "Look Ma!" self-satisfaction in her expression.

Warhol has not been the only one to tamper with the supposedly transparent humanist "truths" of the James Agee/Walker Evans collaboration in praise of all but anonymous suffering. Indeed by the 1980s the circumstantial amalgam of Agee's passionate earnestness and Evans's dispassionate formalism had been thoroughly undone by a generation of piratical production in which Duchamp's practice of the ready-made was elided with various misreadings both strong—that is, seriously provocative—and weak—in short, grad student glib if not egregiously sophomoric—of Walter Benjamin's seminal essay "The Work of Art in the Age of Mechanical Reproduction." It was a fertile but conceptually flawed misalliance informed or deformed by decades of flipping magazine pages, changing television channels, or otherwise gorging on pictures moving as well as static that were spewed forth by the Image Industry. Perhaps the single most confounding gesture announcing the advent of Appropriation Art (since the 1970s adding capital letters to nouns has been customary among postmodern theorists eager to extract terms from common parlance and elevate them to the levels of abstraction, and vagueness, suitable for academic discourses about matters of "world historical" consequence or "meta" dimensionality, and I see no reason to deprive myself of the opportunity to do likewise since in order to make the case for an artist one believes in it is increasingly necessary to speak the language of the critical and scholastic guilds and reciprocate their secret verbal handshakes) was Sherrie Levine's co-optation of Evans's Farm Service Administration photographs of the pseudonymous Gudger, Ricketts,

and Woods families and their environs. In fact, at the time Levine embarked on her "re-presentations" of Evans's representations of rural life, prints made from copy negatives of Evans's originals were readily available from the Smithsonian Institution; they were sold on order through the mail for a nominal cost on the remarkably democratic premise that pictures made on work-for-hire commission by the federal government belonged to the taxpaying citizenry of the United States and should be provided to everybody who wanted one for the lowest possible service fee. All of which is to say that the artist's copyright had already been forfeited and passed to the nation and the originality of original prints had already been stretched to include government-authorized copies of copies virtually ad infinitum. Levine stretched that continuum still further by suspending her copies of copies at an indeterminate point in the chain of reproductive derivations while isolating the content of the pictures from its "original" social and political context and relocating them in an alien and alienating aesthetic domain in which contemplation of the "essential human" and historically specific import of the images yielded to the manipulated economic and social dynamics the traffic of goods in the contemporary art world.

This digression into Levine's work and the gamesmanship involved is justified by both biographical and substantial interpretive factors. First, at a crucial period in the early careers of both Kass and Levine they shared a cutting edge gallery—Baskerville + Watson. Second, an alternative name for what Levine did comes from the lexicon of Situationism, and in particular from Situationist guru Guy Debord's advocacy of the systematic *détournement* of conventional uses and understandings. That is to say, Debord believed in deliberately skewing habitual meanings as a way of dismantling established ideologies and disrupting overdetermined means of communications. Another term for such *détournement* or critical skewing is "queering the pitch," a sports metaphor from cricket and baseball that dovetails nicely with the standard commercial as well as noncommercial rhetoric of persuasion at the point where two definitions of the word "pitch" converge.

Inasmuch as we have entered the zones of propaganda—selling ideas and commodities, but especially ideas as commodities—we should also acknowledge the looming graphic presence of Barbara Kruger's work of the early 1980s. Its calculated assaults on the spectator/reader in the form of hybrid revolutionary modernist/conformity-inducing Madison Avenue montages and the deployment of unreliably gendered pronouns—you/we/they—simultaneously include and exclude individual members of the public from presumed collectivities. Both Kruger and Levine demonstrated that "queering the pitch" could almost invariably entail sexual politics without either

the artist's or the viewer's specific erotic preferences coming into play. Kass relentlessly broaches that question and cheerfully breaches whatever remaining barriers to free-form sexual diversity it leads to. And, I would accent the word "cheerfully" and encourage the double entendre use of its synonym "gaily" because however politically apprehensive the artist may be about the probable fate of America and the world—make no mistake, Kass is in every way a political artist, and a skeptical one at that—and whatever shadows fall in her Kodalithically chiaroscuro Warholian domain, her work is not the product of dystopian pessimism—the defeatist fallback position of puritanically anti-aesthetic, decoration-hating yet excessively Adorno-ed critical theorists—but rather the dimension-giving emblem of the boundary-shifting tragicomic in which anxious giggles and even unbridled laughter are the naturally "unnatural" complement of horrified gasps and uncontrollable sobs.

That double-consciousness—the term derives from W.E.B. Du Bois's description of the divided and conflicted awareness imposed on African Americans by the reductively binary black/white racial dynamics of a formerly slave-owning, latterly "egalitarian" America—is therefore both the source of pain and pleasure, the root of alienation and community, a daily, if not moment to moment test of the synthetic elasticity of human consciousness. Straightness is all about what is given, and expected, what is innate and immutable. Queerness is all about what one must make for oneself and of oneself to assure that there is a place for one to develop and survive in the completeness and ever-changing character of one's contradictions, whether "natural" or "unnatural," inborn or the product of experience, a matter of inherent need and desire, or of elective affinities. Queerness is existential convolution and expansiveness fully recognized and, to the extent that conditions allow, fully realized. If we assume as any educated person must, that both sexual predisposition and erotic preference are never definitively fixed but always occupy relative locations on a continuum of possibilities available and, to a greater or lesser degree accessible and attractive to all, then queerness is—or should be—the norm and not the exception.[1] Accordingly, straightness is an aberration because it tailors the flowing fabric of being to fit rigid, standardized dummies rather than to drape bodies and minds in motion. Indeed, to paraphrase James Baldwin's observation, identity should be like the clothes worn in West Africa, which are voluminous and rather than cover every part of those who wear them, from time to time allow a little nakedness to show.

Needless to say that is not the currently accepted view in American society as a whole. Although north to south, east to west, from small towns to big cities, inner denial does not work as well as it used to, and neither does external repression. Moreover, in the

strict sense, history is on the side of inclusive queerness and against that of exclusive straightness. Even our founding fathers said so. "And what I assume you shall assume," wrote Walt Whitman in the opening lines of the only national hymn we have that unequivocally embraces our actual democratic multiplicity. He didn't stop with generalities. He was very explicit as to what he assumed and what he expected each and every one of his readers to assume, though unlike those that appear in Kruger's polemically barbed graphic riffs on authoritarian propaganda, the bard's collective pronouns are never coercive.

Instead Whitman seduces. And so he continues, "For every atom belonging to me as good belongs to you," and from there proceeds to address a series of explicit invitations directly to his public to partake of the sensual delights he has permitted himself and share in the discoveries he has made. He calls upon the reader to savor his scent as he does. "I breathe the fragrance myself, and know it and like it, / The distillation would intoxicate me also, but I shall not let it." After which he disrobes in order to immerse himself in the atmosphere around him. "I will go to the bank by the wood and become undisguised and naked," inhaling "The smoke of my own breath," taking account of his own genitals "loveroot, silkthread, crotch and vine," and reckoning the presence of others. "Welcome is every organ and attribute of me, and of any man hearty and clean / Not an inch nor a particle of an inch is vile, and none shall be less familiar than the rest." In summation, Whitman beckons all to join him in his ecstasy and make it their own. "Stop this day and night with me and you shall possess the origin of all poems / You shall possess the good of the earth and sun. . . . there are millions of suns left, / You shall no longer take things at second or third hand. . . .nor look through the eyes of the dead. . . .nor feed on the spectres in books, / You shall not look through my eyes either, nor take things from me, / You shall listen to all sides and filter them from yourself."

Have I, a male, heterosexual WASP strayed too far from Deborah Kass, a female Jewish homosexual? Have I reinscribed her in the patriarchal hierarchy after having announced that I was going to focus on her as an exception to the masculine canon, gay as well as straight. I think not. Rather, I have attempted in these concluding paragraphs to explain what stake I have in her work and why I feel anticipated and positively welcomed by it as I do by Whitman. The essence of my affinity for her work—and it is the only essential component of the reality I am trying to encompass since nothing about queerness is "essential" other than an irrepressible, uncontainable tendency to shapeshift—is the primacy of the pleasure principle in a period when pleasure has been denounced as often by revolutionary radicals as it has by conservatives or reactionaries.

Whitman again: "I have heard what the talkers were talking, the talk of the beginning and the end / But I do not talk of the beginning or the end." Neither does Kass.

These days the talkers compete for captive audiences in seminar rooms, on television shows, and in the blogosphere, using every browbeating tool at their disposal to convince the public of their omniscience, omnipotence, and of the inevitability of their routinely dire predictions. The true goal, of course, is to dispossess that public of its capacity for self-determination and render it powerless, in part by depriving it of the *joie de vivre* that makes struggling against the death wish seem worth the effort. Kass belongs among hard-core naysayers to conventional wisdom of all kinds who nevertheless insist that rote negation is just another way of saying yes to the status quo. She too is ready to fight the fight—her fight, our fight—"by any means necessary." Those words are Malcolm X's, but the resolve they bespeak is shared by several generations who heard him utter them even though their specific issues may differ from his in one dimension or another, and the "means" available have altered and expanded along with the increasing diversification of those who contest constraints on their freedom. And though it may seem inadequate to the looming challenge posed by the "outraged moral majorities" marshaled by the bully boys who precipitated the culture wars, style is the stealth weapon of choice in combat played out in the public imagination. Accordingly, if Malcolm and Walt are implicit points of reference for gauging the parameters of Kass's strategic plan, Andy and Barbra are among the cultural icons she has openly deployed on the field those parameters define. To them we should now add Stephen Sondheim (what American artist exploits mordant pessimism and ironic verve our nation inspires to more eloquent or more invigorating effect?) and a host of 1960s girl groups and singer-songwriters (Carol King, for one) whose rhythms Kass has translated into intervals of vibrant color and whose words she has turned into pulsing images.

Back in the 1970s satirist Tom Lehrer made fun of the naïveté of early 1960s radicalism with a ditty whose chorus began "We are the folk song army" and ended "They won all the battles but we had all the good songs." Well perhaps so, but a battle with no songs is, indeed, a hopelessly grim affair. Meanwhile, in our present besieged state queering the pitch musically—as in every previously suggested way—may be our last best hope. If it fails, although I am inclined to Whitman's faith in vital flux, the prospect of going down fighting to the strains of a catchy tune isn't the worst of fates. At any rate, that is the spirit in which Kass paints her pop-derived, pop-rejuvenating call to arms. You'd have to have a tin ear and a leaden heart to resist it. And you'd have to be blind not to see the warm, wry life force beneath her work's cool, detached Warholian surfaces.

1. Starting with the publication of *Sexual Behavior in the Human Male* (the Kinsey Report) in 1948, social scientific research has scuttled virtually every piece of "conventional wisdom" that has been used to support essentialist and normative sexual classifications inherited from the nineteenth century, while the theoretical work of Judith Butler, among others, has greatly increased and nuanced our understanding of the ways in which gender identities are assumed and "performed" rather than given and involuntarily acted out. There is no need to recapitulate that research or her arguments here, but it should be noted that the title of this essay is a tip of the hat to her discourse of sexual "masquerade."

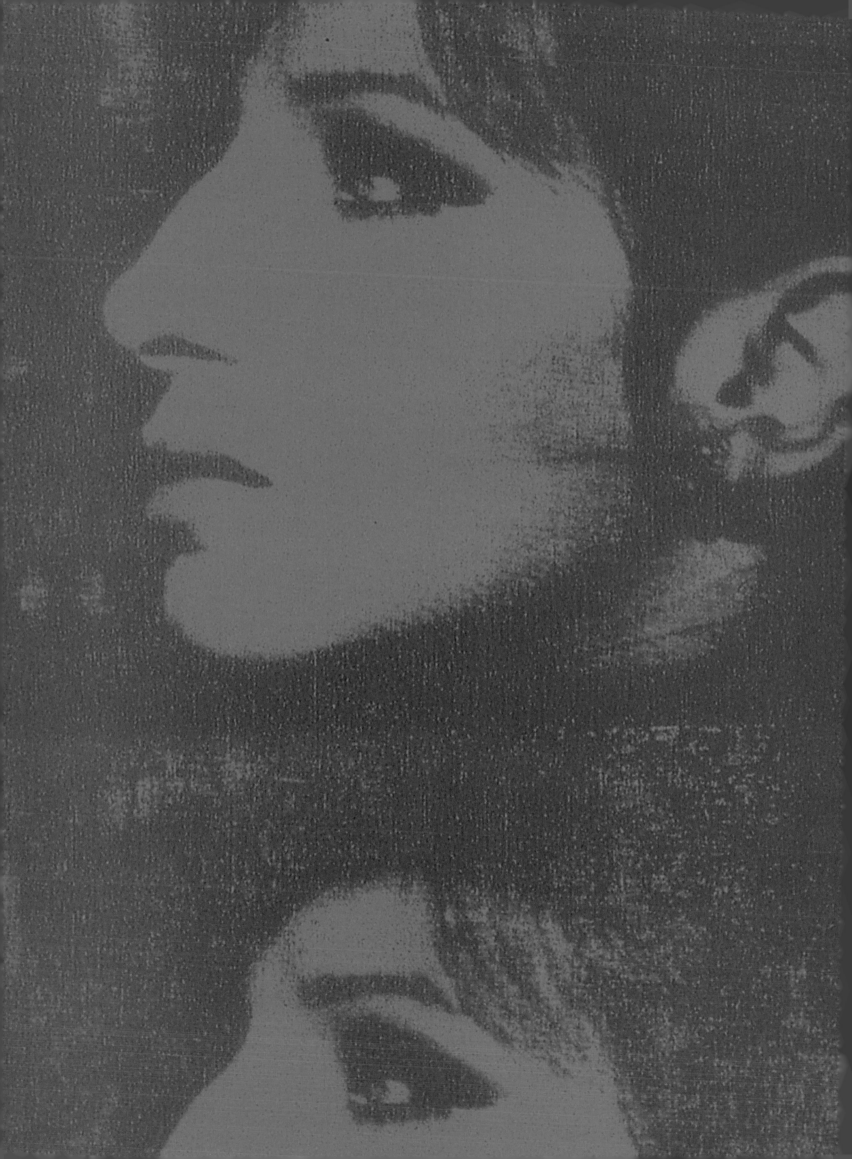

the jewish jackie series
–
my elvis

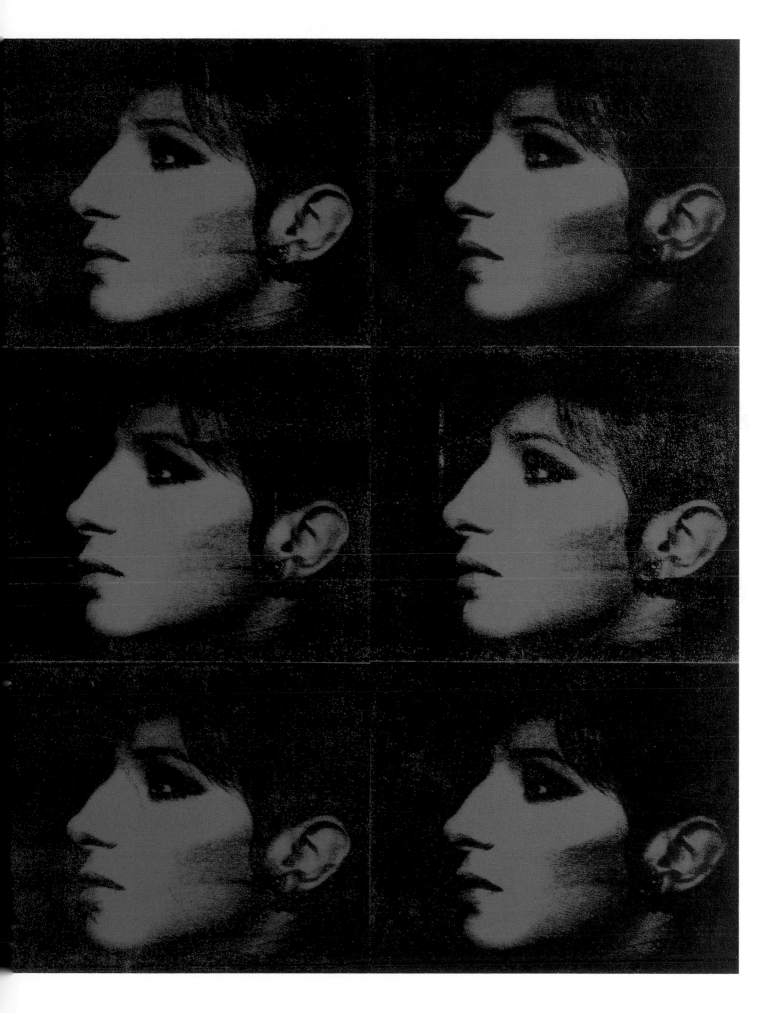

Double Red Barbra (The Jewish Jackie Series), 1992

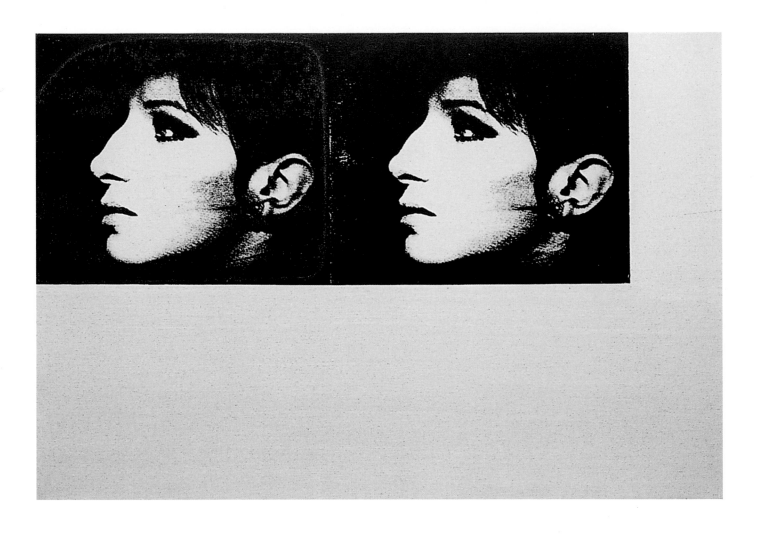

2 Silver Barbras (The Jewish Jackie Series), 1993

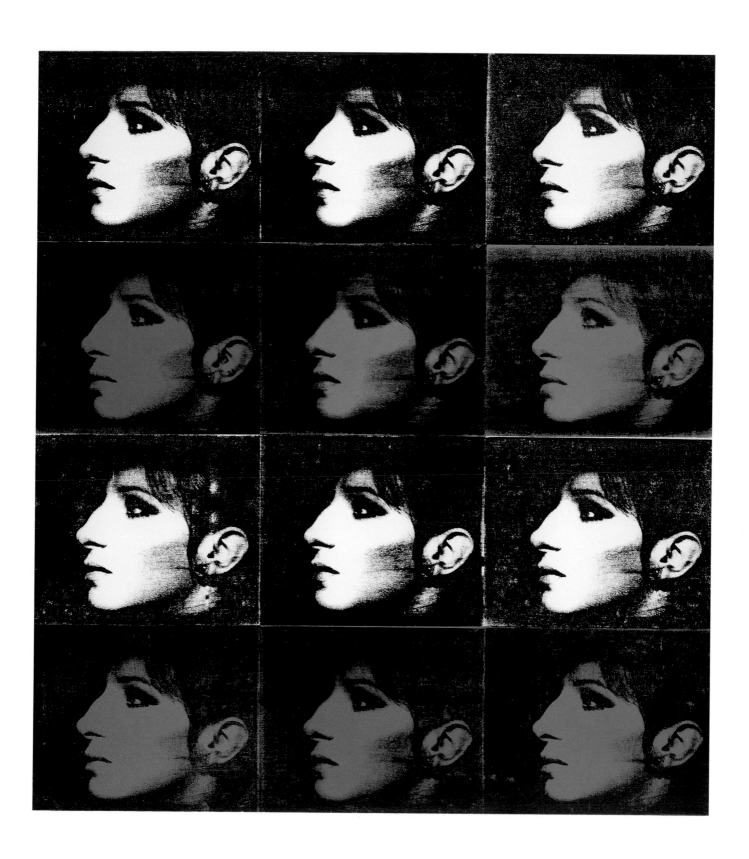

12 Barbras (The Jewish Jackie Series), 1993

10 Black Barbras (The Jewish Jackie Series), 1992

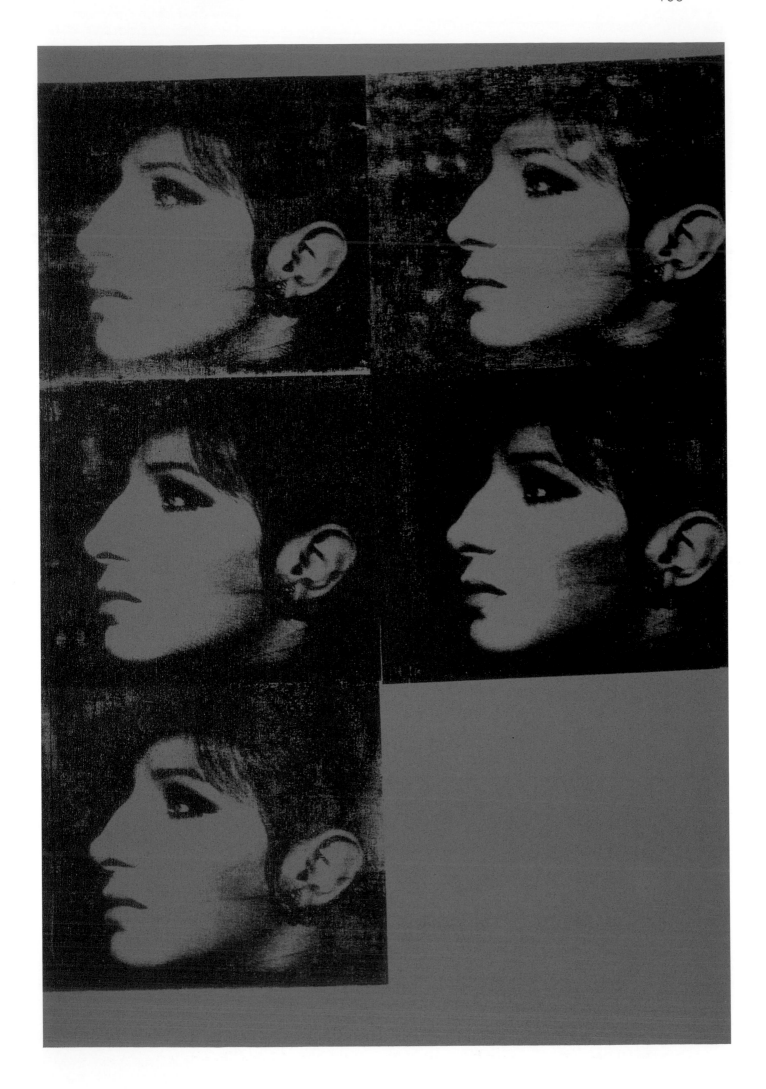

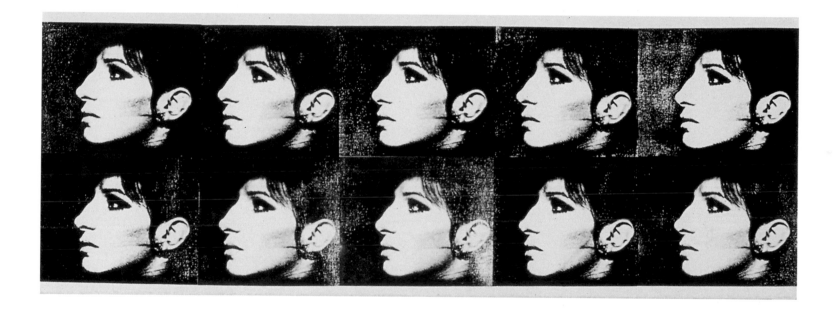

(opposite) **5 Blue Barbras (The Jewish Jackie Series)**, 1992

(above) **10 White Barbras (The Jewish Jackie Series)**, 1992 (following) **4 Barbras (The Jewish Jackie Series)**, 1992

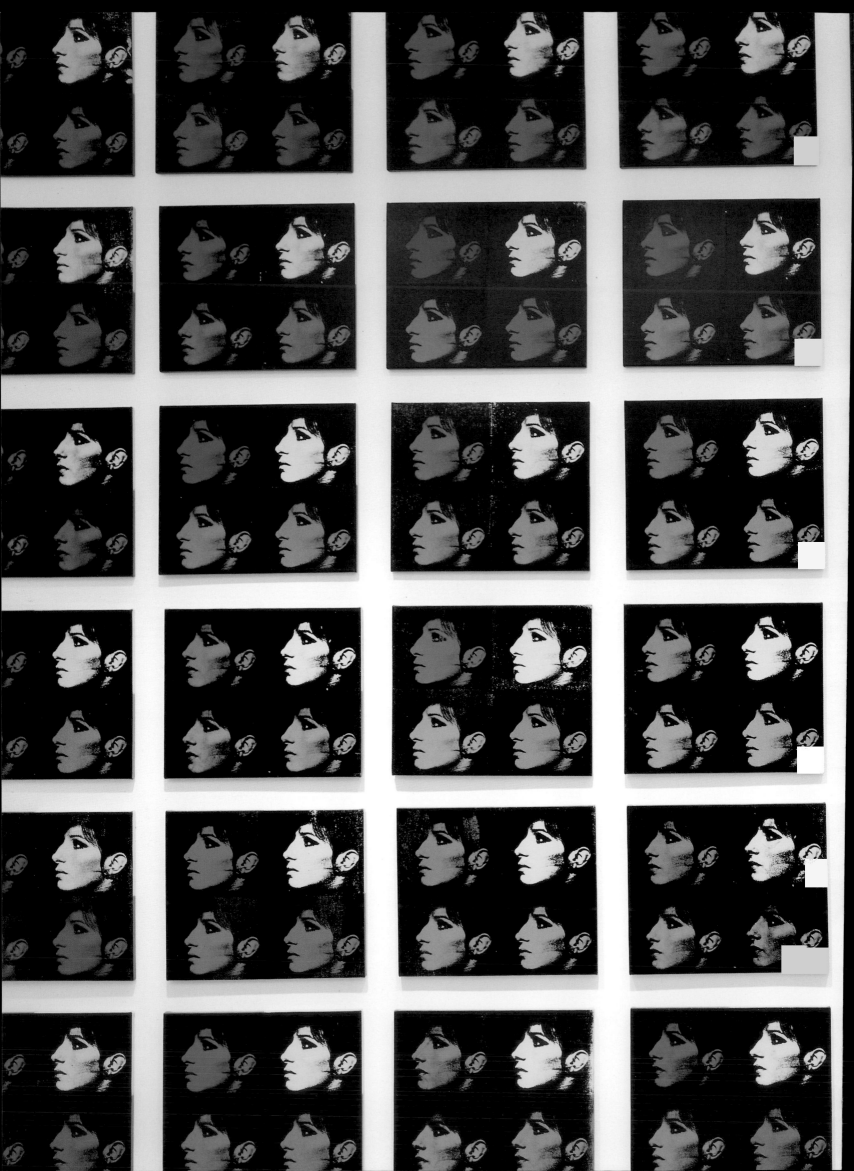

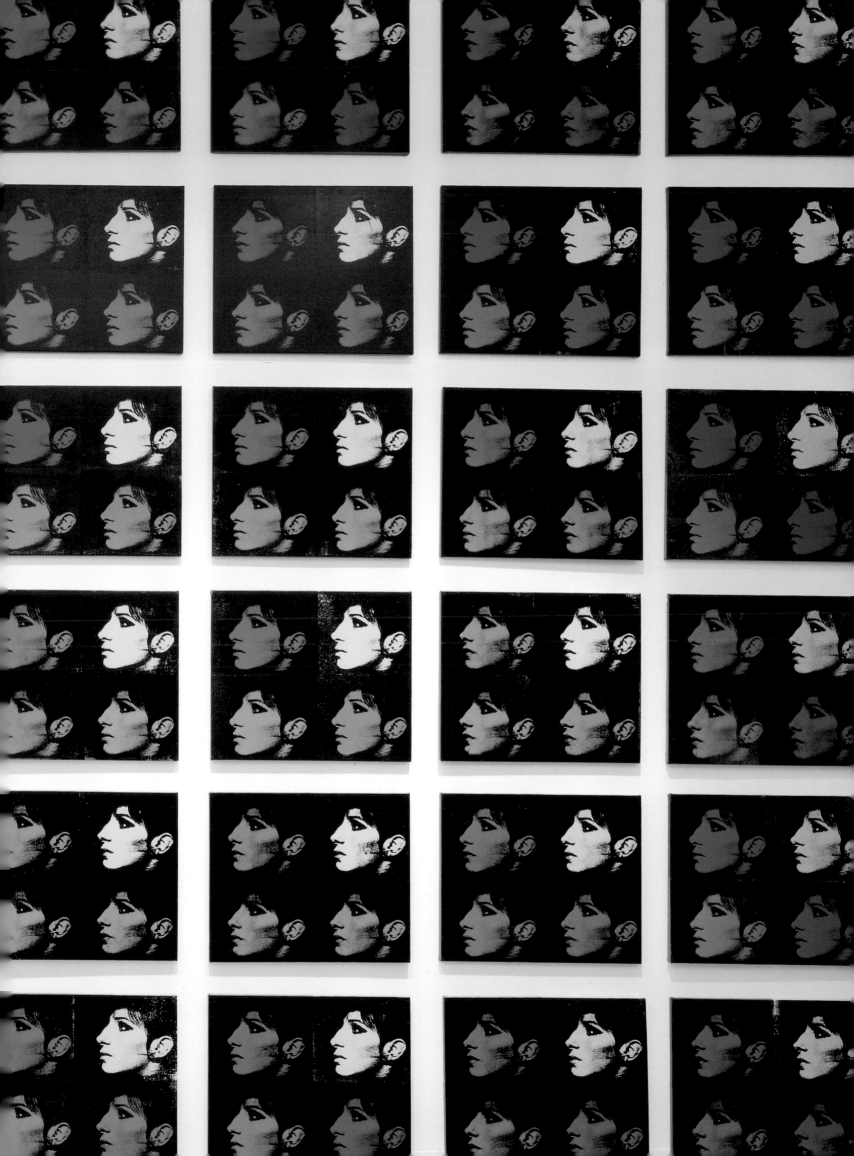

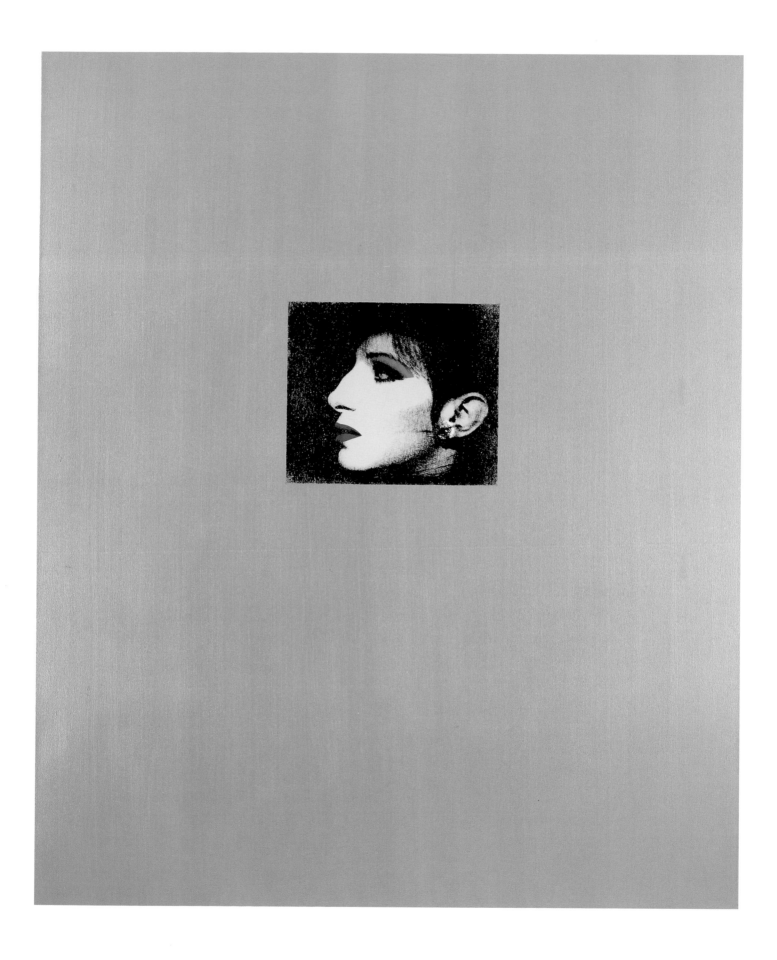

Gold Barbra (The Jewish Jackie Series), 1992

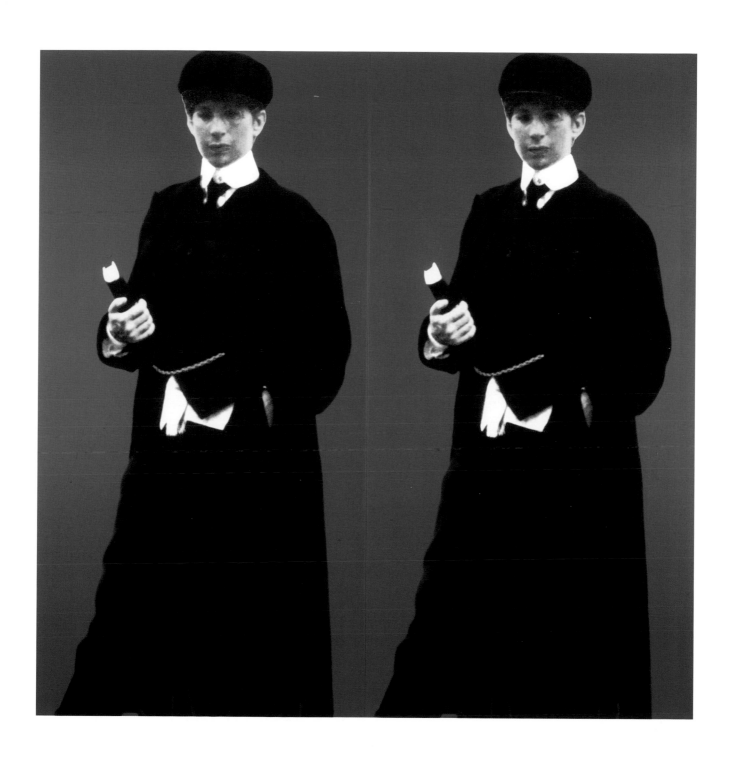

(opposite) **Double Ghost Yentl (My Elvis)**, 1997

(above) **Double Red Yentl, Split (My Elvis)**, 1993

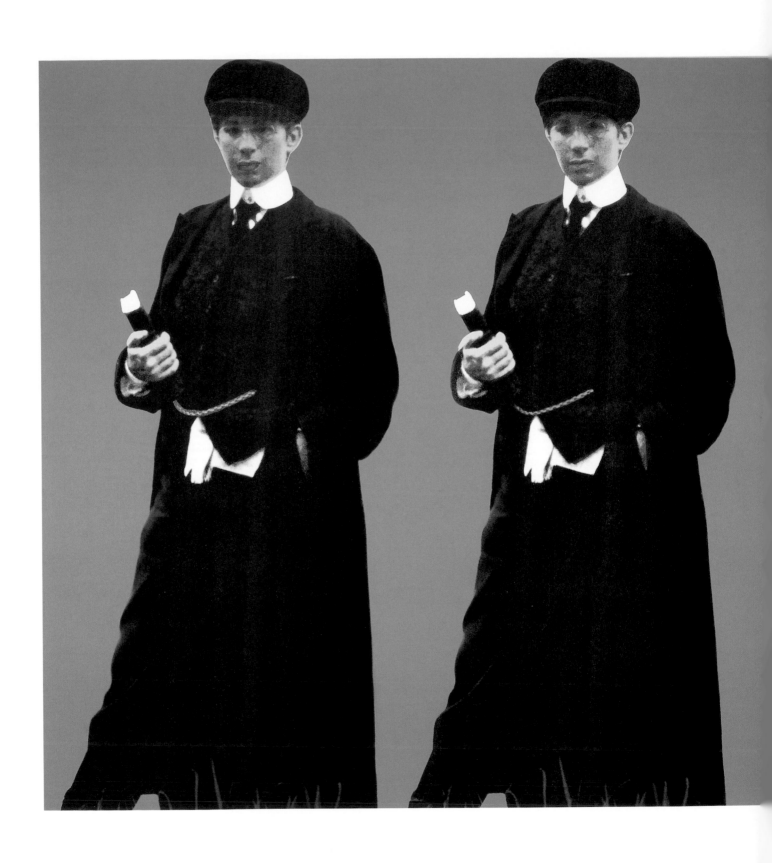

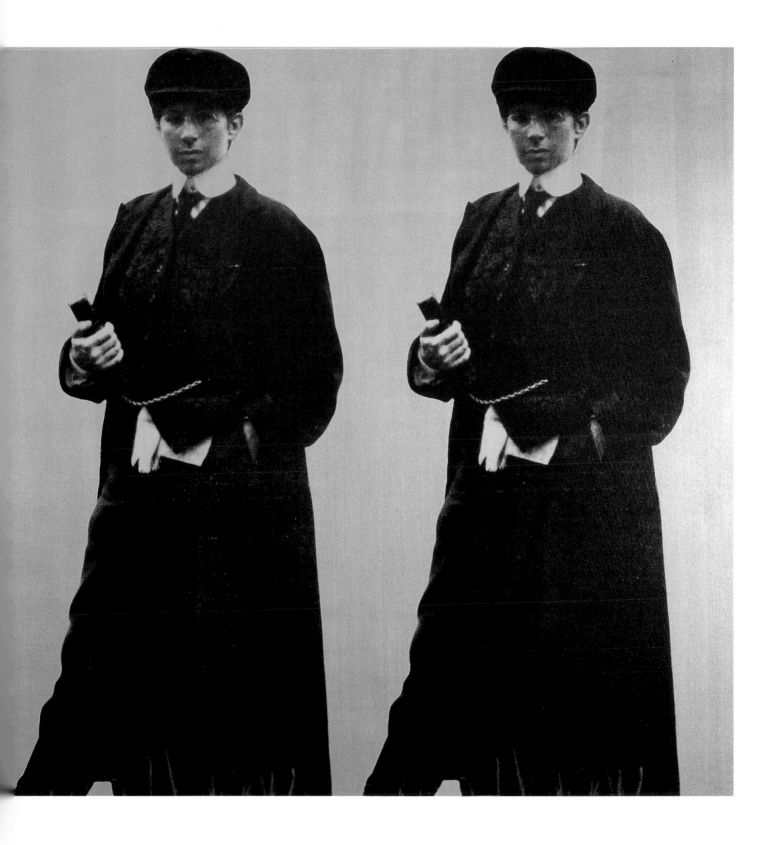

Double Double Yentl (My Elvis), 1992

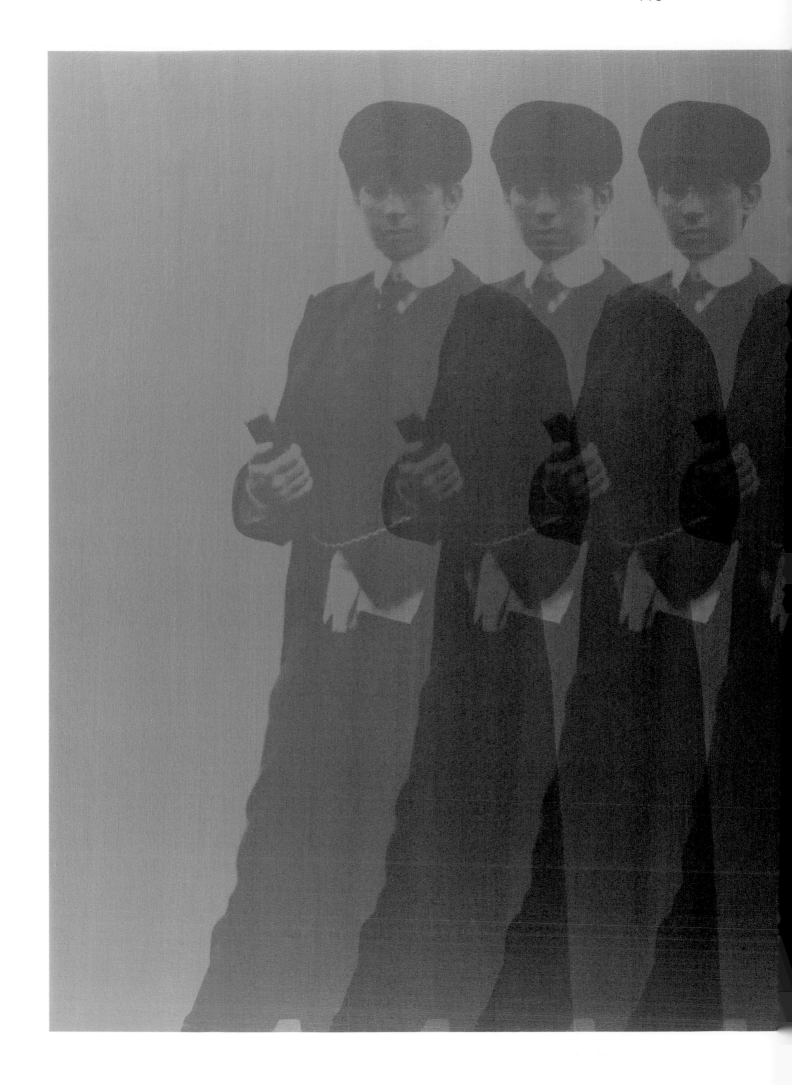

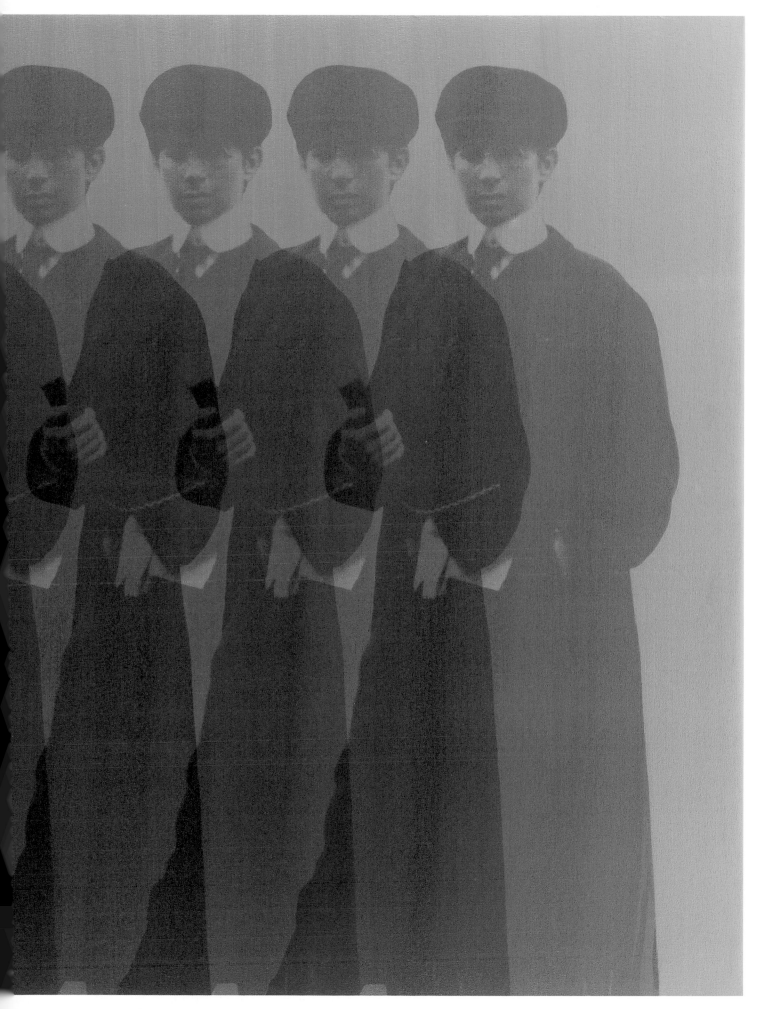

7 Ghost Yentls (My Elvis), 1997

MAKING SPACE FOR MYSELF TAKING A CLOSER LOOK WITH DEBORAH KASS

Griselda Pollock

A retrospective allows a review of work to date. But it also opens up new perspectives on both the art and its critical reception. Deborah Kass has been well-served by many astute and thoughtful critics, some of whom appear in her series, *America's Most Wanted*, a delightfully ironic commentary on the disjuncture between the visibility of the criminal and the marginalization of the intellectual who cares about art. Approaching her bold body of work from the vantage point of the present, I am struck by the new possibilities for reading it with retrospect.

Deborah Kass's practice straddles two cultural moments. The first made it possible. That moment was fueled by feminist intensities challenging gender hierarchies in both society and art, only slowly expanding to accommodate other, sometimes contradicting self-positionings and agonistic dramas of conflicting identities. The second moment is now, when the fuller picture of what Kass has introduced into culture through her singular reclamation of American *painting* becomes legible beyond those enabling, but perhaps now confining frames of feminism and dominant critical vocabularies around appropriative strategies and artistic parody. I am not, however, proposing a postfeminist reading. This work seems profoundly and creatively feminist in its ethos and its effects. Yet its richness as such lies precisely in a singular intervention that enlarges the sphere of the continuing interrogation of our cultures' distorted visions of gender, sexuality, and difference.

Indicative of the present moment of expanded possibilities for reading Kass's project are two books I reached for when thinking about Kass: *Autobiographical Jews: Essays in Jewish Self-fashioning* by Michael Stanislawski (2004), a historical study of

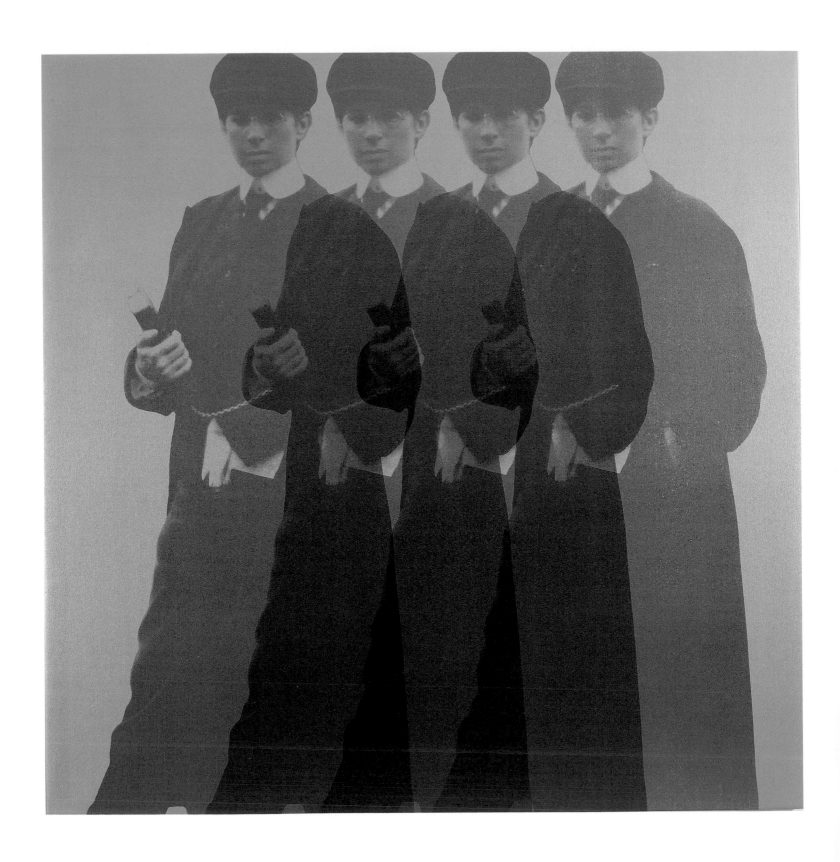

Quadruple Ghost Yentl (My Elvis), 1997

life-writing ranging from the Roman author Josephus to French philosopher Sarah Kofman, and Alisa Lebow's *First Person Jewish*, a study of first-person documentaries in film (2008).[1] Both studies are not about a cultural community, collective history, or unified identity. They address singularity, which is not the same as individualism. Singularity asks: "Who am I?" as opposed to the collectivizing or labeled "What am I?" To label: woman, Jewish, lesbian, is to impose from outside an already known frame on another and thus to contain the labeled other. To explore through one's own chosen aesthetic field the question—what is it to be any of the above, now, here, in this field a complex configuration of possibilities that are at once freighted with multiple "otherings" and open to singular redefinition—is to generate new understandings for oneself and one's culture.

Another indicative text is Lisa Bloom's *Jewish Identities in American Feminist Art* (2006) which reminds us of repressions within feminist discourse itself. To have talked about Eva Hesse, Martha Rosler, or Hannah Wilke "Jewishly" was not part of the initial feminist discourse, or perhaps even these artists' own. In the moment that made Kass's work on notions of subjectivity inflected by gender, Jewishness, and sexuality possible, the 1970s–1980s, the focus was on collectivity but not ethnicities, and only with difficulty on sexualities. The many new social movements discovered and elaborated the intoxication of new kinds of solidarity even if their utopianism was soon, however, fractured by agonistic axes of class, race, gender, sexuality, and ethnicity. We have tended, mistakenly, to attach artists to these movements, collectivizing feminist artists for instance, when in fact, artists, who always and rightly claim speech in the *first person*, were doing something very different. They were introducing into this heightened political awareness of new group consciousness, the complexity of the aesthetic process as a site of research through which to speak to culture, but in the first person, by which I do not mean as autobiography. Art for political movements was not immediately a part of an agenda for social emancipation, except as instrument. Some artists, inflected by questions newly raised about bodies, subjectivities, representation and difference, expanded the art of their time as a site of speaking, not individualistically, but in the first person, hence not daring to speak for others, for the group, but as a series of questions: What makes me who I am? What are the givens, the frames, the limits, and the possibilities for a differencing of the canon, be it of gender, sexuality, or ethnicity by means of strategic negotiations with the current regimes of representation and forms of artistic practice?

Artmaking is a very formal exercise of decision-making. It has to follow its internal logic before it can work culturally. I do not want, therefore, to label Kass. I wish to see

at least some of her works in this sense of their own *poiesis* that seems more serious, more compelling, and more historic than the prevailing discourse on her art as appropriation or as the ironic work of a not-so-dutiful daughter allows us to appreciate.

Let me focus for a moment on just one work to suggest a different way into Kass and her creative work in the company of Andy Warhol, in which the latter is not a fixed Big Daddy, but a fellow searcher after new, American, and contemporary means to signify complex self-positionings in sometimes inhospitable cultures. *Quadruple Ghost Yentl (My Elvis)* (1997) is a subdued work in muted harmonies of gray. This is striking for an artist so exuberant in her use of color as a signifier for a defiant anti-modernist engagement with the vernacular forms of American culture. This tonal work makes clearer to me a more tender and sometimes melancholy strand beneath jazzy hues. Four figures are repeated, but at the point at which there is overlay the printing process generates a secondary repeat of a trio of partial shapes in more saturated black that center the frieze-like composition. The effect is strange. It emphasizes a relation between a white hand holding a book and the flash of white shirt escaping a waistcoat. The two bracketing figures focus our attention on only one or the other gesture: the extreme left reveals the right hand and the extreme right, the left hand slipping into the pocket, a classic signature of masculinizing coding, hence unsettling the veracity of what we see.

The image captures a rather formal pose, extracting an actor in costume from the flow of a romantic narrative, *Yentl* (1983), a film based on a play by Leah Napolin and Isaac Bashevis Singer, that traces the defiance by one woman of a traditional Jewish ban on women's learning. At once a tale of the "old country" of Jewish gender hierarchies which turned men into scholars and women into breadwinners, and the eighties, the era of Kass's coming of age as an artist, the story becomes allegorical of any woman aspiring to a self-determining creative life in a world that places general and local restrictions on access to such self-creation. Yet, clothed in its Jewish specificity, the work also asks if a general truth can be articulated through a specific cultural narrative without being confined sentimentally and seen as merely ethnographic. What would art have to do to make that translation possible? This is where donning another costume, that of Warhol, doubles the ready-mades of *Yentl* and Warhol's *Elvis* to create a space for Deborah Kass.

Kass's work confronts the viewers with a repeating figure that seems to address them in that guise of transvestite defiance. Yet if it were so simple, so purely narrative, there would be no art. The figure in the work is different precisely because of the repeat, the formal effects, and the specific degrees of silk-screening reproduction

Chairman Ma (Gertrude Stein #22), 1993

of a photographic still. The figure looked at the camera and in so doing became an image that now looks into the place a viewer will later be. This is not, however, either a close-up (prototypically feminizing) nor a narrative moment (typically identified with agency and hence masculinized in the economy of cinema). In its multiple form, it becomes an interpellation, a hailing: What do you see? What am I? Where are we? The head is slightly tilted and the eyes shaded. Reticence is suggested. Yet one leg stands forward creating a stance. Body coding, we know, is highly gendered. This stance has an opposite effect to reticence. There is thus tension and ambiguity. The head is topped with a rounded cap with a brim low on the brow. Cap and short hair are masculine, but boyishly so. A glint of light catches steel-rimmed spectacles. Spectacles signify both intellectuality and shielded vision. To be desirable is not to see, but to be seen. Seeing is active, possessive, mastering. Yet this figure's gaze is guarded. Book in hand, this figure does indeed look, but at words. The figure is a student. Masculinity is not necessarily brainy. Indeed the scholar is often a feminized masculine figure. But there are precious few images of the woman intellectual.

The archive of images of American writer and self-declared genius, Gertrude Stein, presents one of the richest, yet most challenging array of images of the embodied modern intellectual as a woman, a Jewish woman, and a woman desiring women. The *Yentl (My Elvis)* series converses with the *Chairman Ma (Gertrude Stein)* (1993) series (Stein's wonderfully sculptural head and steady gaze displacing Warhol's *Chairman Mao* series); they suggest a need for the missing cultural memory of what Stein so defiantly presented to the camera's gaze and to her contemporaries amongst the painters and sculptors, who, like Picasso, struggled with finding a way to represent her extraordinary being in the world. Having worked myself for many years on the problem of Western visual representation of the woman intellectual as an absence, woman as embodied mind, Stein's fascinating self-fashionings in the visual archive from Picasso to Cecil Beaton remain a rich challenge. Kass's invocation of Stein serves here to heighten my sense of the fragility present in the *Yentl* cinematic masquerade.

The white versus black of starched shirt collar and long gabardine also reminds us of what costume historian J. C. Flügel named the great masculine renunciation; men adopted a standard uniform that does not draw in the gaze to the spectacle that woman alone was to become.[2] One hand holds a book, thick, leather bound while another slots itself into a pocket drawing the eye towards a gold watch chain that is slung around the belly guarded by a waistcoat, but there is a flash of white: the shirt protrudes. Here a tiny detail catches my eye: a glimpsed exposure of skin between jacket end and pocket is not quite a *punctum* in Roland Barthes's sense. The *punctum*

is a telling detail that catches the viewer's attention in a totally contingent and often personal manner.[3] For me this glimpse of skin, signifier of the ordinary and common if potentially gendered body, interrupts the costume drama suggesting embodiment, itself gendered, and sometimes raced in the form of marked bodies, all sharing a vulnerable nakedness. Everything else is posed, posturing, taking a stand for the camera, trying to adopt a set of mannerisms and attributes that will convince the viewer of what s/he is seeing. Yet it is make-believe. This is exposed. The image is a still from a movie where everyone dresses up, strikes poses, puts on a masquerade, plays roles. But there is something serious beyond the game, about real bodies, continuing limitations, and unfulfilled desires.

As we know from the history of Hollywood cinema, movies came to life only when the anonymous actors became stars, with studio-fashioned identities that persist beyond film roles, offering pleasure to audiences in the actors turning up again and again in different guises, while always being that star persona. *My Elvis* is the subtitle of this work. Elvis was not merely a star, but one of the great divas, as Elisabeth Bronfen describes those figures who are not just famous, but embody excess and fragility, distanced from the rest of us and yet absolute in their ultimately human vulnerability.[4] Bronfen put Elvis on the cover of her book about the diva to remind us that the condition is not gender-exclusive. "*My*" *Elvis* is clearly not the Elvis of others, the desired masculine object of both straight and queer desire that Warhol so tenderly portrayed. In Kass's series, her figure is a substitute for Warhol's object of desire and object of identification. Hers, however, is not only drawn from another movie carrying a different cultural memory; it is based on another diva, whose vulnerability, hence humanity, has to be rescued from ready-made and often cruel assumptions, stereotypes about Jews, Jewish women, Jews as jokes.

Barbra Streisand

Barbra Streisand played the title role of Yentl in the 1983 film that she directed. This double role—her being on both sides of the camera—is crucial, as is her creating a compelling study of a woman in conflict with norms of her age and culture in the past. Before the 1980s, in one of the most influential of cultural apparatuses, Hollywood cinema, only two women (Dorothy Arzner and Ida Lupino) had ever directed major movies.

Andy Warhol, *Self-Portrait*, 1986. Acrylic and silkscreen on canvas. 80 x 80 in. (203.2 x 203.2 cm). The Metropolitan Museum of Art, New York. Purchase, Mrs. Vera G. List Gift, 1987 (1987.88)

Camouflage Self-Portrait, 1994. Silkscreen ink and acrylic on canvas. 70 x 70 in. (177.8 x 177.8 cm)

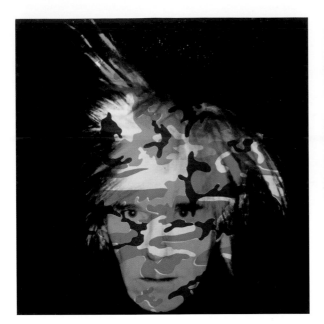 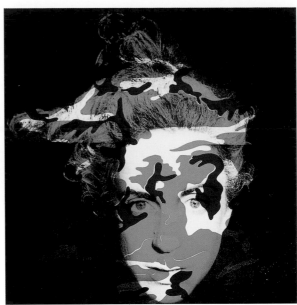

Kass's *Jewish Jackie Series* is not a one-liner. It does not simply substitute a less culturally visible or acceptable icon like Streisand for either Elvis or Warhol's celebrities like Marilyn, Jackie, and Liz.

I would imagine that Kass does not subscribe to a simplified vision of Jacqueline Kennedy, certainly a privileged, but also a betrayed and then bereaved woman, or Elizabeth Taylor—a good Jewish icon by the time she was being imaged by Warhol. For that matter, Marilyn Monroe was technically Jewish at the time of her death. Despite being divorced from Arthur Miller, she maintained her converted status to the end of her life. So I do not buy into a simple opposition here between the Jewish Streisand and the more famous non-Jewish divas whom Warhol merely celebrated. This would fall into the worst notions of racial typing. What is it to look Jewish after all? In whose eyes? Streisand's look is her own self-fashioning in a creative intervention that she was making into an industry in which her specific ethnic difference had been hidden, disavowed, renamed, silenced. I am interested in what happens when the encounter between the cinematic ready-made of the posed still, the Warholian ready-made of the enlarged silkscreen "portrait" (that is both seeming to be an anti-portrait and functioning as a work of love and longing), and an ambitious painter who is a woman in search of a space in the world of representations and art, occasions a radical gesture of disturbance to known norms. Kass's strategies force an unsettling event in the history of art that cannot be shrugged off as appropriative wit or irony. The repetition of Streisand as Yentl, referencing Warhol and Elvis, deferring to that gesture and its history, also *differences* the entire premise. It invites us, at least this reader, to think about Streisand in the *first person* as a creative woman and Kass

equally so, working in respectful, interrogative, confessional conversation with this complex creative artist, a marked other/woman in a man's industry, a self-defining Jewish woman holding onto her unique sound and appearance, making a film about gender confusion and defiance in the name of ambition and her own negotiation of conflicting desires for autonomy and relationships.

Kass's search for her own "pose" also takes her to both sides of the camera as it were. She too will be encountered in a series of *Camouflage Self-Portraits* (1994) of extraordinary beauty in their formal execution and effect. Again, only very close reading moves us beyond just seeing the intended gesture of reference and deference to Warhol's *Self-Portrait* (1986) in order to see the difference, which occurs in her re-inhabiting his image and that place before the camera. Warhol's own gaze is directed up and to his right with the camouflage patterns effectively leaving his features in their normal configuration, the eyes intensely focusing and the focus of the image. Kass's *Camouflage Self Portraits* are much more daring in their color ways and in the effects of allowing a disjuncture between color field and supporting image. The intense colors flood and reconfigure the face. Altering the affective quality of each recurring self-image, color plays with the eyes and the mouth so that the expression shifts with every image. Less a wary defiance, I see in these works more an openness to a continuing questioning of what the image might tell she who made it about the meaning of this strangest of all confrontations with one's own image. That ensures we cannot claim what we see for a "what." It is about a "who" who is also asking herself the question.

Writing of French-Jewish author Marcel Proust, Hannah Arendt extrapolated from his work and life a brilliant analysis of the predicament of "the Jew" in the modernizing West. No longer defined by religion and thus set apart for faith, "the Jew" is not a figure of belief, but a condition, an effect of a relation between margins and centers, dominants and aspirants. Arendt diagnosed an oscillating condition: as a Jewish modern, one could be either a *parvenu* or a *pariah*.[5] The latter position was infinitely preferable since the former would always be wounded in the ultimate and inevitable failure of tolerance to hide its deep racism. Adopting the position of *pariah* was a way to acknowledge knowingly the delusions of identity and to accept the fragile sets of relations and positions that were always to be negotiated. Julia Kristeva followed Hannah Arendt into this social analysis of the modernity of *judaïcité* (Jewishness) as distinct from Judaism. Kristeva, however, linked the refusal of essences (so often absorbed by the victims of racism from the language of racist oppression) across a whole spectrum of life-worlds shaped by difference from the hegemonic norms of whiteness, maleness, and heteronormativity. Thus, for Kristeva, *woman is not*, that

is, woman does not belong to an order of *being*, just as the homosexual is not in the order of being: namely, an essence, a given, a fact of nature. This is not to make gender and sexuality a freak of semiotics or a mere social construction through language games. Reminding us that even our sense of lived and felt identities are effects of complex formations and positionings, this insistence also brings back into creative view and imaginative play the function of the aesthetic as a possibility for undoing the ideologically fixed meanings and illusions of identity which they try to hold in place. The way we live gender, sexuality, and difference is embodied and intensely real, but also relational, positional, and cultural. Julia Kristeva explained:

> In his book, Proust not only reveals that every society is excluding and rejecting. He also shows how each and every identity is derisory. Anyone who takes him/herself as being someone, assuming an identity and putting him/herself on a pedestal invites ridicule. If I, for instance, deluded myself that "I am Julia Kristeva," I would make myself ridiculous. Thus for Proust, a Jewish person who declares him/herself to *be* a Jew is ridiculous. A homosexual who claims this identity is to be derided. It is the pulverization and shattering of all pretensions to given or fixed identity that forms the characteristic irony of Proust's position, a position that shares something with what we now call postmodernism, while also being linked to the tradition of work-play and irony we find in Madame de Sévigne and Saint-Simon. The fact that beauty is allied with irony marks this project's difference from the logic of the group and identity.[6]

A younger contemporary of Proust, Claude Cahun, born Lucy Schwob in a very well reputed French-Jewish literary dynasty with noted figures in the queer circle around Oscar Wilde, asks to be in this conversation. Coming of artistic age amidst the mayhem of early surrealism and symbolist theater, Cahun opted for creating staged photography, performatively created in collaboration with her life-partner, Suzanne Malherbes, pseudonym Marcel Moore. When Cahun's tiny photographs were "rediscovered" in the 1990s, feminists projected back onto her work postmodern preoccupations with identity game playing typified by Cindy Sherman. Countering this reading, I would call for a much deeper appreciation of what indeed was missing for Lucy Schwob herself: in her moment, she found no given resources in the form of images through which she might come to know what it was she could be and become. Her work is not deconstructive of identity, or even representative of "being a lesbian," Jewish or otherwise. Culturally the terms of such self-identification had to be created by her by using, and abusing, the typologies of both French culture in general and avant-garde coteries like surrealism in particular. Her elective Jewishness and avowed

same-sex desire would have to find forms in which to be articulated by working with and against the grain of an exploration of the ethos and aesthetic unfolding through surrealist photography. Being left wing, anti-fascist, and belonging to political groups did not protect her against racist and heteronormative phobias. So why make art? Where else could she find out what it was all about except in making and remaking?

This Kristevan sense of negotiating the logic of the game of the social from spaces within it that are passionately significant for continuing to live, but do not come ready-made, brings me back to Warhol and to Marilyn. Now elevated to godlike status in the pantheon of American art of the twentieth century, Warhol, because of his social and geopolitical origins, was placed in his class and his queerness outside the fragile world of the *parvenu* queer men successfully operating in the New York art world of the 1950s. Gavin Butt's astute reading of Warhol's difficult relation to his elder peers points out how class cut across any kind of solidarity based on sexuality at the turn of the 1950s when Warhol, the working-class Czech white boy from Pittsburgh, sought a space in New York.[7] It was when another working-class kid died too young, a beautiful creature, made ragged by a misogynist industry and a sexist cinematic regime, that Warhol mourned and hid himself behind her glamour. His first *Marilyn* works, created in immediate response to her tragic death, were works of genuine mourning protectively offered to a culture that could so swiftly cannibalize the real agonies of class and gender and turn them into trite stories of commodified celebrity that are now unquestioningly, and cruelly repeated.

So if I now read Warhol back through Kass, Warhol is transformed because of what Kass dared to do by reinhabiting precisely that doubled domain of his formats and media, and because of the questions they pose to his own culture about articulating a marked, often othered, self in the world of inhospitable representations. I do not see Kass's work as that of a playful but undutiful daughter. I see a very intelligent project that also tips into guarded visibility deep issues that remind us why making art is a fundamental activity as it joins speaking in the first person to speaking to one's culture. Holding together joyousness of color and medium, Deborah Kass belongs in a long tradition with Proust, Stein, and Cahun, and she has wonderfully remade Warhol as part of their story of making space in culture for difference through a fidelity to the question of speaking for oneself.

1. Michael Stanislawski, *Autobiographical Jews: Essays in Jewish Self-fashioning* (Seattle: University of Washington Press, 2004); Alisa Lebow, *First Person Jewish* (Minneapolis: University of Minnesota Press, 2008).

2. J. C. Flügel, *The Psychology of Clothes* (International Universities Press, 1966).

3. Roland Barthes, *Camera Lucida*, trans. Richard Howard (New York: Hill and Wang, 1981).

4. Elisabeth Bronfen, *Die Diva: Geschichte einer Bewunderung* (The Diva: The History of Fascination) (Schirmer/Mosel, 2002).

5. Hannah Arendt, "Antisemitism" in *The Origins of Totalitarianism* (New York: Harcourt and Brace, 1951).

6. Julia Kristeva, Dialogue, Parallax 8 (1996); Special Issue *Julia Kristeva 1966–96: Aesthetics, Ethics, Politics*, edited by Griselda Pollock, p. 13.

7. Gavin Butt, *Between You and Me: Queer Disclosures in the New York Art World 1948–1963* (Durham, N.C.: Duke University Press, 2005).

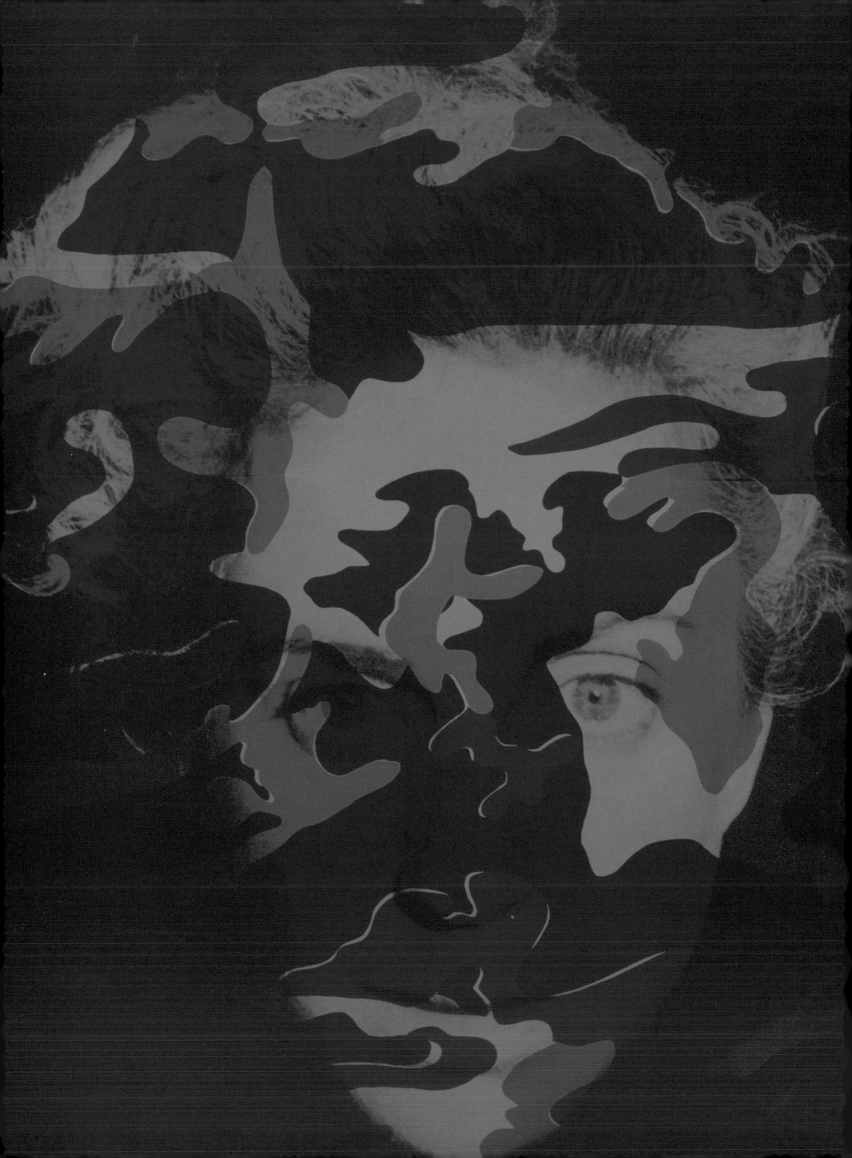

self-portraits
-
america's most wanted
-
celebrities
-
commissions

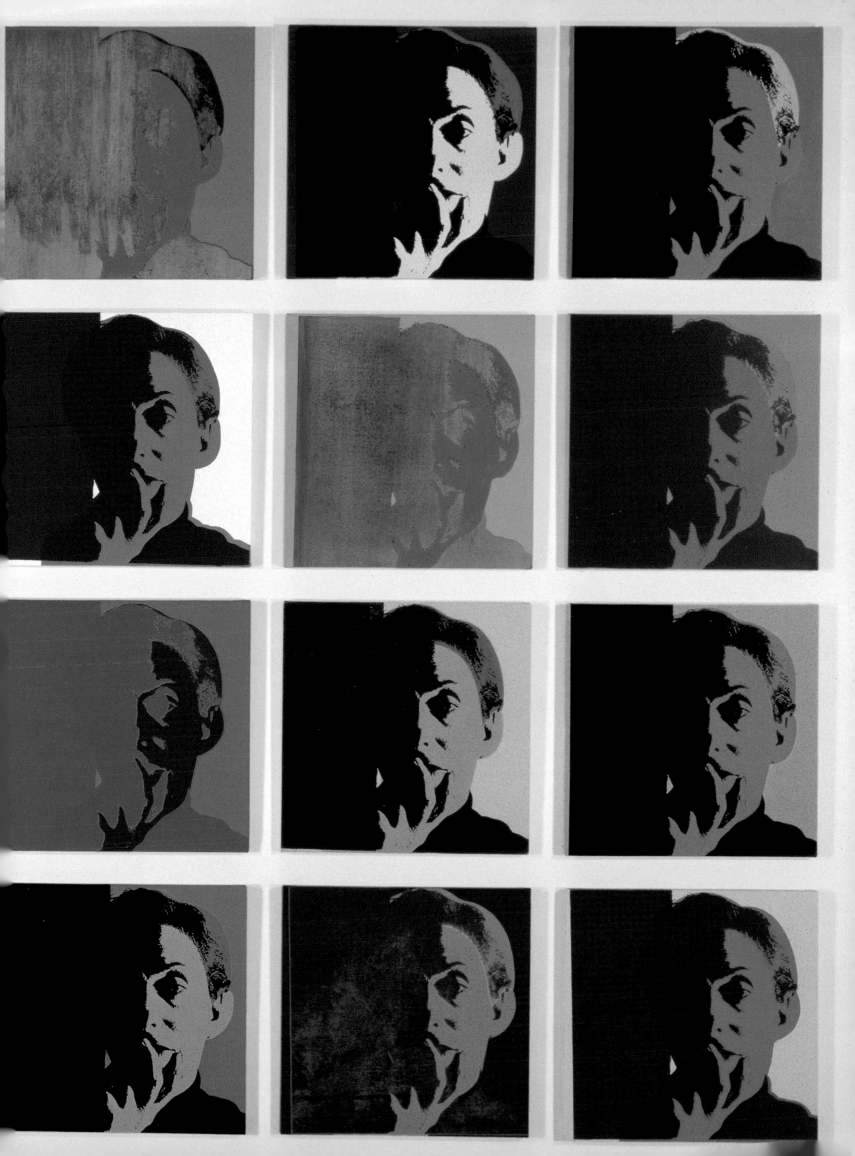

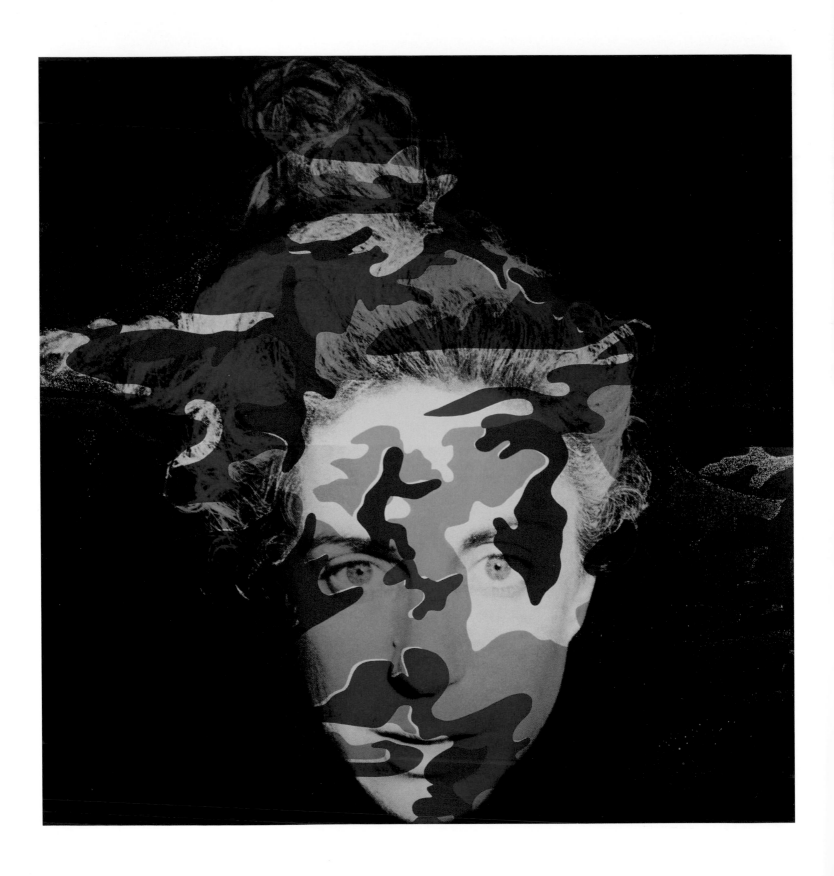

(previous spread) **Portrait of the Artist as a Young Man**, 1994

Camouflage Self-Portrait, 1994

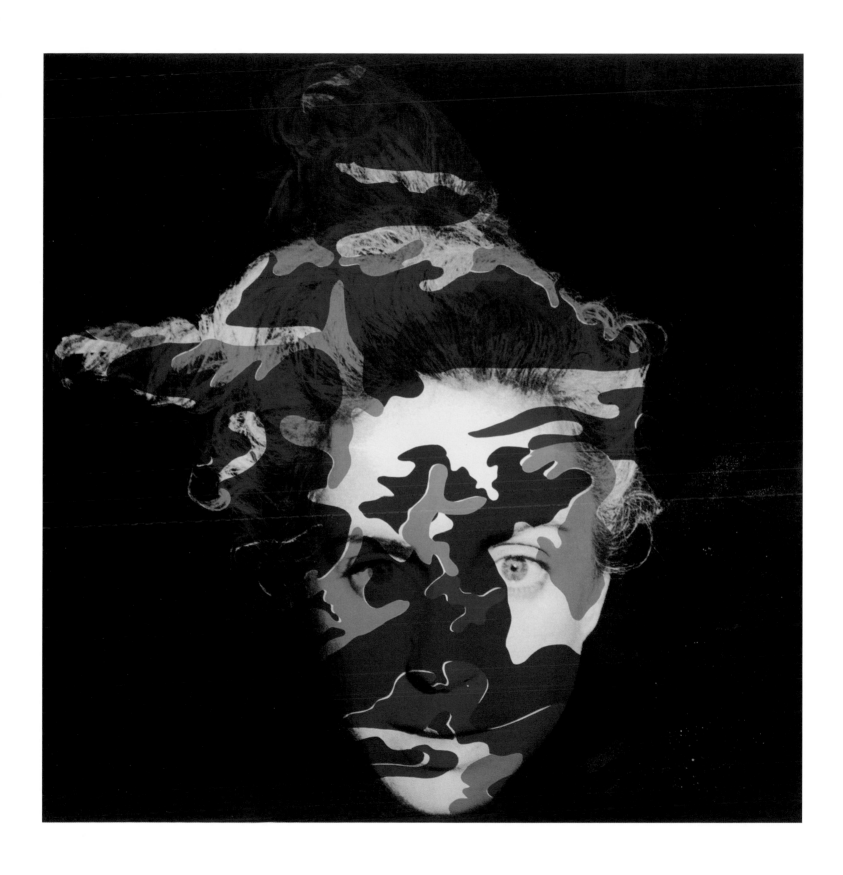

Camouflage Self-Portrait, 1994

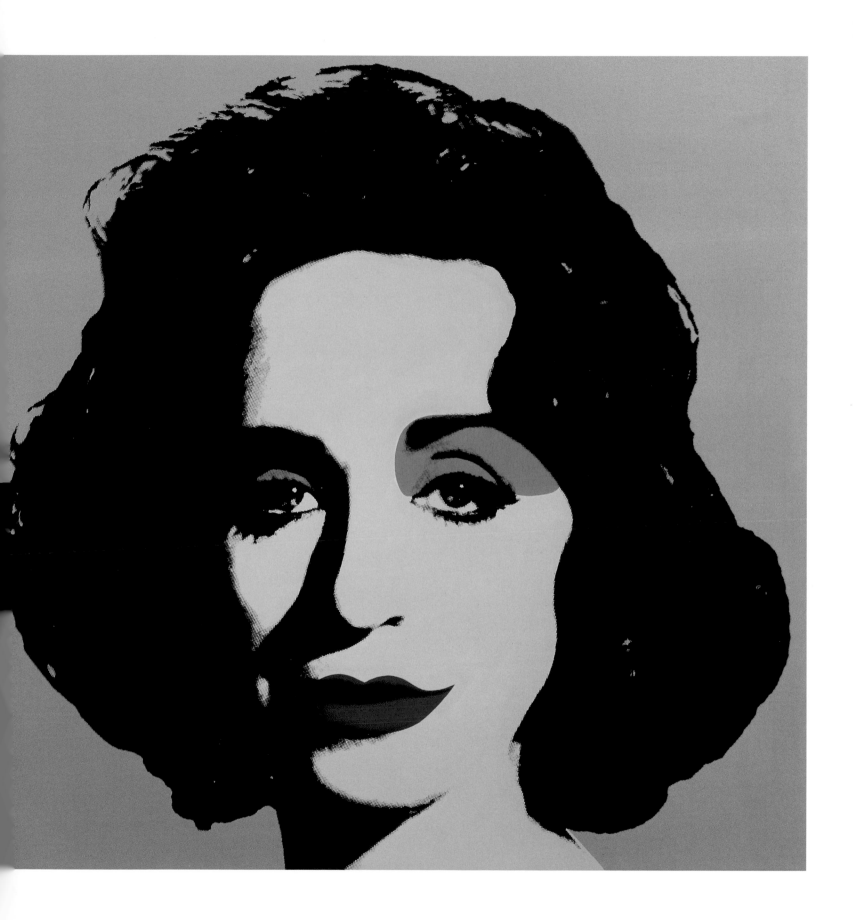

Double Silver Deb, 2000

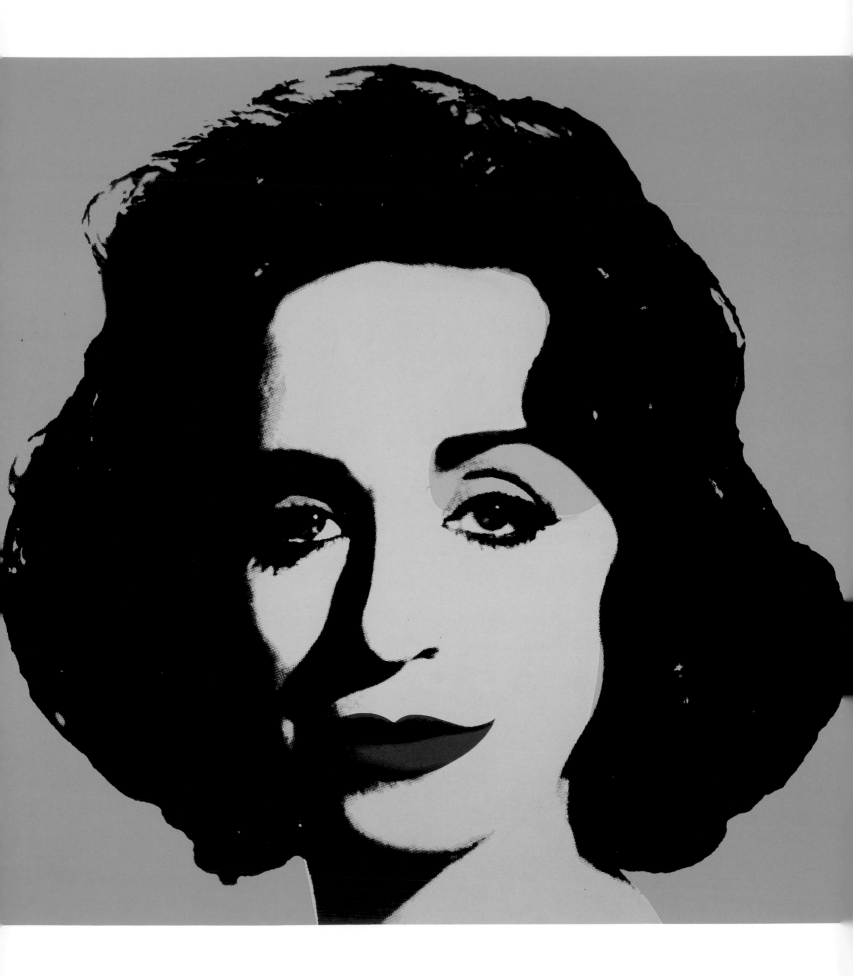

Blue Deb, 2000

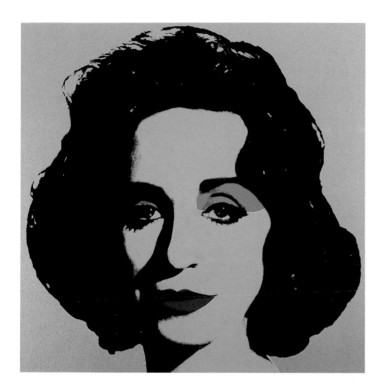 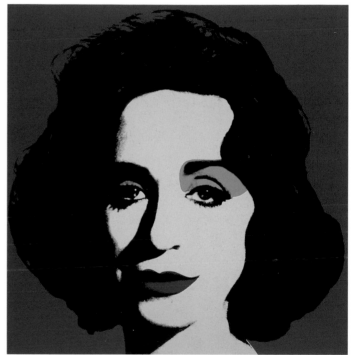

(left) **Silver Deb**, 2000

(right) **Red Deb**, 2000,

(top) **America's Most Wanted, Trevor F.,** 1998

(bottom) **America's Most Wanted, Dan C.,** 1999

(top) **America's Most Wanted, Robert S.**, 1998

(bottom) **America's Most Wanted, Terrie S.**, 1998

America's Most Wanted, Dean S., 1999

America's Most Wanted, Lisa D., 1999

America's Most Wanted, Thelma G., 1998

America's Most Wanted, Donna D., 1999

America's Most Wanted, Paul S., 1999

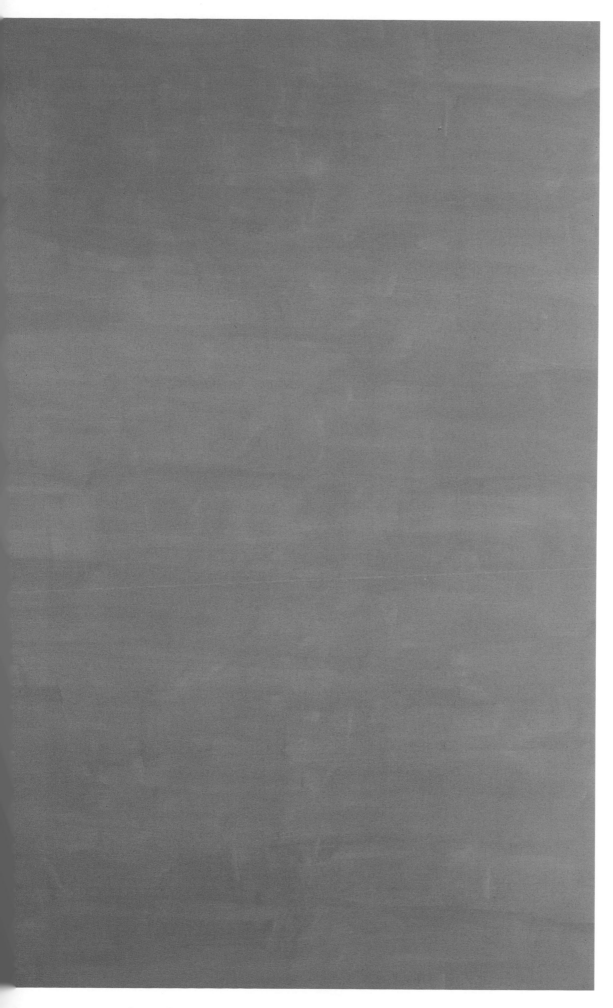

Orange Disaster (Linda Nochlin), 1997

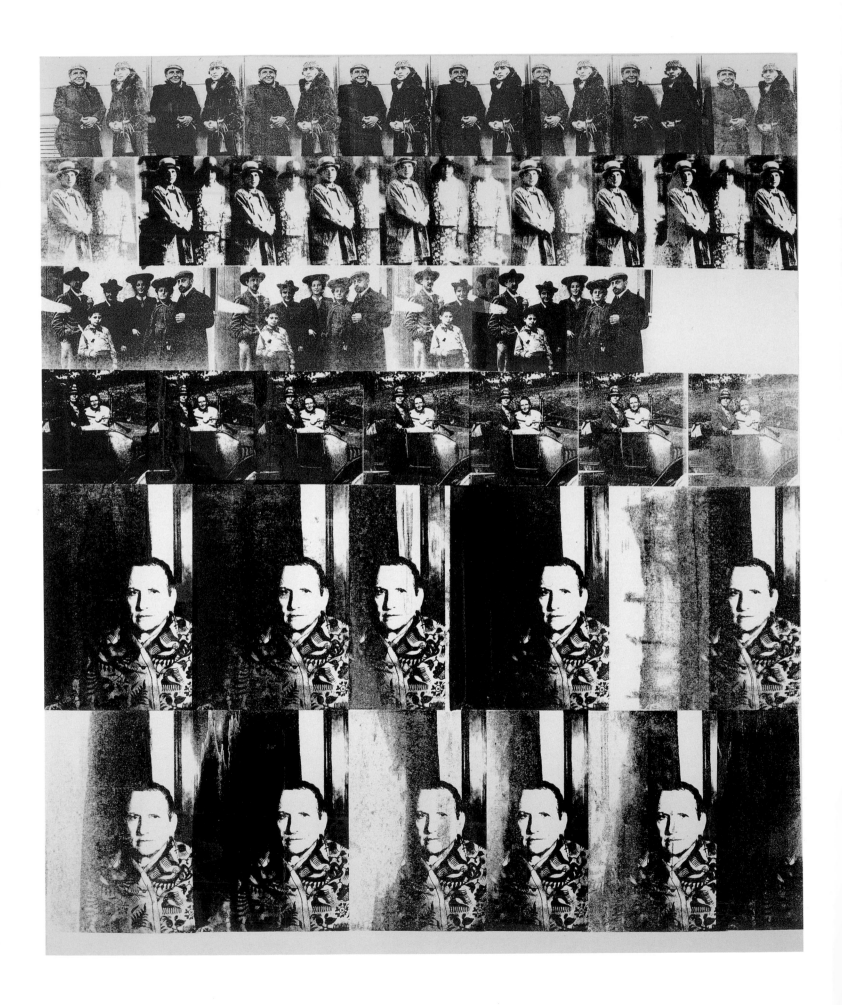

Let Us Now Praise Famous Women, 1994–95

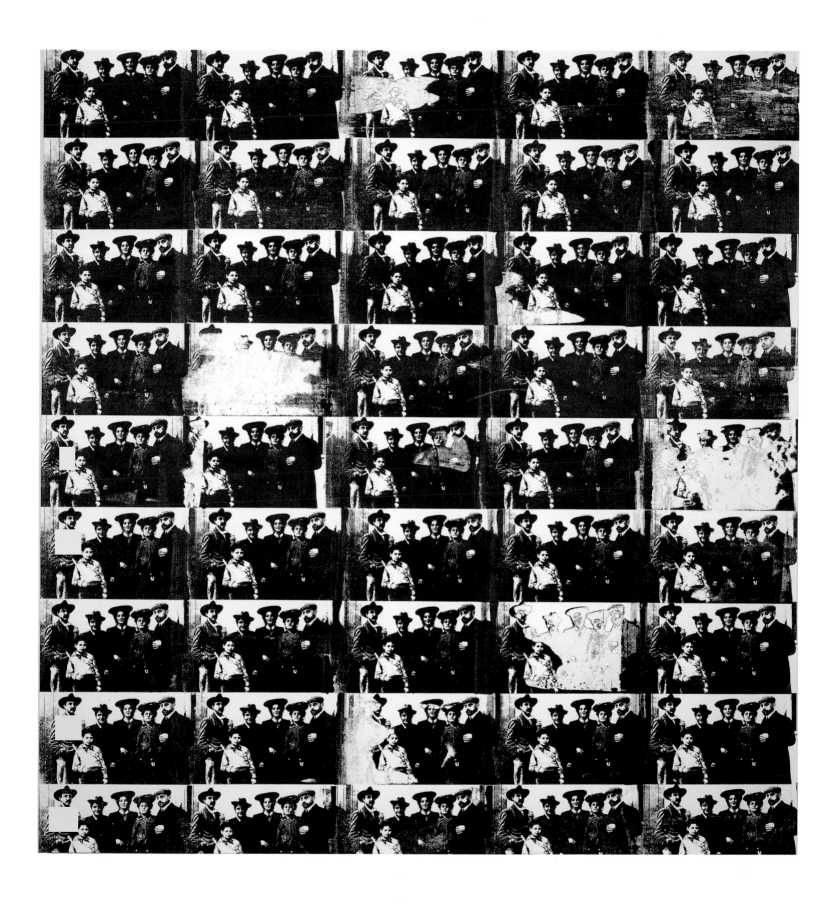

The Family Stein, 1994

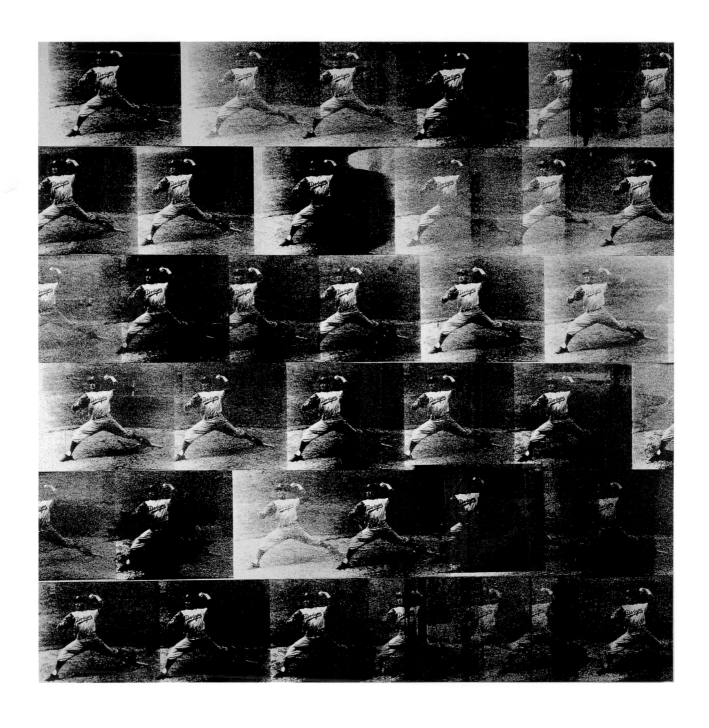

Sandy Koufax, 1997

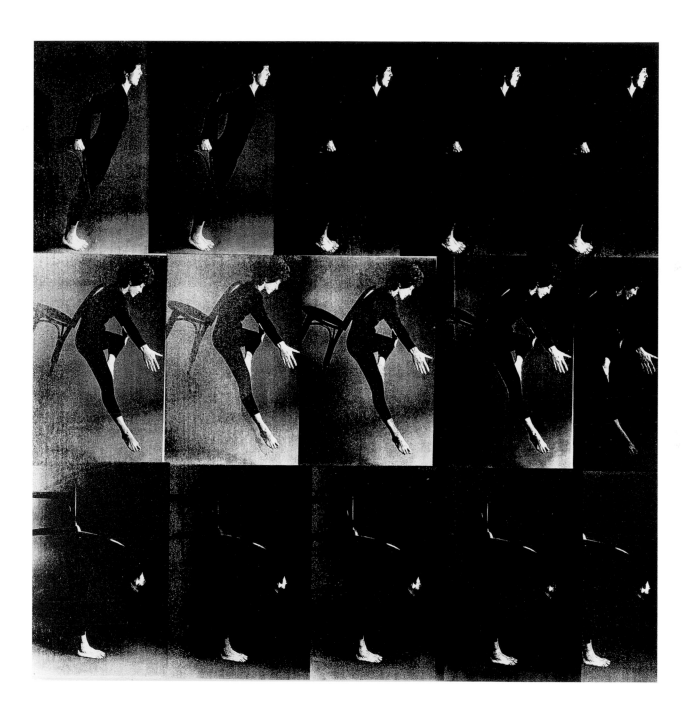

Streb, 1998

Robert Rosenblum, 1997

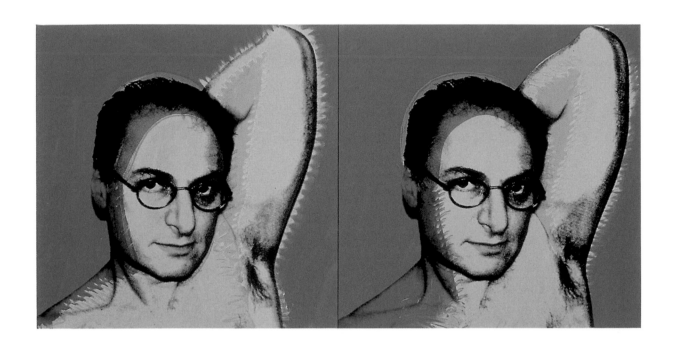

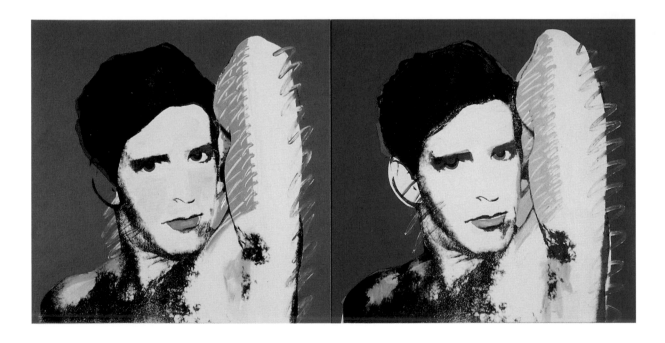

(top) **Norman Kleeblatt**, 1997

(bottom) **William Diamond**, 1995

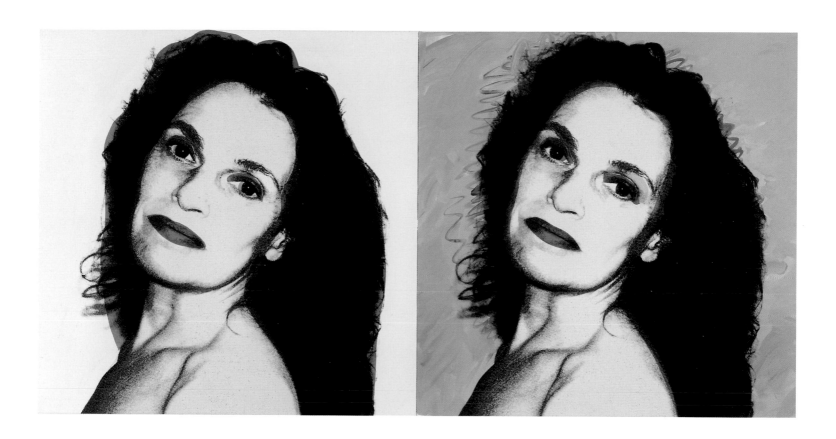

Pat Steir, 1997

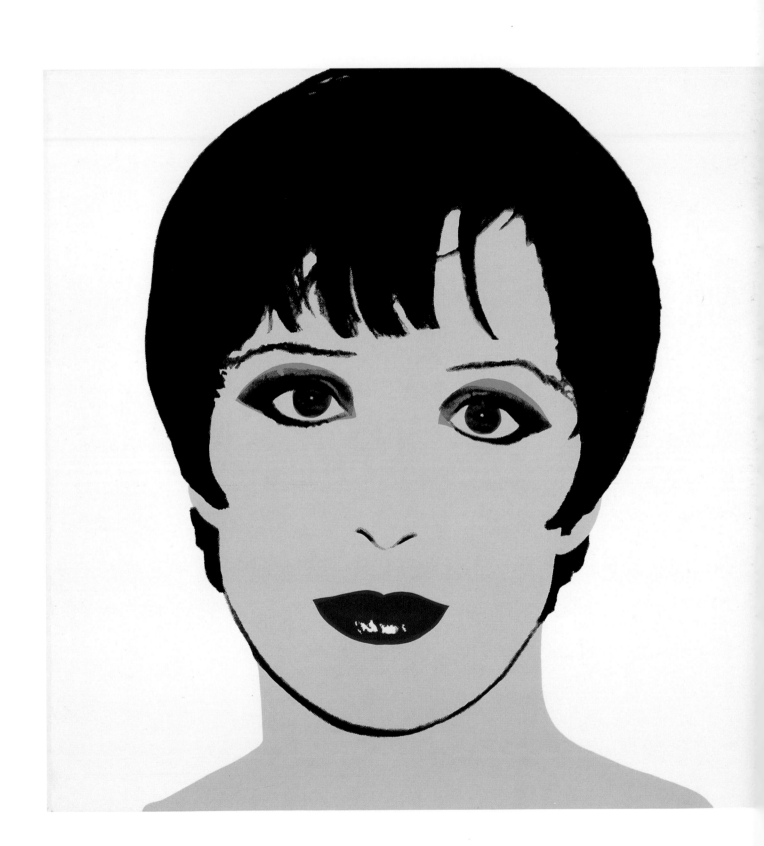

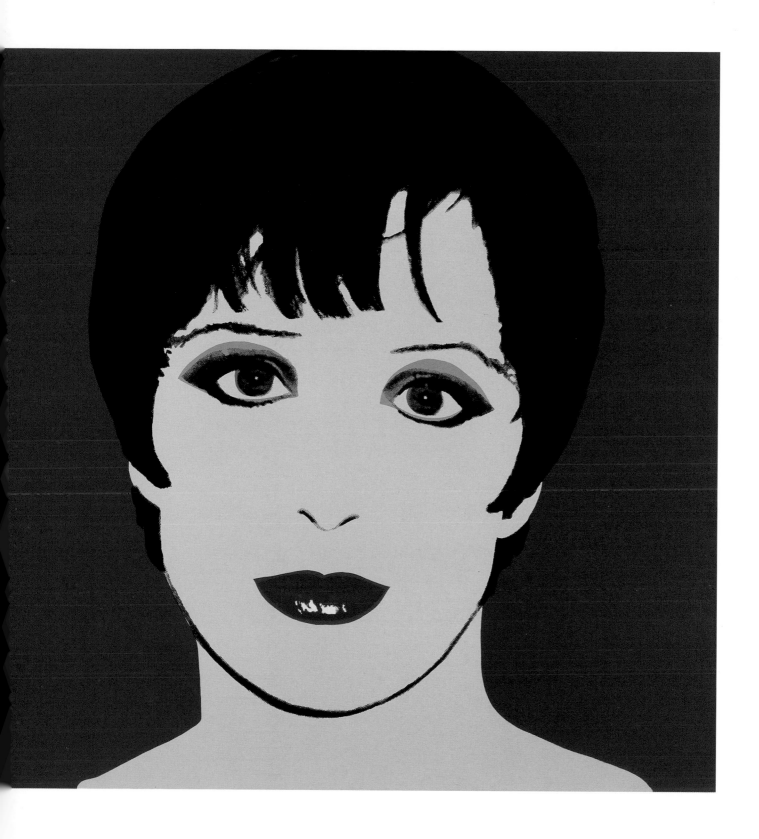

Cindy Sherman, 1995

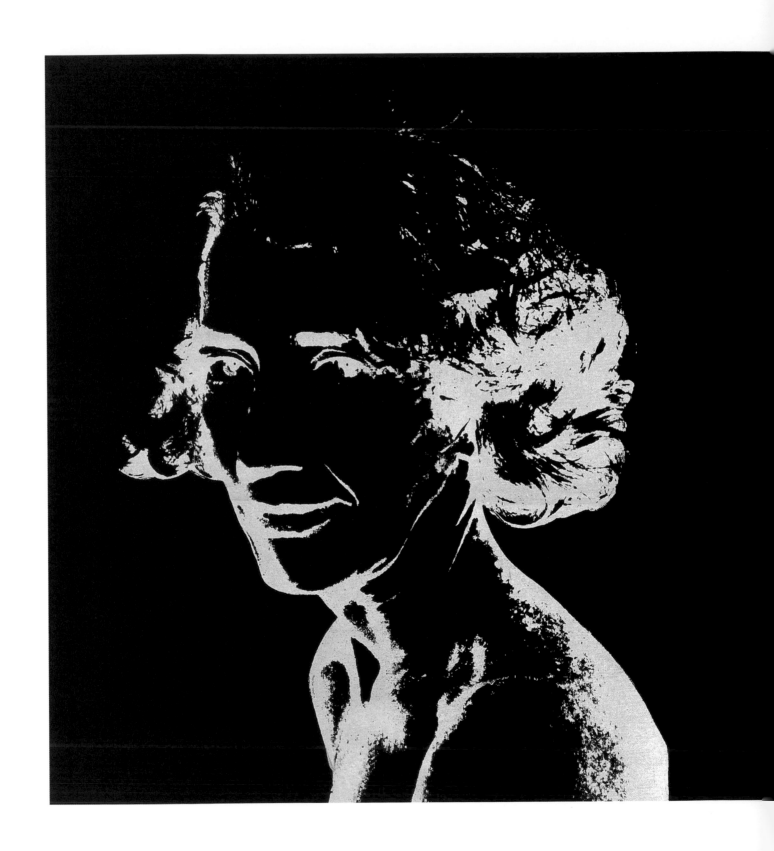

Elizabeth Murray, 1995

(opposite, top) **Miriam Schapiro**, 1997

(opposite, middle) **Jose Freire**, 1994

(opposite, bottom) **Jeanne Kaufax (Grandma)**, 1995

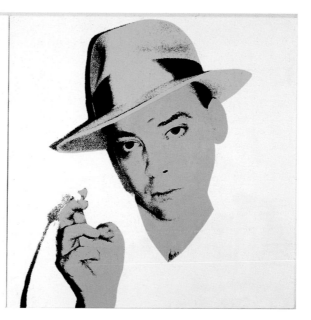

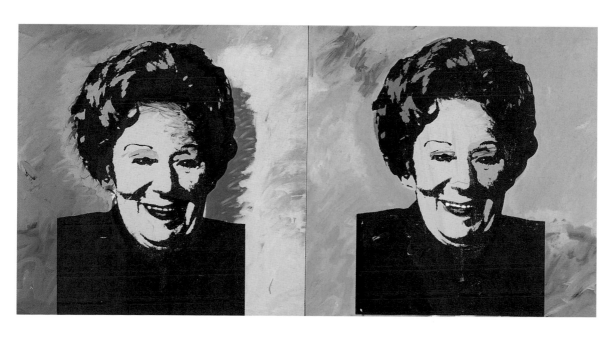

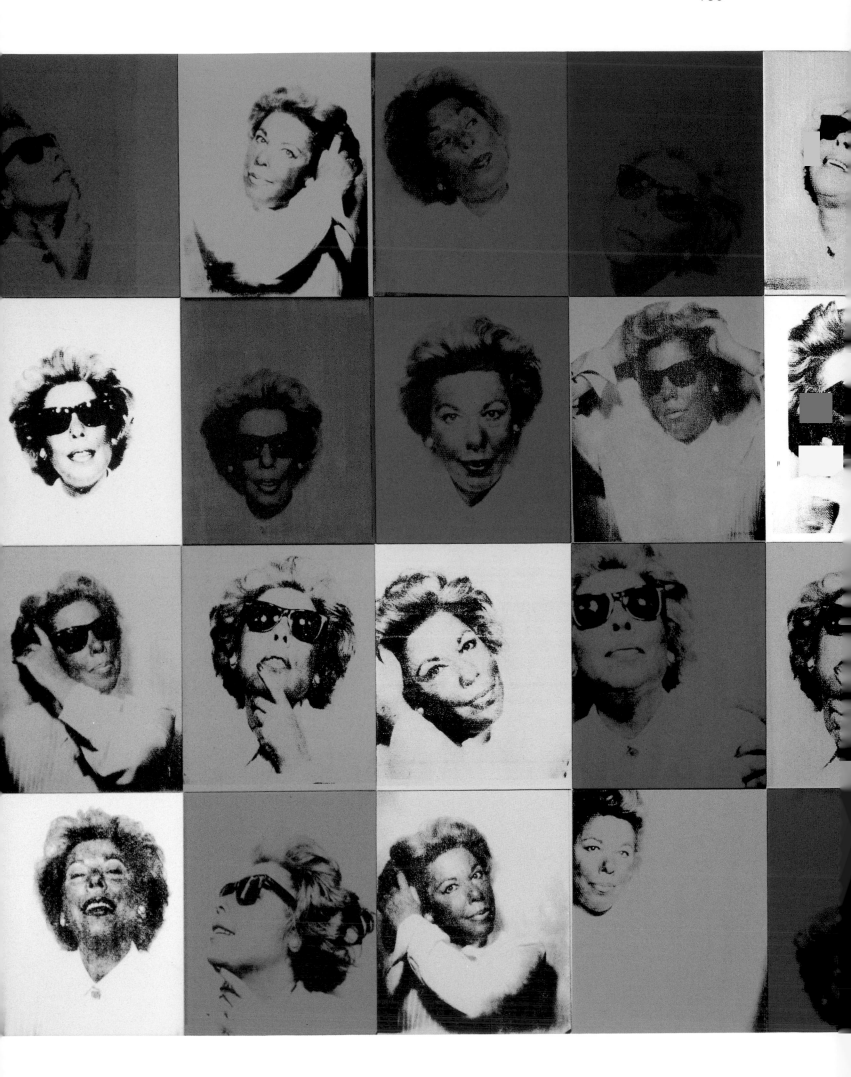

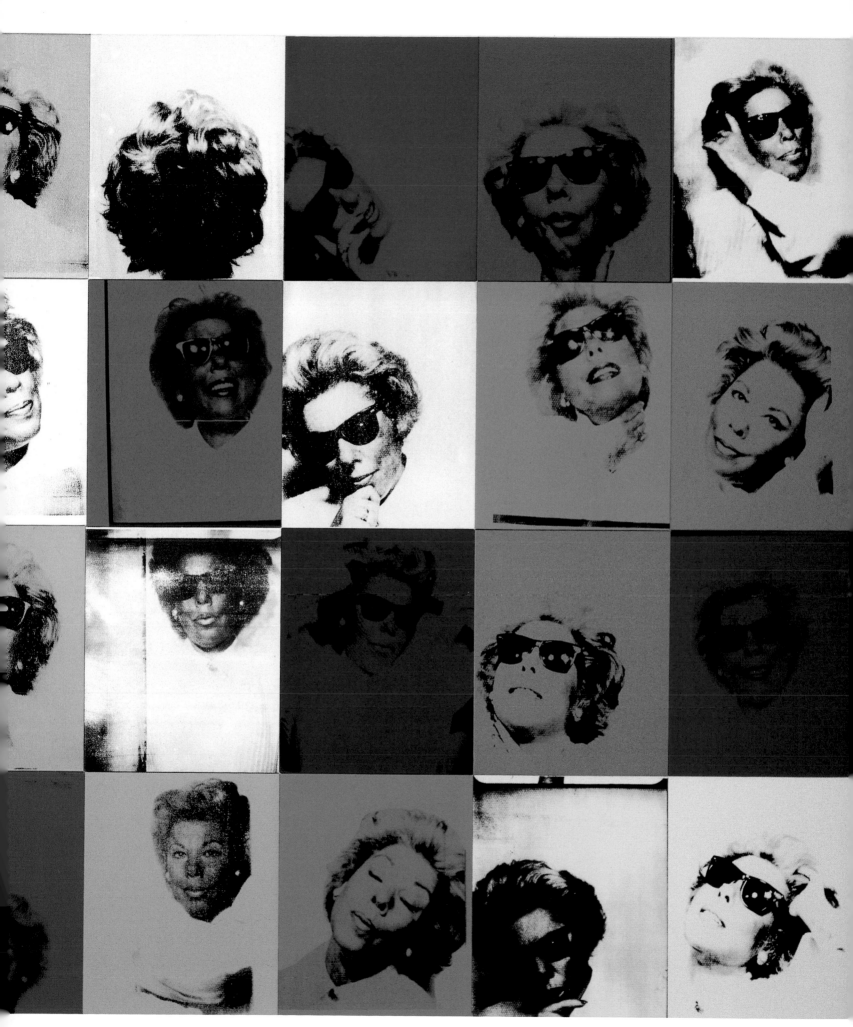

Alice Kosmin 36 Times, 1994

Jennifer Dicke, 2001

An American Man, Arthur G. Rosen, 1996

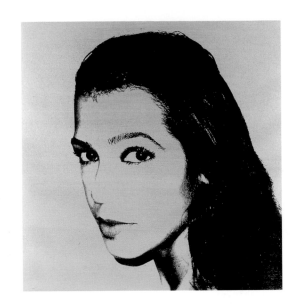
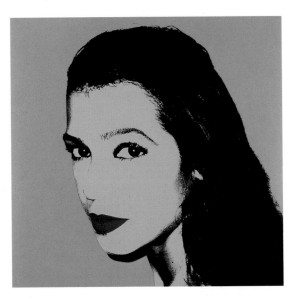
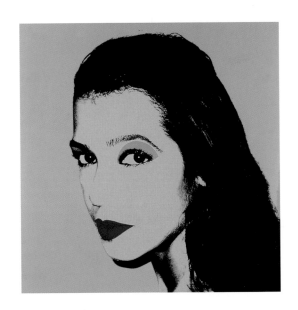
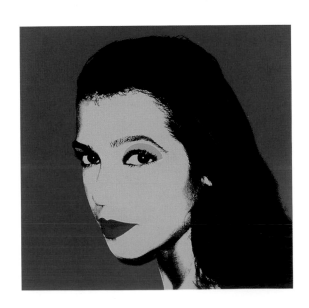
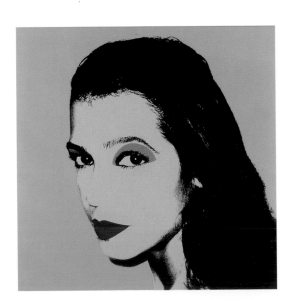

(all 6 plates) **Juliana Costa**, 2007

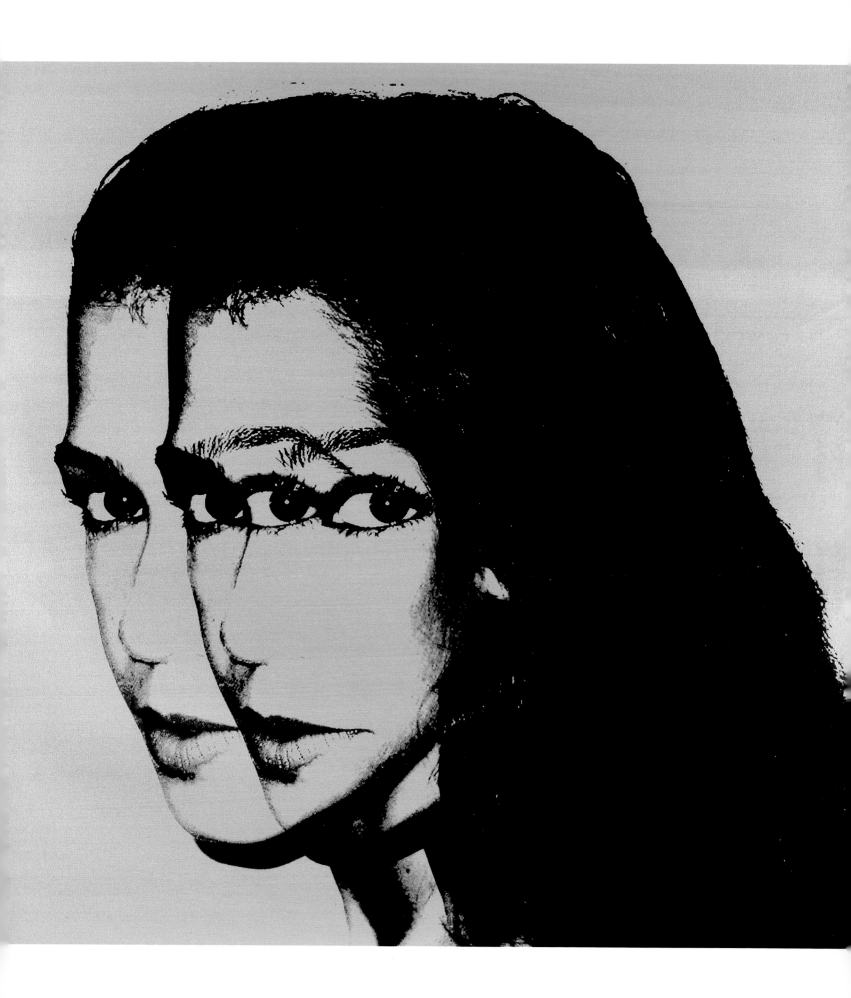

Juliana Costa, 2007

JOHN WATERS INTERVIEWS DEBORAH KASS 2007

JOHN WATERS: From neighbors to an interview. When *were* we neighbors in Provincetown?

DEBORAH KASS: Summer, 2001.

JW: For the record, and full disclosure, we moved into Pat de Groot's house in Provincetown without knowing each other and now we are united in the art world. So, I love your new painting that says *Oh God I Need This Show*.

DK: Oh good.

JW: You're talking to someone who has two Broadway shows and is anything but a Broadway babe.

DK: I'm aware of that.

JW: Broadway and Barbra Streisand: two things that I ran from before *Hairspray* became a hit…and I'm still not so sure I don't run from Barbra Streisand, but you're convincing me. Anyway, *Oh God I Need This Show*, tell me, is that the Broadway world or the art world speaking?

DK: Both. Actually, it's [a line from] the first song in *A Chorus Line*. The kids, dancers, are onstage. All their insecurity, their ambitions, hopes and dreams, and future are pinned on this audition. And it's a very poignant moment. Something everyone can definitely relate to. Certainly me right now.

JW: Has contemporary art and Broadway ever come together again? I can't think of any.

DK: That's a really good question. My guess would be "no" on principal alone. Talk about politically incorrect!

Oh God I Need This Show, 2002. Gouache on paper.
10¼ x 14¼ in. (26 x 35.9 cm)

JW: And how did this first come to you from *The Warhol Project*, and from the other stuff you've done and everything, when did this begin? What was the first one you did?

DK: **The first one I made was *Sing Out Louise*. I had given myself a year to recharge. Sort of a sabbatical, something I had never done. That's why I went to Provincetown that whole summer. Staring at the bay all day from the deck was heaven, as you well know. I came back to Tribeca where I lived, very mellow. And then 9/11 happened. It was some year. A year after I started my "sabbatical" I had a big birthday. The very next day I went to my studio and I sat down and took my own advice, basically the advice I'd give anybody else, which was sit in the corner and do what you want. And I did. I wanted to do what I have always done just in a different way. To make paintings about how that with which we identify, emotionally and in other ways, somehow defines us. And how completely subjective meaning really is.**

JW: And you sang and painted.

DK: **Of course.**

JW: You've always referenced other artwork from what I can see, and tell me if I'm wrong here, in the new work sometimes you do, but sometimes you don't.

DK: **Right, sometimes it's very generic.**

JW: But you've never done that before.

DK: **Actually, I have. The work before *The Warhol Project*, the *Art History Paintings* I did from 1989 to 92 reference other artists. I really love art about art. I even did this before college. I made a "Rauschenberg" in my basement at home with our old ping-pong table and dart target when I was sixteen. So it's always been my impulse to use art history as almost a ready-made.**

JW: But you're not always looking for a reference in this new work?

DK: **I'm trying to feel as entitled as I can to every vocabulary I know and love. Musical, visual, and emotional.**

JW: Do you think it's sampling in the same way the rap world does?

DK: **Absolutely, I have felt that way about my work since the *Art History Paintings* and**

that's exactly how I talk about my work. And I go further back to jazz, where it's called covering, so there's a real history.

JW: Covering can mean something very different. Covering, can be, as we remember, a negative term, as in Pat Boone covering a black singer.

DK: I think more in terms of Ella and Billie covering the same song and each of them giving the song an entirely different meaning.

JW: Okay, that's a different kind of covering; that's good covering.

DK: I come from the good covering world of jazz. I was brought up listening to it.

JW: You said in an interview that you basically replaced Andy's male homosexual gaze with a Jewish female voice and blatant lesbian diva worship. I love that quote!

DK: Thank you.

JW: You and I have talked about this, that my "Jewdar" is really bad.

DK: How's your "gaydar?"

JW: Better than my "Jewdar." When I grew up, Barry Levinson and I have had this talk, we never knew each other until later in life. And we both grew up in Baltimore. He told me that he never knew until after he got out of high school that everyone wasn't Jewish, and I had never met a Jewish person till after high school, and we lived four beltway exits away!

DK: You know, that was the nature of the times. I grew up in a very similar situation. I assumed everyone was Jewish or Catholic. And they were. I never met a WASP till college. And then I couldn't hook up with him fast enough, that gorgeous *goy*. Very *The Way We Were.*

Barbara Kruger, *Untitled (You make history when you do business)*, 1981. Photograph. 72 x 48 in. (182.9 x 121.9 cm)

JW: Do you feel that your work should have been in the *Wack!* show at MoCA in LA? You are very much a feminist.

DK: The *Wack!* show is about feminist art made before 1985. I can't wait to see it. I wouldn't say that my work got overtly feminist till after that.

JW: How do you think it did become overtly feminist?

DK: It really changed in the mid-eighties because of the reading I was doing and the art I was looking at. I showed with Sherrie Levine at Baskerville and Watson Gallery and was very influenced by her. I was enormously influenced by Barbara Kruger and Cindy Sherman, as well.

Mary Heilmann, *Little Three for Two: Red, Yellow, Blue*, 1976.
Acrylic on canvas. 13 ½ x 24 in. (34.3 x 61 cm)

Art After Modernism, edited by Brian Wallis, was my bible. I read the sources, the footnotes, which got me to feminist literary criticism. I felt that was particularly pertinent to what I wanted to do. And I wanted to do it with paint. All this reading really focused my work.

JW: See, I always liked the feminists that everyone hated, like Ti-Grace Atkinson and Ginny Foat and Kate Millett, they were my favorite feminists that I read all the time too, but I don't know how much they changed how I looked at art.

DK: **The feminists who changed how I looked at art were the women painters of the 1970s. I have a piece coming out in the *Brooklyn Rail* about being in New York in the seventies as a very young artist when it seemed obvious to me that the most important painters of the time were women. This generation of women did a very specific thing. They put content and subject matter into the language of abstraction and back on the table in general. I am talking specifically about Elizabeth Murray, Pat Steir, Mary Heilmann, Joan Snyder, and Louise Fishman, painters who all made work at the intersection of New York School painting and feminism. These women changed the subject of abstraction in the political sense. That's why Elizabeth Murray rocked my world when I was really young, because I realized that unlike the great moderns I studied at MoMA, I was looking at a painting that was talking to me about things I understood.**

JW: Which artists do you think would be artistically incorrect for you to use in any way? Is that possible? Is the artist's politics part of your choices?

DK: **No, not at all. For me, in formal terms, this work is sort of a celebration of post-war New York painting and optimism. And so I feel like anybody who is part of that history, which is basically the history of painting, particularly in New York, is up for grabs.**

JW: You have been quoted as saying it's a political tool—a strategy. I understand that. Could it also be an attack?

DK: **Oh I think this is the sincerest form of flattery.**

JW: Okay, so you feel there's no anger in it.

DK: **I didn't say that. I refer you to the Louise Bourgeois painting. And to quote another great Louise, Nevelson, "I'd be dead without my anger." And yes, I have made a piece out of this quote. But not anger towards the painters I'm addressing. Anger at being constantly marginalized for no good reason. My generation of women painters really**

got the shaft. If anything, it's a plea for inclusion.

JW: So, it's an audition?

DK: "Everything you do, you still audition." (Sondheim's special lyrics for Streisand's "Putting it Together" on *The Broadway Album*.)

JW: I always balk when people I've never met ask are you an artist? I always think don't ask me! History will be the judge!

You call this work *feel good paintings*, which I agree with. Are "feel good" paintings artistically incorrect today?

DK: Oh, probably. I am breaking new artistically incorrect ground with the musical lyrics, I hope. Snobs don't like musicals. So low brow!

JW: Yeah, I agree.

DK: But really, these musicals are brilliant. The music, the language, the optimistic vision of America! I am sure they will be performed by repertory companies, like opera is, in the very near future. And these genius lyricists could instill so much emotion into the fewest words. Sondheim, Rodgers and Hammerstein, Dorothy Fields, Irving Berlin. It's an endless list. Those Jews sure were good with "the word." There's a generalization for you.

JW: Right.

DK: It's my vocabulary. It really is my specificity. And I celebrate it. And yes, I think it is utterly politically incorrect in the art world because it's so uncool and nerdy. And artists are not supposed to seem familiar, like you went to summer camp with them. I am so that person. God, artists are supposed to be cowboys, aren't they?

JW: You've also said "Resistance runs through my work." What exactly do you mean by that? That sounds great, but what are you resisting?

DK: See above! The accepted narrative of art history, particularly painting. And marginalization. When, as in *Hairspray*, the fat girl defies expectations, successfully auditions and then gets the cutest guy, that's a refusal to be marginalized. She doesn't even have to lose weight! When the cast sings "You Can't Stop the Beat," a close read of that implies that someone is trying to stop the beat and you won't, can't, and refuse to stop singin' and dancin' your chubby little heart out. Although I have

You Can't Stop the Beat, 2002. Gouache on paper. 10 x 14 in. (25.4 x 35.6 cm)

feel good paintings
for feel bad times

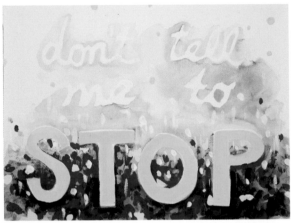

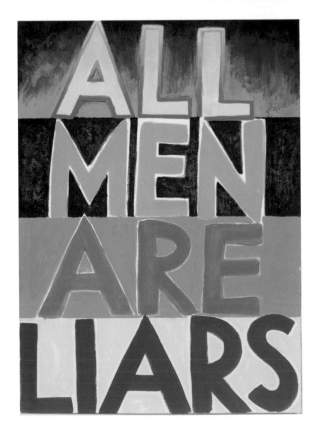

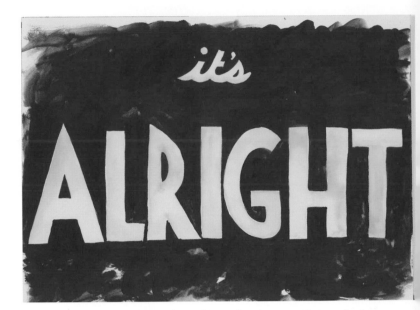

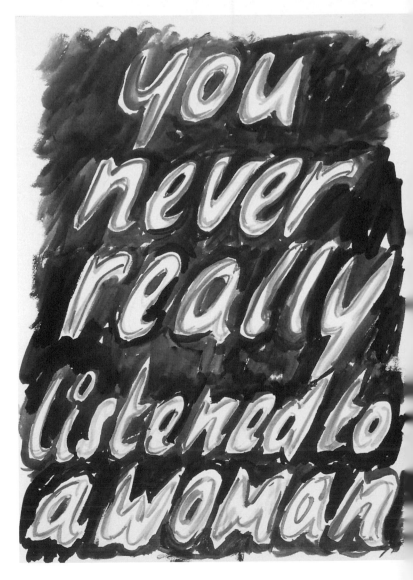

(top) **Female Trouble**, 2002

(middle) **Don't Tell Me To Stop**, 2002

(bottom) **All Men Are Liars**, 2002

(top) **It's Alright**, 2002

(bottom) **You Never Really Listened To A Woman**, 2002

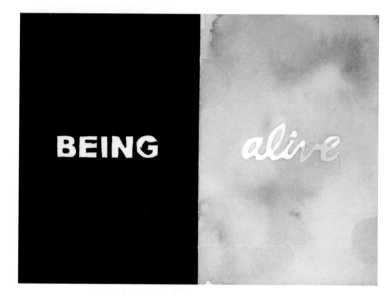

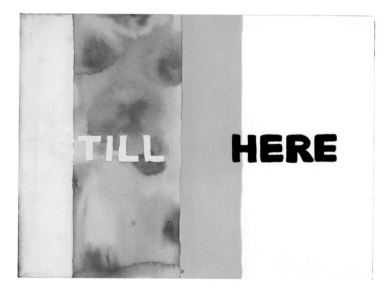

(top) **Do Something Special**, 2002

(middle) **The Nerve**, 2002

(bottom) **You'll Know Then & There**, 2002

(top) **For Me**, 2002

(middle) **Being Alive**, 2002

(bottom) **Still Here**, 2002

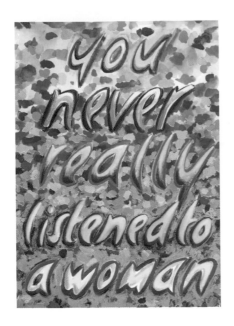

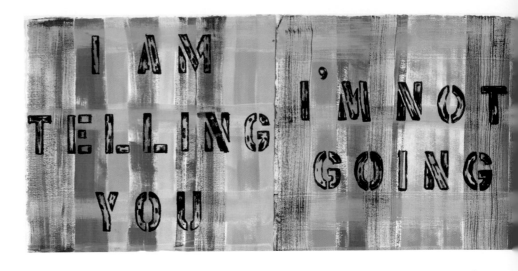

(top) **You Never Really Listened To A Woman**, 2002

(middle) **For Me**, 2002

(middle) **You Can't Stop the Beat**, 2002

(bottom) **Gone**, 2002

(top) **I Am Telling You I'm Not Going (diptych)**, 2002

(bottom) **Good Times**, 2005

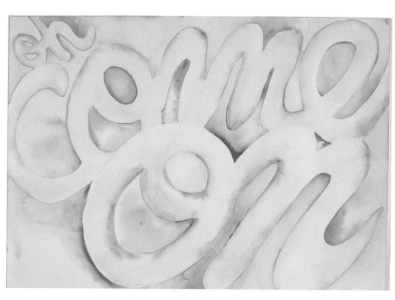

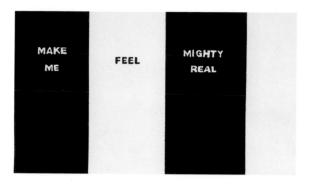

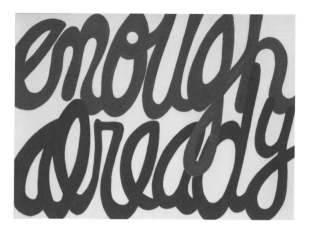

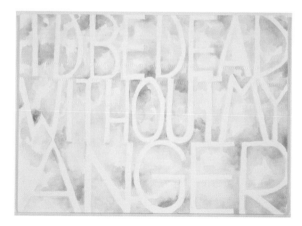

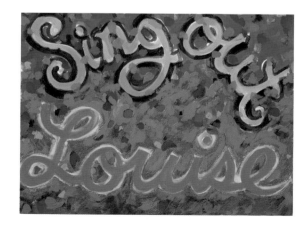

(top) **It Was Mary**, 2006

(bottom) **Oh Come On**, 2002

(top) **Make Me Feel Mighty Real**, 2007

(middle) **Enough Already**, 2003

(middle) **I'd Be Dead Without My Anger**, 2002

(bottom) **Sing Out Louise**, 2002

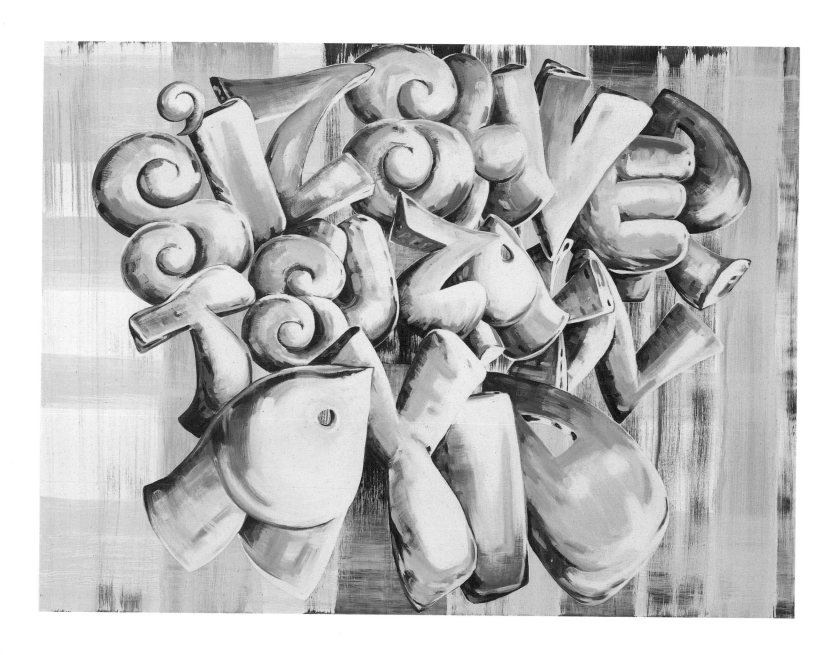

Hard To Be A Jew, 2003

If I Were a Wealthy Man, 2006

You Can't Stop The Beat, 2003

(following spread) For Me, 2004

Painting With Balls, 2005

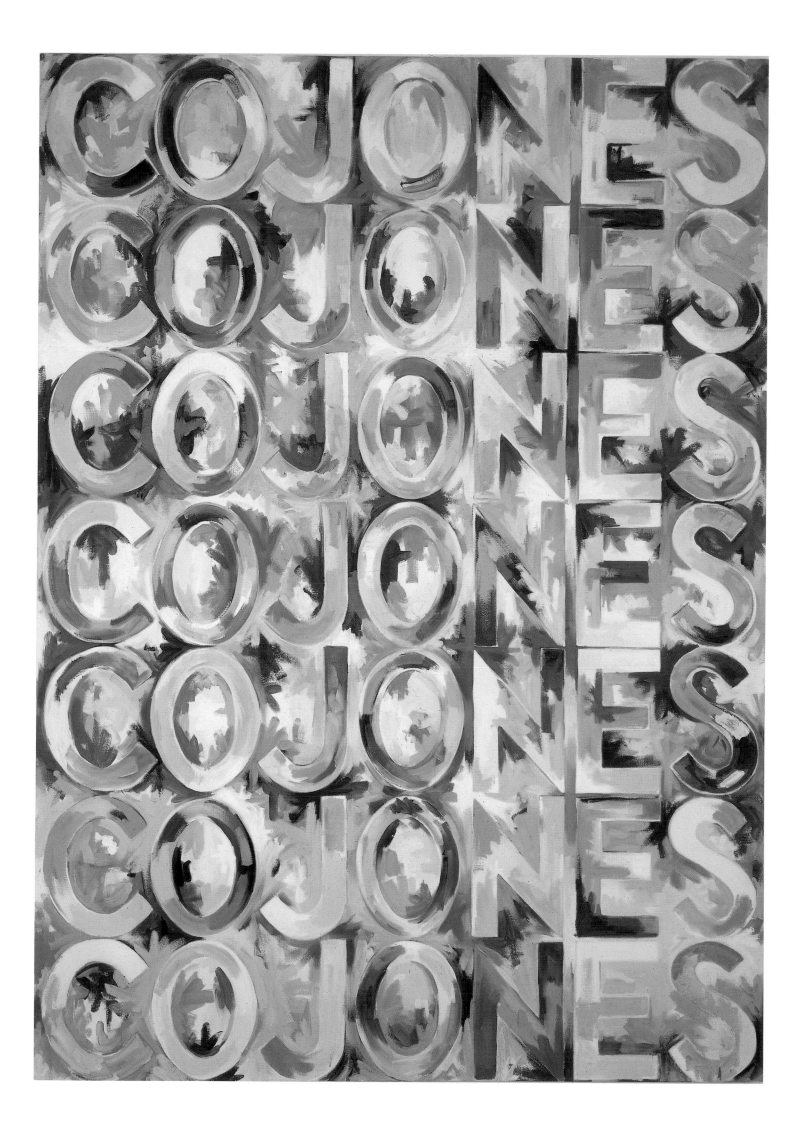

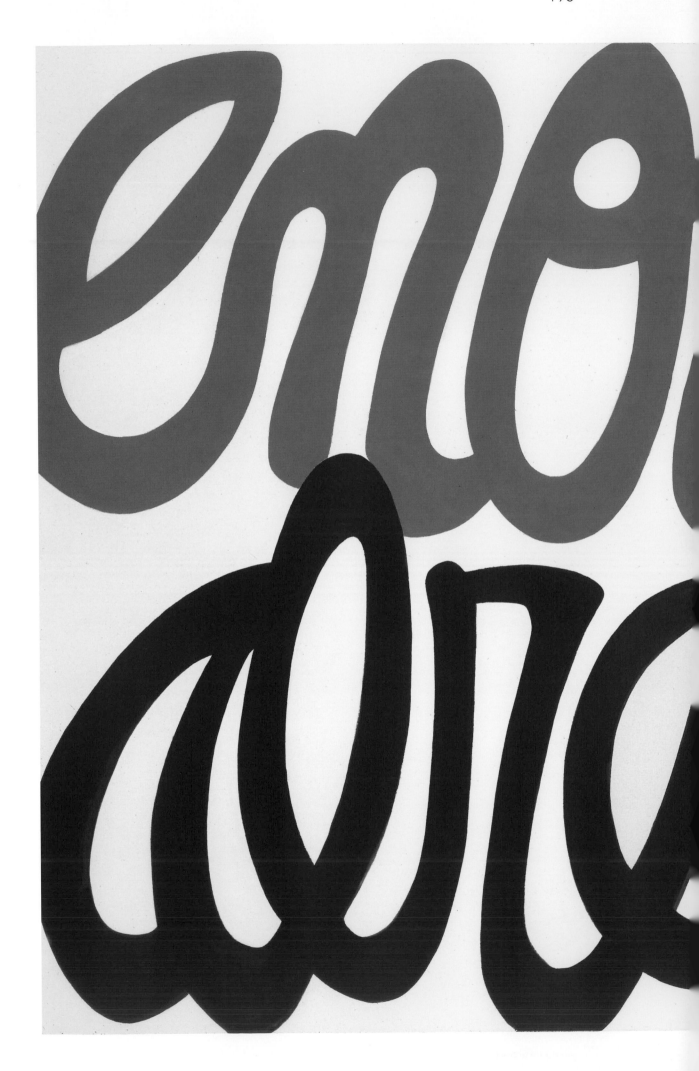

Enough Already, 2006

HERE

Still Here, 2007

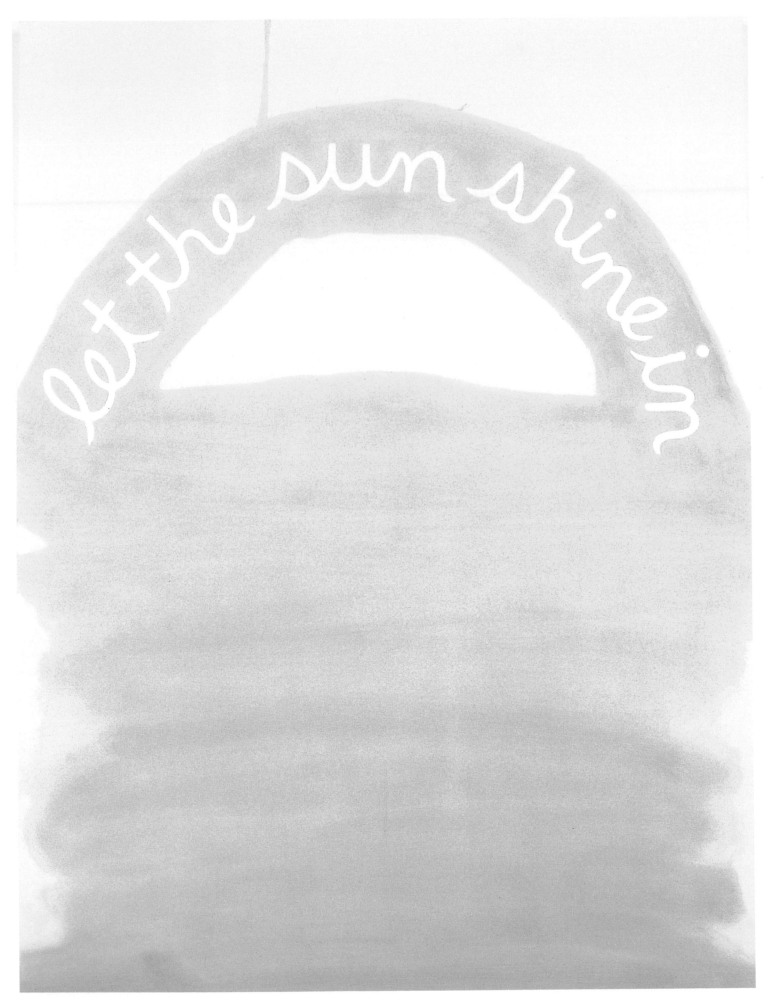

Let The Sun Shine In, 2006

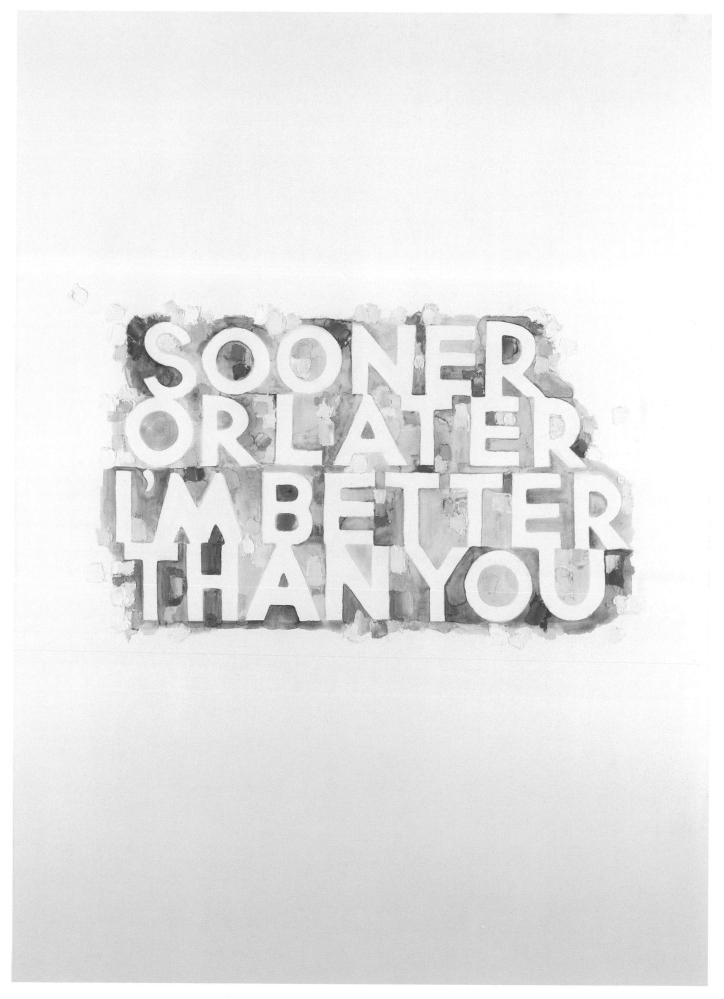

Sooner or Later, 2007

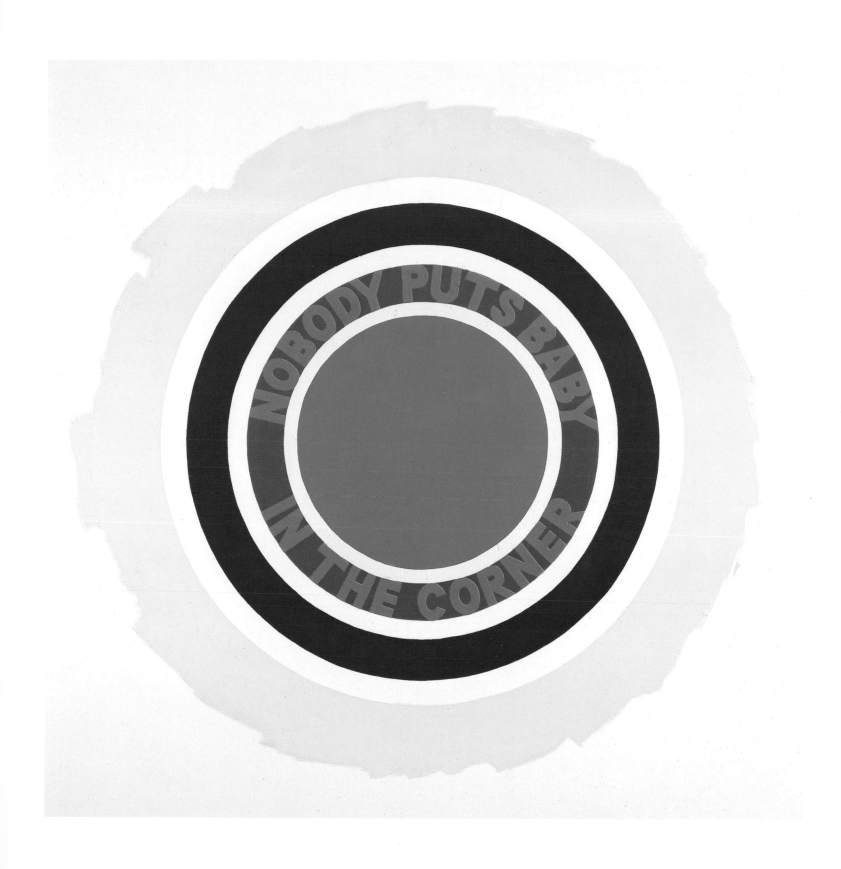

Nobody Puts Baby In The Corner, *2007*

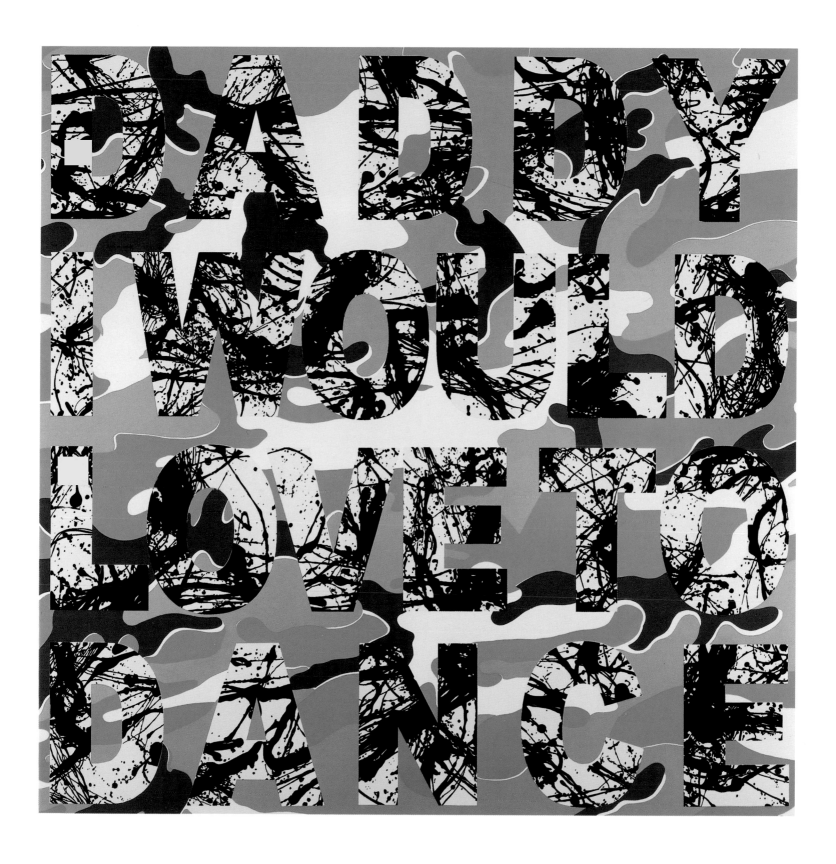

Desert Daddy #2, 2007

Mighty Real, 2007

Do You Wanna Funk With Me, 2008

you made m

You Made Me Love You, 2007

Super Freak, 2008

Sweet Thing, *2008*

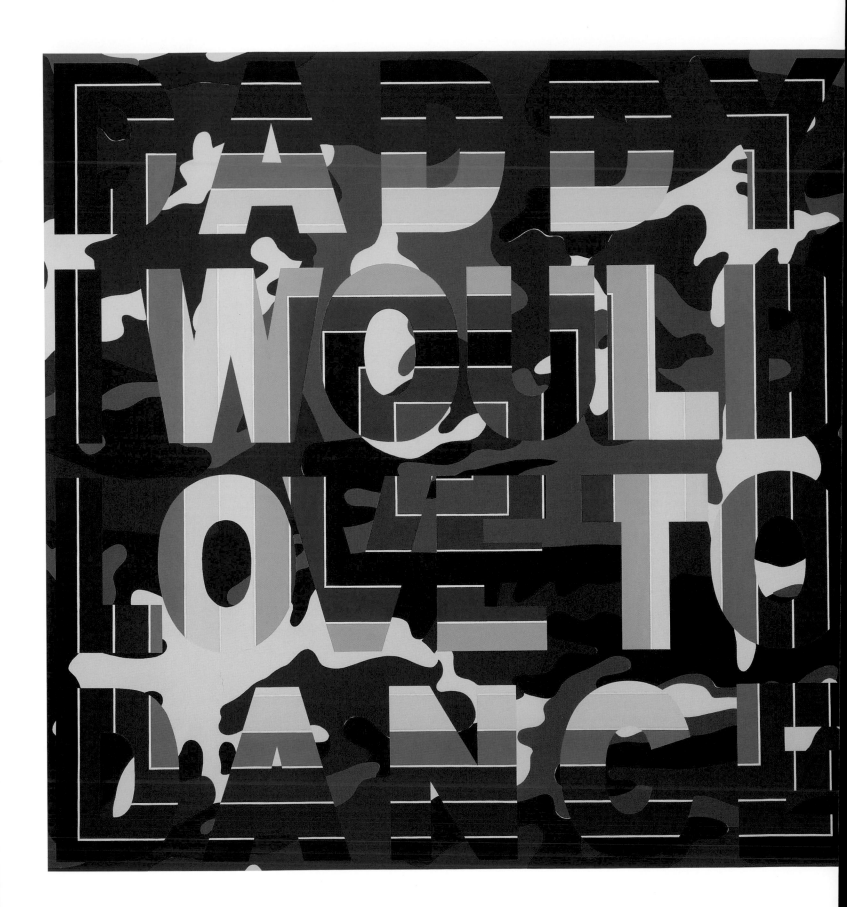

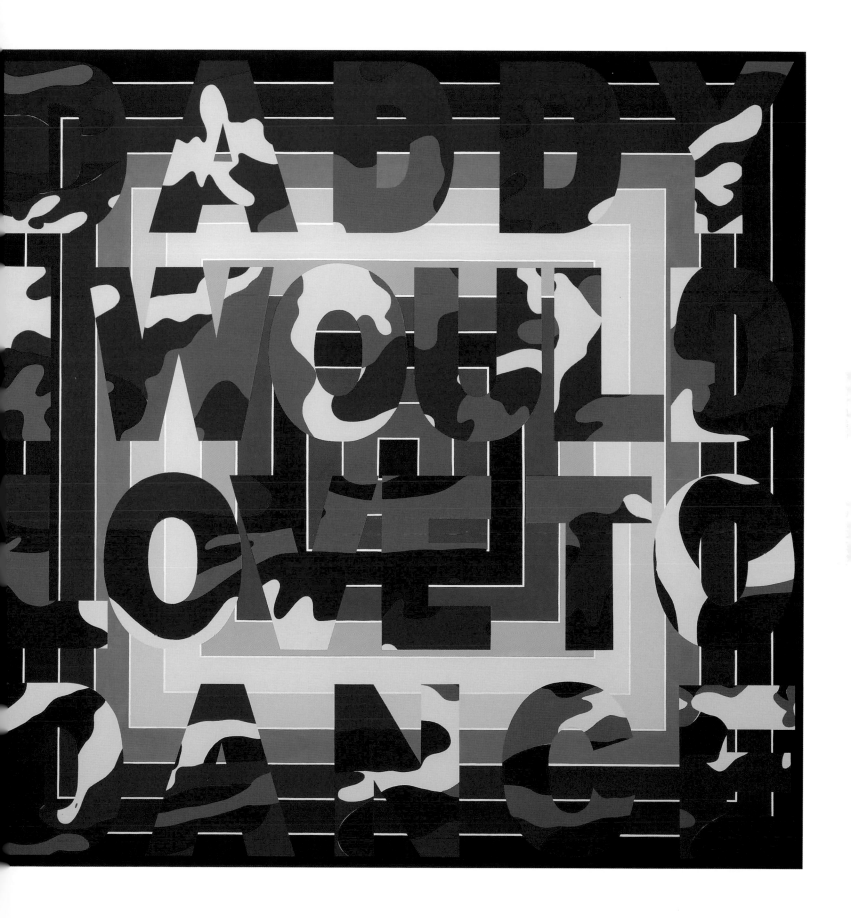

Frank's Dilemma, 2009

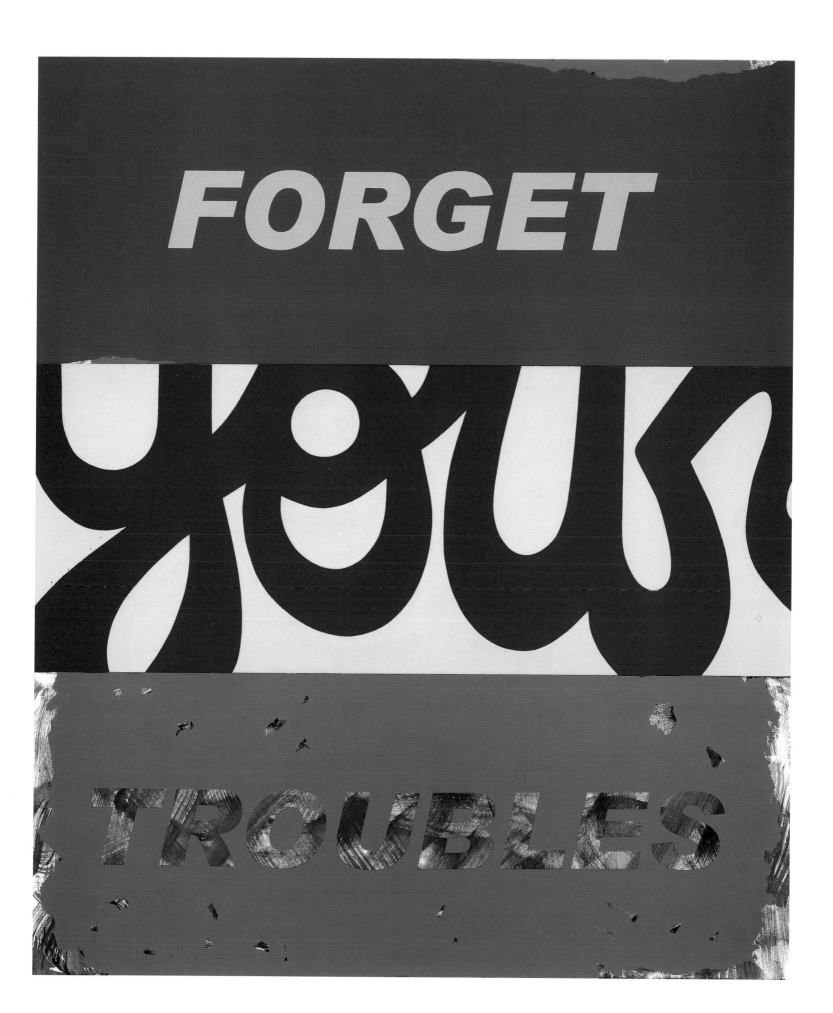

Forget Your Troubles, 2010

Happy Days, 2009

C'Mon Get Happy, 2010

C'MON

GET

happy

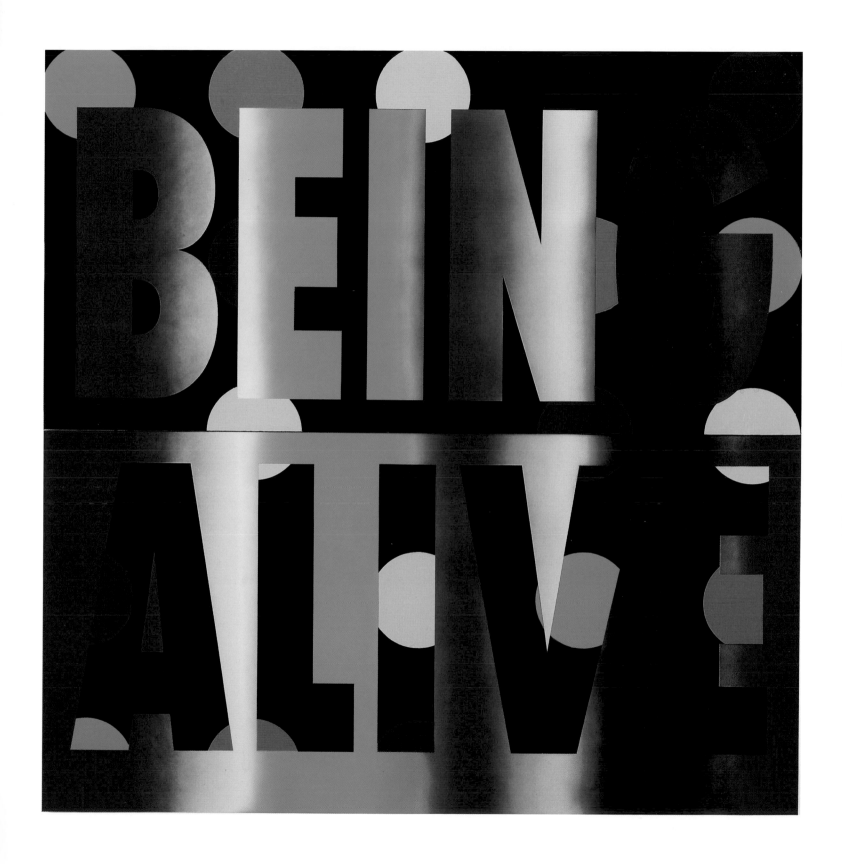

Being Alive, 2010

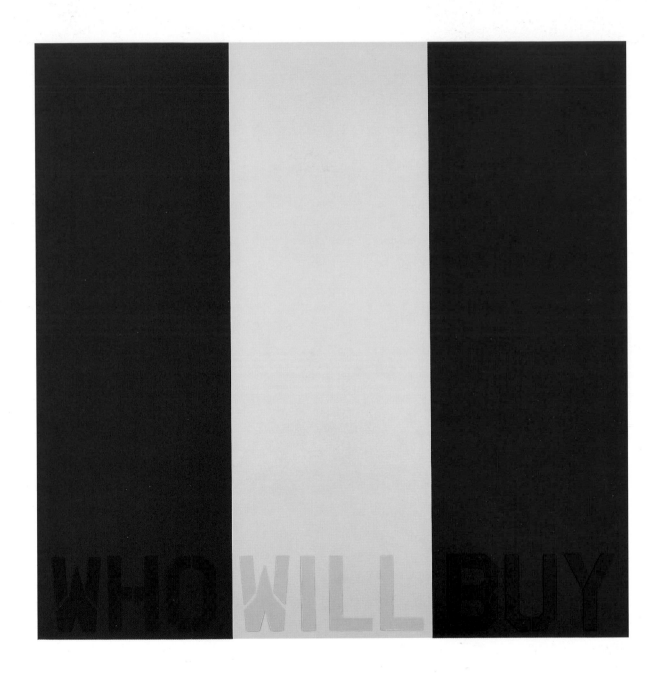

(above) **Who Will Buy**, 2008

(opposite) **Save the Country**, 2009

SAVE

THE

COUNTRY

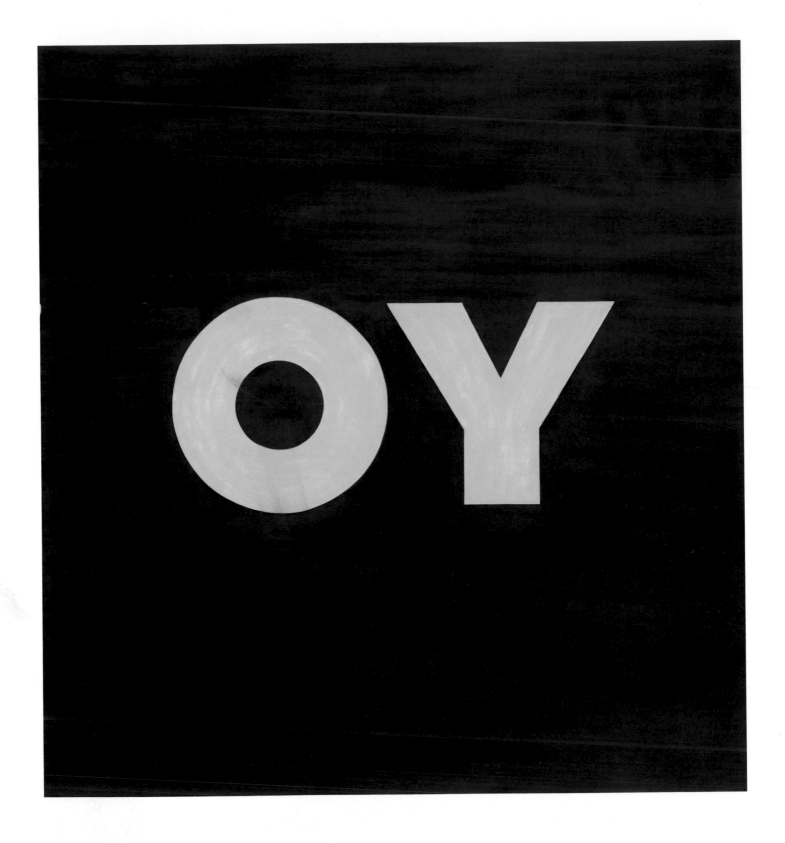

OY, 2009

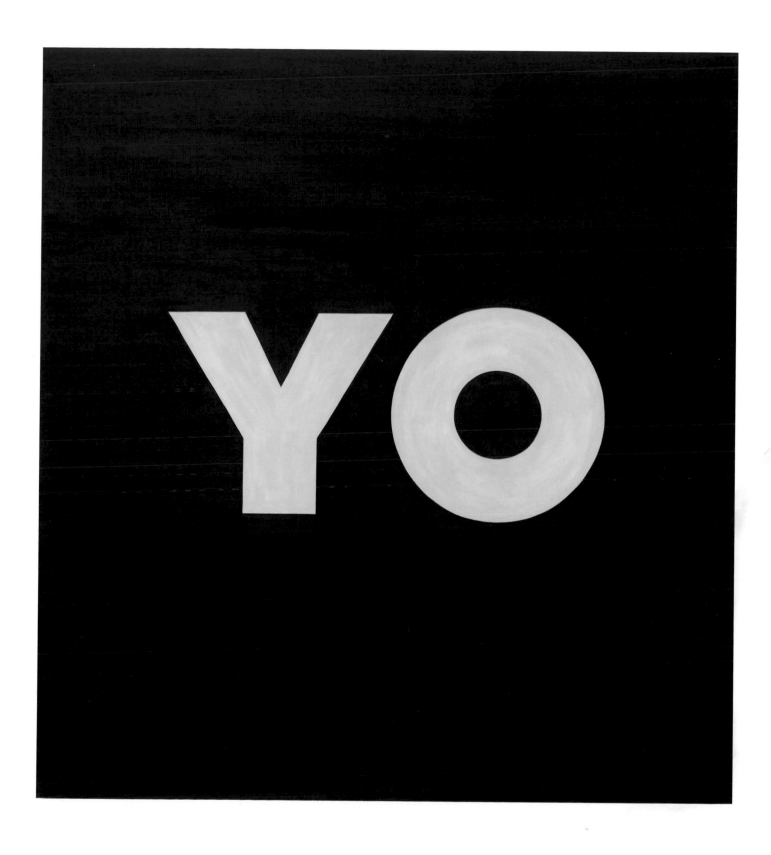

YO, 2010

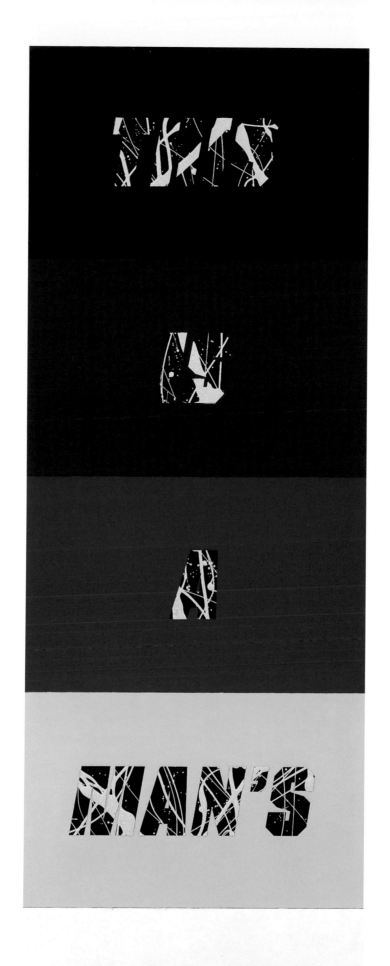

Day After Day, 2010

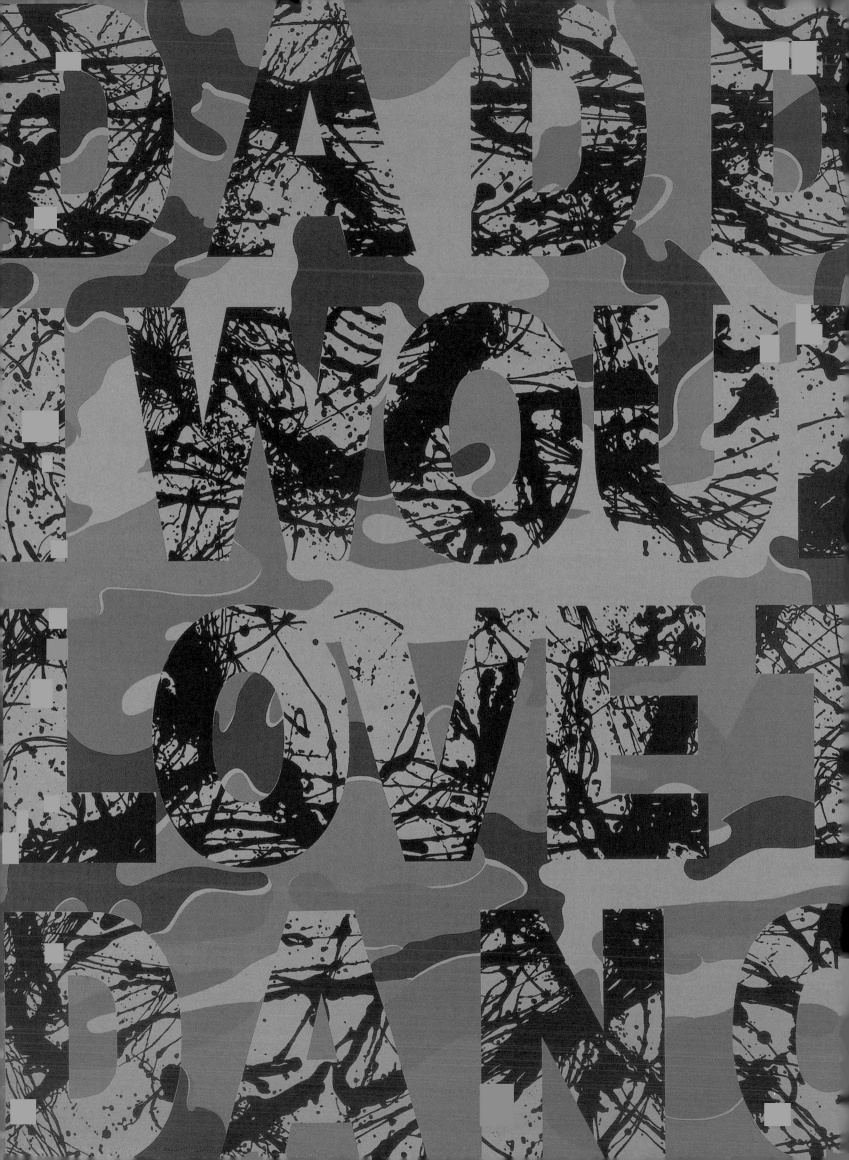

index of artworks

–

biography

–

bibliography

Index of Artworks

Works in **bold** are confirmed in the exhibition *Deborah Kass: Before and Happily Ever After* at The Andy Warhol Museum, Pittsburgh, PA, at the time of publication.

Dimensions are listed height x width

pages 48–49
Untitled (Sky), 1988
Oil on canvas
40 x 100 in.
(101.6 x 254 cm)
The Collection of
James E. Cottrell and
Joseph F. Lovett

page 50
**Sense and Sensibility
I**, 1987
Oil on canvas
63 x 76 in. (160 x 193 cm)
Courtesy the artist and
Paul Kasmin Gallery

page 51
**Sense and Sensibility
II**, 1987
Oil on canvas
63 x 76 in. (160 x 193 cm)
Courtesy the artist and
Paul Kasmin Gallery

pages 52–53
Untitled (Pollock), 1987
Oil on canvas
50 x 120 in.
(127 x 304.8 cm)
Private collection

pages 54–55
Something of Value I, 1988
Oil and enamel on canvas
45 x 105 in.
(114.3 x 266.7 cm)
Collection of the artist

pages 56–67
Second Nature, 1988
Oil and enamel on canvas
50 x 120 in.
(127 x 304.8 cm)
Courtesy of Francis J.
Greenburger

pages 58–59
Object Relations, 1989
Oil on canvas
45 x 105 in.
(114.3 x 266.7 cm)
Courtesy the artist and
Paul Kasmin Gallery

pages 60–61
Table of Content (Part I),
1988
Oil, enamel, and vinyl
on canvas
8 panels: 48 x 96 in.
(121.9 x 243.8 cm) overall
Private collection

pages 62–63
Short Story II, 1989
Oil, enamel, and Flashe on
denim and canvas
32 ¼ x 65 ¼ in.
(81.9 x 165.7 cm)
The Frances Young Tang
Teaching Museum and Art
Gallery at Skidmore College,
Saratoga Springs, New York
Gift of Dan Cameron
in memory of Margaret
Cameron, 20011.13.1

pages 66–67
Emissions Control,
1989–90
Oil, acrylic, Flashe, and
enamel on canvas
63 x 135 in.
(160 x 342.9 cm)
Courtesy the artist and
Paul Kasmin Gallery

pages 68–69
**Call of the Wild
(for Pat Steir)**, 1989
Oil, enamel, and acrylic
on canvas
39 ¼ x 81 ¼ in.
(99.7 x 206.4 cm)
The Collection of
James E. Cottrell and
Joseph F. Lovett

page 71
My Spanish Spring, 1991
Oil, acrylic, and Flashe
on canvas
76 x 63 in.
(193 x 160 cm)
Collection of the artist

pages 72–73
Nature Nature II, 1991
Enamel, oil, and acrylic
on canvas
45 x 100 in.
(114.3 x 254 cm)
Courtesy the artist and
Paul Kasmin Gallery

pages 74–75
*Untitled (First World Third
World)*, 1990
Oil and Flashe on canvas
45 x 105 in. (114.3 x 266.7 cm)
Courtesy the artist and
Paul Kasmin Gallery

pages 76–77
Subject Matters, 1989–90
Enamel, gold leaf, and
acrylic on canvas
63 x 135 in. (160 x 342.9 cm)
The Jewish Museum,
New York
Purchase: Barbara S.
Horowitz and Joan C. Sall
Gifts, 1992-38a-b

page 78
Nature Morte, 1990
Oil, acrylic, and enamel on
canvas
76 x 63 in. (193 x 160 cm)
The Solomon R. Guggenheim
Museum, New York

page 79
**Portrait of the Artist as a
Young Man**, 1991
Oil, enamel, and acrylic
on canvas
84 x 66 in. (213.4 x 167.6 cm)
Courtesy the artist and
Paul Kasmin Gallery

pages 80–81
How Do I Look?, 1991
Mixed media on canvas
50 x 100 in.
(127 x 254 cm)
The Collection of
James E. Cottrell and
Joseph F. Lovett

page 82
Read My Lips, 1990
Oil and acrylic on canvas
72 x 60 in.
(182.9 x 152.4 cm)
Courtesy the artist and
Paul Kasmin Gallery

page 83
Making Men #4, 1992
Oil, enamel, and acrylic
on canvas
78 x 63 in. (198.1 x 160 cm)
The Collection of
James E. Cottrell and
Joseph F. Lovett

page 84
Making Men #3, 1992
Oil, acrylic, and wooden ruler
on canvas
70 x 84 in. (177.8 x 213.4 cm)
Courtesy the artist and
Paul Kasmin Gallery

page 85
Making Men #2, 1992
Oil and acrylic on canvas
70 x 84 in. (177.8 x 213.4 cm)
Courtesy the artist and
Paul Kasmin Gallery

page 87
**Before and Happily Ever
After**, 1991
Oil and acrylic on canvas
72 x 60 in. (182.9 x 152.4 cm)
Collection of the artist

page 89
Puff Piece, 1992
Acrylic, Flashe, and enamel
on canvas
78 x 63 in. (198.1 x 160 cm)
Collection of the artist

pages 102–3
**Double Red Barbra
(The Jewish Jackie Series)**,
1992
Silkscreen ink and acrylic
on canvas
2 panels: 45 x 36 in.
(114.3 x 38.5 cm) each,
45 x 72 in.
(114.3 x 182.9 cm) overall
Courtesy the artist and
Paul Kasmin Gallery

page 104
*2 Silver Barbras (The
Jewish Jackie Series)*, 1993
Silkscreen and acrylic
on canvas
28 x 45 in.
(71.1 x 114.3 cm)
Private collection,
Malibu, CA

America's Most Wanted, Lisa D., 1999
Silkscreen and acrylic
on canvas
48 x 40 in.
(121.9 x 101.6 cm)
Courtesy the artist and
Paul Kasmin Gallery

page 146
America's Most Wanted, Thelma G., 1998
Silkscreen ink and acrylic
on canvas
2 panels: 48 x 40 in.
(121.9 x 101.6 cm) each,
48 x 80 in.
(121.9 x 203.2 cm) overall
Courtesy the artist and
Paul Kasmin Gallery

page 147
America's Most Wanted, Donna D., 1999
Silkscreen ink and acrylic
on canvas
2 panels: 48 x 40 in.
(121.9 x 101.6 cm) each,
48 x 80 in.
(121.9 x 203.2 cm) overall
Courtesy the artist and
Paul Kasmin Gallery

pages 148–49
America's Most Wanted, Paul S., 1999
Silkscreen ink and acrylic
on canvas
2 panels: 48 x 40 in.
(121.9 x 101.6 cm) each,
48 x 80 in.
(121.9 x 203.2 cm) overall
Courtesy the artist and
Paul Kasmin Gallery

pages 150–51
Orange Disaster (Linda Nochlin), 1997
Silkscreen ink and acrylic
on canvas
2 panels: 120 x 75 in.
(304.8 x 190.5 cm) each,
120 x 150 in.
(304.8 x 381 cm) overall
Courtesy the artist and
Paul Kasmin Gallery

page 152
Let Us Now Praise Famous Women, 1994–95
Silkscreen ink and acrylic
on canvas
72 x 61 in.
(182.9 x 154.9 cm)
Courtesy the artist and
Paul Kasmin Gallery

page 153
The Family Stein, 1994
Silkscreen ink and acrylic
on canvas
65 x 65 in.
(165.1 x 165.1 cm)
Courtesy the artist and
Paul Kasmin Gallery

page 154
Sandy Koufax, 1997
Silkscreen ink and acrylic
on canvas
72 x 66 in.
(182.9 x 167.6 cm)
Courtesy of The Ginsberg
Group

page 155
Streb, 1998
Silkscreen ink and acrylic
on canvas
81 x 81 in.
(205.7 x 205.7 cm)
Courtesy the artist and
Paul Kasmin Gallery

pages 156–57
Robert Rosenblum, 1997
Silkscreen ink and acrylic on
canvas
2 panels: 40 x 40 in.
(101.6 x 101.6 cm) each,
40 x 80 in.
(101.6 x 203.2 cm) overall
Courtesy the artist and
Paul Kasmin Gallery

page 158
Norman Kleeblatt, 1997
Silkscreen ink and acrylic
on canvas
2 panels: 40 x 40 in.
(101.6 x 101.6 cm) each,
40 x 80 in.
(101.6 x 203.2 cm) overall
Collections of the artist and
Norman Kleeblatt

William Diamond, 1995
Silkscreen ink and acrylic
on canvas
2 panels: 40 x 40 in.
(101.6 x 101.6 cm) each,
40 x 80 in.
(101.6 x 203.2 cm) overall
Courtesy the artist and
Paul Kasmin Gallery

page 159
Pat Steir, 1997
Silkscreen ink and acrylic
on canvas
2 panels: 40 x 40 in.
(101.6 x 101.6 cm) each,
40 x 80 in.
(101.6 x 203.2 cm) overall
Courtesy the artist and
Paul Kasmin Gallery

pages 160–61
Cindy Sherman, 1995
Silkscreen ink and acrylic
on canvas
2 panels: 40 x 40 in.
(101.6 x 101.6 cm) each,
40 x 80 in.
(101.6 x 203.2 cm) overall
Weatherspoon Art Museum,
University of North Carolina,
Greensboro

pages 162–63
Elizabeth Murray, 1995
Silkscreen ink and acrylic on
canvas
2 panels: 40 x 40 in.
(101.6 x 101.6 cm) each,
40 x 80 in.
(101.6 x 203.2 cm) overall
Collections of the artist and
Murray Holman Family Trust

page 165
Miriam Schapiro, 1997
Silkscreen ink and acrylic
on canvas
2 panels: 40 x 40 in.
(101.6 x 101.6 cm) each,
40 x 80 in.
(101.6 x 203.2 cm) overall
Courtesy the artist and
Paul Kasmin Gallery

Jose Freire, 1994
Silkscreen ink and acrylic
on canvas
2 panels: 40 x 40 in.
(101.6 x 101.6 cm) each,
40 x 80 in.
(101.6 x 203.2 cm) overall
Collection Jose Freire

Jeanne Kaufax (Grandma), 1995
Silkscreen ink and acrylic
on canvas
2 panels: 40 x 40 in.
(101.6 x 101.6 cm) each,
40 x 80 in.
(101.6 x 203.2 cm) overall
Collection of the artist

pages 166–67
Alice Kosmin 36 Times,
1994
Silkscreen ink and acrylic
on canvas
36 panels: 20 x 16 in.
(50.8 x 40.6 cm) each,
80 x 144 in.
(203.2 x 365.8 cm) overall
Collection of Alice and
Marvin Kosmin

pages 168–69
Jennifer Dicke, 2001
Silkscreen ink and acrylic
on canvas
4 panels: 40 x 40 in.
(101.6 x 101.6 cm) each,
80 x 80 in.
(203.2 x 365.8 cm) overall
The Dicke Collection

page 171
An American Man, Arthur G. Rosen, 1996
Silkscreen ink and acrylic
on canvas
36 panels: 16 x 16 in. each
(40.6 x 40.6 cm), approx.
128 x 64 in.
(325.1 x 162.6 cm) overall
Collection of A. G. Rosen

pages 172–73 all:
Juliana Costa, 2007
Silkscreen ink and acrylic
on canvas
40 x 40 in.
(101.6 x 101.6 cm)
Private collection

pages 194–95
For Me, 2004
Oil and acrylic on canvas
84 x 112 in.
(213.4 x 284.5 cm)
Collection of Sara M. and
Michelle Vance Waddell

page 197
Painting With Balls, 2005
Oil on linen
84 x 60 in.
(213.4 x 152.4 cm)
Courtesy the artist and
Paul Kasmin Gallery

pages 198–99
Enough Already, 2006
Oil and acrylic on canvas
45 x 63 in.
(114.3 x 160 cm)
Private collection, Rolling
Hills, CA

pages 200–201
Still Here, 2007
Oil, enamel, and acrylic
on canvas
45 x 63 in.
(114.3 x 160 cm)
Courtesy of Injoa Kim

page 202
Let The Sun Shine In, 2006
Oil on canvas
60 x 45 in.
(152.4 x 114.3 cm)
Private collection, New York

page 203
Sooner or Later, 2007
Oil on canvas
63 x 45 in.
(160 x 114.3 cm)
Courtesy the artist and Paul
Kasmin Gallery

page 204
Oh God I Need This Show,
2007
Oil on canvas
72 x 96 in.
(182.9 x 243.8 cm)
Courtesy the artist and
Paul Kasmin Gallery

page 205
**Nobody Puts Baby In
The Corner**, 2007
Oil and acrylic on canvas
72 x 72 in.
(182.9 x 182.9 cm)
Collection of Tim and
Sally Howard

page 207
Desert Daddy #2, 2007
Silkscreen ink and acrylic on
canvas
78 x 78 in.
(198.1 x 198.1 cm)
Courtesy the artist and
Paul Kasmin Gallery

page 208
Mighty Real, 2007
Oil and enamel on canvas
72 x 72 in.
(182.9 x 182.9 cm)
Private collection in Newport
Coast, CA

page 209
**Do You Wanna Funk With
Me**, 2008
Oil and enamel on canvas
52 x 68 in.
(132.1 x 172.7 cm)
Collection of Beth Rudin
DeWoody

pages 210–11
You Made Me Love You,
2007
Oil and acrylic on canvas
24 x 70
(61 x 177.8 cm)
Daryl and Steven Roth

page 212
Super Freak, 2008
Oil and enamel on canvas
48 x 48 in.
(121.9 x 121.9 cm)
Courtesy the artist and
Paul Kasmin Gallery

page 213
Sweet Thing, 2008
Oil and acrylic on canvas
48 x 48 in.
(121.9 x 121.9 cm)
Collection of Rory Tahari

pages 214–15
Frank's Dilemma, 2009
Acrylic on canvas
78 x 156 in.
(198.1 x 396.2 cm)
Collection of Margaret and
Daniel S. Loeb

page 217
Forget Your Troubles, 2010
Oil and acrylic on canvas
72 x 60 in.
(182.9 x 152.4 cm)
Collection of David Corkins

pages 218–19
Happy Days, 2009
Oil and enamel on linen
26 x 80 in.
(66 x 203.2 cm)
Private collection, courtesy
Guggenheim, Asher
Associates

page 221
C'Mon Get Happy, 2010
Oil and acrylic on canvas
72 x 48 in.
(182.9 x 121.9 cm)
Private collection

page 223
Being Alive, 2010
Oil and acrylic on linen
72 x 72 in.
(182.9 x 182.9 cm)
Private collection

page 224
Who Will Buy, 2008
Oil and acrylic on canvas
72 x 72 in.
(182.9 x 182.9 cm)
Courtesy the artist and
Paul Kasmin Gallery

page 225
Save the Country, 2009
Oil and acrylic on canvas
84 x 72 in.
(213.4 x 182.9 cm)
Courtesy the artist and
Paul Kasmin Gallery

page 226
OY, 2009
Oil on canvas
71 ¼ x 66 ½ in.
(181 x 168.9 cm)
Private collection

page 227
YO, 2010
Oil on canvas
71 ¼ x 66 ½ in.
(181 x 168.9 cm)
Private collection

page 229
This Is A Man's World, 2011
Enamel and acrylic on canvas
80 ¼ x 26 ¾ in.
(203.8 x 67.8 cm)
Courtesy the artist and
Paul Kasmin Gallery

pages 230–31
Day After Day, 2010
Oil and acrylic on canvas
72 x 252 in. (182.9 x 640.1 cm)
Courtesy the artist and
Paul Kasmin Gallery

page 256
After Louise Bourgeois,
2010
Neon and transformers
on powder-coated aluminum
panel
Edition of 6 plus 3 artist's
proofs
66 x 68 x 5 in.
(167.6 x 172.7 x 12.7 cm)
Courtesy the artist and
Paul Kasmin Gallery

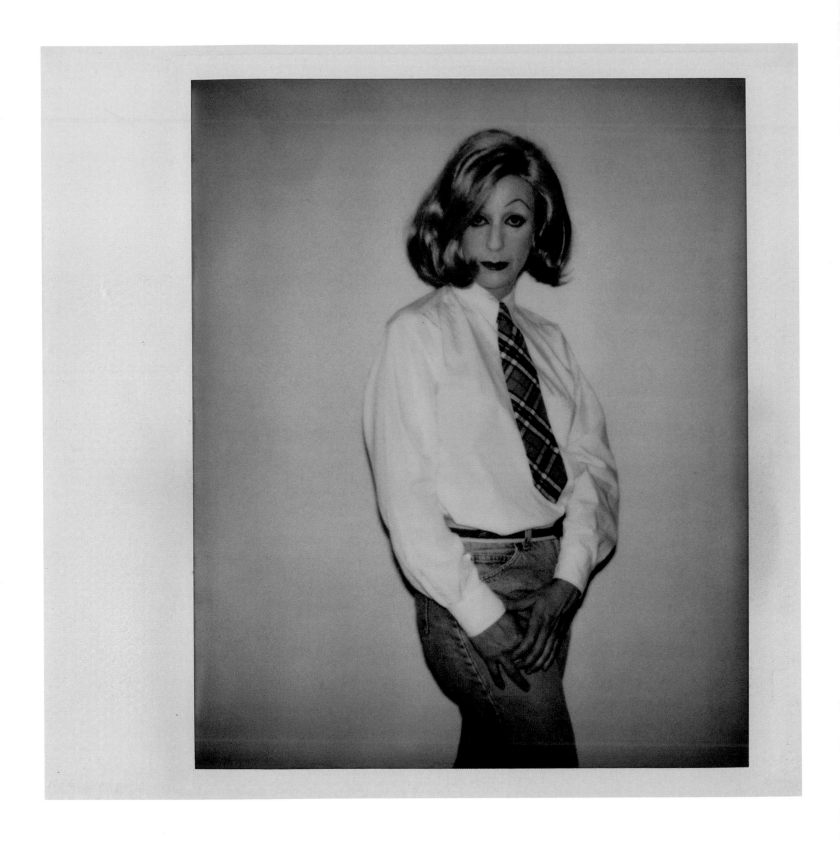

Polaroid of Deborah Kass, 1994

Deborah Kass

Born in 1952

Education

1974
BFA, Painting, Carnegie Mellon University, Pittsburgh, PA

1972
Whitney Museum Independent Study Program, New York, NY

1968–70
Art Students League, New York, NY

Selected Teaching

2005–present
Yale University School of Art, Visiting Critic and Graduate Seminar, M.F.A. Painting Department, New Haven, CT

1997
Skowhegan School of Painting and Sculpture, Skowhegan, ME, resident artist

New York University, New York, NY, graduate seminar, fall semester

1993
School of the Art Institute of Chicago, Chicago, IL, Visiting Artist with seniors and graduates, spring semester

School of the Museum of Fine Arts, Boston, MA, "Four Painters Program" with seniors and graduates, fall semester

1990–91
Rhode Island School of Design, Providence, RI, "Distinguished Visiting Artist" with senior and graduates, spring semester

Solo Exhibitions

2012
Deborah Kass: Before and Happily Ever After, The Andy Warhol Museum, Pittsburgh, PA (cat.)

2010
MORE feel good paintings for feel bad times, Paul Kasmin Gallery, New York, NY

2007
feel good paintings for feel bad times, Paul Kasmin Gallery, New York, NY

Paul Kasmin Gallery, Armory Show, New York, NY

2001
Deborah Kass: The Warhol Project, Weatherspoon Art Museum, University of North Carolina, Greensboro, NC

2000
Deborah Kass: The Warhol Project, University Art Museum, University of California, Santa Barbara, CA

Deborah Kass: The Warhol Project, Blaffer Gallery, University of Houston, Houston, TX

1999
Deborah Kass: The Warhol Project, Newcomb Art Gallery, Tulane University, New Orleans, LA (traveling, cat.)

1998
Arthur Roger Gallery, New Orleans, LA

1996
My Andy: a retrospective, Kemper Museum of Contemporary Art, Kansas City, MO (cat.)

1995
My Andy: a retrospective, Jose Freire Fine Art, New York, NY

My Andy: a retrospective, Arthur Roger Gallery, New Orleans, LA

1994
Barbara Krakow Gallery, Boston, MA

1993
Chairman Ma, Jose Freire Fine Art, New York, NY

Chairman Ma, Arthur Roger Gallery, New Orleans, LA

1992
The Jewish Jackie Series and My Elvis, fiction/nonfiction, New York, NY

The Jewish Jackie Series, Simon Watson, New York, NY

1990
Simon Watson Gallery, New York, NY

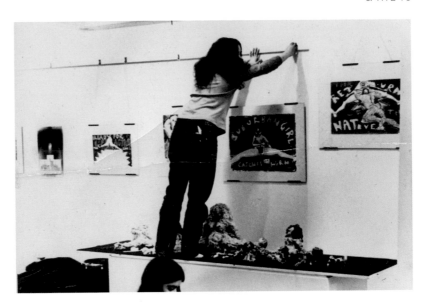

Deborah Kass, Carnegie Mellon University, c. 1972–73

1988
Scott Hanson Gallery, New York, NY (cat.)

1986
Baskerville + Watson Gallery, New York, NY

1984
Baskerville + Watson Gallery, New York, NY

1982
Zolla/Lieberman Gallery, Chicago, IL

1972
Raymond Barnhardt Gallery, University of Kentucky, Lexington, KY

Selected Group Exhibitions

2012
Regarding Warhol: Fifty Artists, Fifty Years, The Metropolitan Museum of Art, New York, NY

2011
The Pittsburgh Biennial, The Andy Warhol Museum, Pittsburgh, PA

Identity Crisis: Authenticity, Attribution and Appropriation, The Heckscher Museum of Art, Huntington, NY

The Deconstructive Impulse, Neuberger Museum of Art, Purchase, NY (cat.)

Seeing Gertrude Stein: Five Stories, Contemporary Jewish Museum, San Francisco, CA and the National Portrait Gallery, Smithsonian Institution, Washington, D.C. (cat.)

January White Sale, Loretta Howard Gallery, New York, NY (cat.)

2010
Shifting the Gaze: Painting and Feminism, The Jewish Museum, New York, NY

Hide/Seek: Difference and Desire in American Portraiture, National Portrait Gallery, Smithsonian Institution, Washington, D.C. (cat.)

At the Edge, Portsmouth Museum of Art, Portsmouth, NH

Thanks for Being With Us: Contemporary Art from the Douglas Nielsen

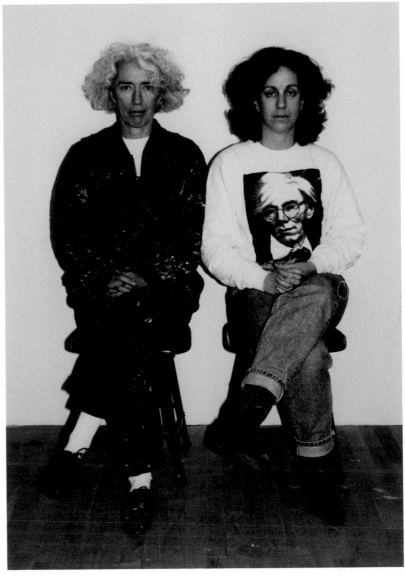

Elizabeth Murray and Deborah Kass, 1994, New York

Collection, Tucson Museum of Art, Tucson, AZ (cat.)

Shrewd: The Smart and Sassy Survey of American Women Artists, The Sheldon Museum of Art, Lincoln, NE

Think Pink, Gavlak Gallery, Palm Beach, FL

Look Again, Marlborough Chelsea, New York, NY (cat.)

2009
Beg Borrow and Steal, Rubell Family Collection, Miami, FL (cat.)

The Female Gaze, Cheim & Read, New York, NY

sh[OUT], Glasgow Museums Gallery of Modern Art, Glasgow, Scotland (cat.)

Great Women Artists: Selections from the Permanent Collection, Neuberger Museum of Art, Purchase, NY

2008
Art, Image, and Warhol Connections, The Jewish Museum, New York, NY

Just Different!, Cobra Museum of Modern Art, Amstelveen, Netherlands

Thirtieth Anniversary Exhibition, Arthur Roger Gallery, New Orleans, LA

Twisted into Recognition: Clichés of Jews and Others, Spertus Museum, Chicago, IL

typisch!, Jewish Museum Berlin, Berlin, Germany

2007
What F Word?, Cynthia Broan Gallery, New York, NY

2006
The Eighth Square, Museum Ludwig, Cologne, Germany

2005
American Art: 1960–Present, Selections From the Permanent Collection, Weatherspoon Art Museum, The University of North Carolina, Greensboro, NC

Co-Conspirators: Artists and Collectors,

The James Cottrell and Joe Lovett Collection, Chelsea Museum, New York, NY and Samuel Dorsky Museum, New Paltz, NY

2004
Open House: Working in Brooklyn, Brooklyn Museum, Brooklyn, NY

Likeness: Artists' Portraits of Artists by Other Artists, (2004–2006), California College of the Arts, Wattis Institute, San Francisco, CA; McColl Center for Visual Art, Charlotte, NC; Institute of Contemporary Art, Boston, MA; Dalhousie Art Gallery, Halifax, Nova Scotia, Canada; University Art Museum, California State University, Long Beach, CA; Illingworth Kerr Gallery, Alberta College of Art + Design, Calgary, Alberta, Canada; Contemporary Art Center of Virginia, Virginia Beach, VA (cat.)

Muse, Leslie Tonkonow Gallery, New York, NY

Co-Conspirators: Artists and Collectors, The James Cottrell and Joe Lovett Collection, Orlando Museum of Art, Orlando, FL

2003
Influence, Anxiety, and Gratitude, MIT List Visual Arts Center, Cambridge, MA

Crimes and Misdemeanors. Politics in U.S. Art of the 1980s, Contemporary Art Center, Cincinnati, OH

The Recurrent, Haunting Ghost: Reflections of Marcel Duchamp in Modern and Contemporay Art, Francis M. Naumann Fine Art, New York, NY

2002
Queer Visualities, Stony Brook University Art Gallery, Stony Brook, NY

2001
A Family Album: Brooklyn Collects, Brooklyn Museum, Brooklyn, NY

Voice, Image, Gesture: Selections from The Jewish Museum's Collection 1945–2000, The Jewish Museum, New York, NY

Contemporary Art and Celebrity Culture, Betty Rymer Gallery, School of the Art Institute of Chicago, Chicago, IL

Recasting the Past: Beneath the Hollywood Tinsel, Main Art Gallery, Cal State University, Fullerton, CA

2000
Revealing and Concealing: Portraits and Cultural Identity, Skirball Cultural Center, Los Angeles, CA (cat.)

Deja vu: Reworking the Past, Katonah Museum of Art, Katonah, NY

1999
Fifteen, New York Foundation for the Arts, Deutsche Bank, New York, NY

The Perpetual Well: Contemporary Art from the Collection of the Jewish Museum, The Jewish Museum, New York, NY; Harn Museum of Art, University of Florida, Gainesville, FL; Sheldon Memorial Art Gallery and Sculpture Garden, University of Nebraska, Lincoln, NE; Parrish Art Museum, Southampton, NY; Huntington Museum of Art, Huntington, WV (cat.)

1998
In Your Face, The Andy Warhol Museum, Pittsburgh, PA

Conversation: Patricia Cronin and Deborah Kass, Art Resources Transfer, Inc., New York, NY

5729–5756: Contemporary Artists Welcome the New Year, The Jewish Museum List Graphic Commisssion, The Jewish Museum, New York, NY

Art on Paper, Weatherspoon Art Museum, The University of North Carolina, Greensboro, NC

1997
The Prophecy of Pop, Contemporary Arts Center, New Orleans, LA

Identity Crisis: Self Portraiture at the End of the Century, Milwaukee Art Museum, Milwaukee, WI and Aspen Art Museum, Aspen, CO (cat.)

1996
Too Jewish?: Challenging Traditional Identities, The Jewish Museum, New York, NY; The National Museum of American Jewish History, Philadelphia, PA; Contemporary

Museum, Baltimore, MD; The Jewish Museum, San Francisco, CA; The Hammer Museum, University of California, Los Angeles, CA (cat.)

NowHere: Incandescent, Louisiana Museum of Modern Art, Humlebæk, Denmark (cat.)

Real Fake, Neuberger Museum of Art, Purchase, NY

Gender, Fucked, Center on Contemporary Art, Seattle, WA

Seoul International Art Fair, Seoul, Korea

1995
In a Different Light, University Art Gallery, University of California, Berkeley, CA (cat.)

On Beauty, Regina Gallery, Moscow

Face Forward: Self-Portraiture in Contemporary Art, John Michael Kohler Arts Center, Sheboygan, WI

Pervert, University of California, Irvine, CA (cat.)

Imperfect, Herter Art Gallery, University of Massachusetts, Amherst, MA and Tyler School of Art, Temple University, Philadelphia, PA (cat.)

Semblances, Museum of Modern Art, New York, NY

1994
2 X IMMORTAL: Elvis + Marilyn, McDaris Exhibition Group, Memphis, TN; Institute of Contemporary Art, Boston, MA; Contemporary Arts Museum, Houston, TX; The Mint Museum, Charlotte, NC; The Cleveland Museum of Art, Cleveland, OH; The Philbrook Museum of Art, Tulsa, OK; Columbus Museum of Art, Columbus, OH; Tennessee State Museum, Nashville, TN; San Jose Museum of Art, San Jose, CA; Honolulu Academy of Arts, Honolulu, HI (cat.)

Democratic Vistas: 50 Years of American Art from Regional Collections, State University of New York, Albany, NY (cat.)

Stonewall 25: Imaginings of the Gay Past, Celebrating the Gay Present, White Columns, New York, NY

Absence, Activism & The Body Politic, Fischbach Gallery, New York, NY

Working Around Warhol, Pittsburgh Center for the Arts, Pittsburgh, PA

Bad Girls West, Wight Art Gallery, University of California, Los Angeles, CA (cat.)

1993
Ciphers of Identity, University of Maryland, Baltimore and Baltimore County Fine Arts Gallery, Catonsville, MD; Ronald Feldman Gallery, New York, NY; Contemporary Arts Center, New Orleans, LA; Woodruff Arts Center, Atlanta, GA; University of California, Irvine, CA; Kemper Museum of Contemporary Art, Kansas City, MO (cat.)

Regarding Masculinity, Arthur Roger Gallery, New Orleans, LA

I Love You More Than My Own Death, A Melodrama In Parts By Pedro Almodovar, The Venice Biennial, Venice, Italy

I Am The Enunciator, Thread Waxing Space, New York, NY

1992
The New American Flag, Max Protetch Gallery, New York, NY

Shapeshifters, Amy Lipton Gallery, New York, NY

Fear of Painting, Arthur Roger Gallery, New York, NY

Painting Culture, University of California, Irvine, CA

1991
Painting Culture, fiction/nonfiction, New York, NY

Rope, Galería Fernando Alcolea, Barcelona, Spain

Out Art, St. Lawrence University, Saint Lawrence, NY

Something Pithier and More Psychological, Simon Watson Gallery, New York, NY

Just What Is It That Makes Today's Homes So Different, So Appealing?, The Hyde Collection, Glens Falls, NY (cat.)

1990
The Last Laugh: Irony, Humor, Self-Mockery and Derision, Massimo Audiello Gallery, New York, NY

Fragments, Parts and Wholes: The Body in Culture, White Columns, New York, NY

1989
Young New York, Bellarte, Helsinki, Finland

The Mirror in Which Two Are Seen as One, Jersey City Museum, Jersey City, NJ

Painting Between the Paradigms-Part One: Between Awareness and Desire, Galerie Rahmel, Cologne, Germany

Erotophobia: A Forum on Contemporary Sexuality, Simon Watson Gallery, New York, NY

1988
Meaningful Geometry, Postmasters Gallery, New York, NY

Five Corners of Abstraction, Jacob Javits Center, New York, NY

1987
Dreams of the Alchemist, Carl Solway Gallery, Cincinnati, OH

Romantic Science, One Penn Plaza, New York, NY

Major Acquisitions, Small Appliances, Solo Gallery, New York, NY

1986
A Radical Plurality, Ben Shahn Galleries, William Paterson University, Wayne, NJ

Two-Person Exhibition, Turnbull Lutjeans Kogan Gallery, Costa Mesa, CA

1985
Six Painters, Zilkha Gallery, Wesleyan University, Middletown, CT

1984
The New Expressive Landscape, Sordoni Art Gallery, Wilkes University, Wilkes-Barre, PA

Fantastic Landscape, Exit Art, New York, NY

1982
Two-Person Exhibition, Baskerville + Watson Gallery, New York, NY

Red, Stefanotti Gallery, New York, NY

Landscape/Cityscape, Josef Gallery, New York, NY

Critical Perspectives, P.S.1, Long Island City, NY

1981
Black Paint/Dark Thoughts, Pratt Manhattan Center, New York, NY

Drawings at the Mudd Club, The Mudd Club, New York, NY

1980
First Person singular: Recent Self Portraiture, Pratt Manhattan Center, New York, NY and Pratt Institute, Brooklyn, NY

1979
Artists by Artists, Whitney Museum of American Art, New York, NY

Selected Public Collections

Chemical Bank, New York, NY
Cincinnati Art Museum, Cincinnati, OH
First Bank of Minneapolis, Minneapolis, MN
Fort Wayne Museum of Art, Fort Wayne, IN
Glickenhaus Company, New York, NY
The Jane Voorhees Zimmerli Art Museum, New Brunswick, NJ
The Jewish Museum, New York, NY
La Jolla Museum of Contemporary Art, La Jolla, CA
McCrory Corporation, New York, NY
Mobil Oil Corporation, New York, NY

Museum" of Contemporary Art, San Diego
Museum of Fine Arts, Boston, MA
The Museum of Modern Art, New York, NY
New Museum, New York, NY
New Orleans Museum of Art, New Orleans, LA
The Norton Family Foundation, Santa Monica, CA
Pacific Bell, Los Angeles, CA
The Progressive Corporation, Cleveland, OH
Prudential Bache, New York, NY
The Prudential Life Insurance Company of America, NJ
Solomon Brothers, New York, NY
The Solomon R. Guggenheim Museum, New York, NY
The Weatherspoon Art Museum, University of North Carolina, Greensboro, NC
The Whitney Museum of American Art, New York, NY

(top) Invitation, *Two-Person Exhibition*, Turnbull Lutjeans Kogan Gallery, Costa Mesa, CA, 1986

(bottom) Poster, "Representation and Value: What Role Will the Languages of Feminism Play in the Art World of the Nineties," panel discussion, 1991

Selected Bibliography

2012

Kadet, Anne. "Metro Money, The Art Scene, Then & Now." *Wall Street Journal*, March 3.

2011

Baker, Kenneth. "Gertrude Stein gets her due in 'Five Stories.'" *San Francisco Chronicle*, May 21.

Bernstein, Amy. "The Beginning of the End of Us: a Conversation with Deborah Kass." Portlandart.net, May 5.

Bigger Than Life 100 Years of Hollywood: A Jewish Experience, exhibition catalogue. Jewish Museum Vienna. Berlin: Bertz and Fischer.

Corn, Wanda M., and Latimer, Tirza True. *Seeing Gertrude Stein: Five Stories.* University of California Press: Berkeley.

Denson, Roger G. "XX Chromosocial: Women Artists Cross the Homosocial Divide." Huffingtonpost.com, March 8.

Hodara, Susan. "Taking on the Role of Gender in Media." *New York Times*, March 13.

Johnson, Ken. *Are You Experienced? How Psychedelic Consciousness Transformed Modern Art.* Prestel USA: New York.

Levin, Gail. *Lee Krasner: A Biography.* William Morrow: New York.

Moyer, Carrie. "The Deconstructive Impulse." *Art in America*, May.

Princenthal, Nancy. "In Theory: Postmodernism and Polemics," *The Deconstructive Impulse*, exhibition catalogue. Neuberger Museum of Art, Purchase, NY. Neuberger Museum of Art and Delmonico Books: New York.

Reed, Christopher. *Art and Homosexuality: A History of Ideas.* Oxford University Press: New York.

Rosenberg, Karen. "Jewish Museum: 'Shifting the Gaze: Painting and Feminism.'" *New York Times*, January 28.

Shaw, Anny. "Spreading the Word."

The Art Newspaper, December 3–4.

Shridhare, Lori. "Modern-day Neon Expressionism." *Sign Builder Illustrated*, March, cover.

Will, Barbara. *Gertrude Stein, Modernism, and the Problem of "Genius."* Edinburgh University Press: Edinburgh.

Zaytoun, Constance. "Enough Already!: It's Deborah Kass's Turn to Take the Stage." *TDR The Drama Review*, Fall.

2010

Acevedo, Carla. "Deborah Kass: Feel Good Paintings." DaWire.com, September 24.

Belasco, Daniel. "Size Matters." *Lilith*, Fall.

Budick, Ariella. "Shifting the Gaze: Painting and Feminism, Jewish Museum, New York." *Financial Times*, October 27.

Finch, Charlie. "Kassasstrophies." Artnet.com, October 7.

Goldsworthy, Rupert. "Deborah Kass: Back to Broadway." Artinamericamagazine.com, October 15.

Homes, A. M. "Elizabeth Streb." *Bomb*, Summer.

Katz, Jonathan. *Hide/Seek: Difference and Desire in American Portraiture*, exhibition catalogue. National Portrait Gallery, Smithsonian Institution, Washington, D.C. Smithsonian Books: Washington, D.C.

Myers, Terry. "Deborah Kass with Terry Myers." *The Brooklyn Rail*, September, cover.

Nadelman, Cynthia. "Reviews: Deborah Kass." *ARTnews*, December.

Rosenberg, Karen. "A Raucous Reflection on Indentity: Jewish and Feminine." *New York Times*, September 10.

Rubenstein, Bradley. "Parallel Lines—

Deborah Kass." Culturecatch.com, October 8.

Russeth, Andrew. "Singing on the Edge of Extinction: A Q&A with Painter Deborah Kass." Artinfo.com, October 19.

Saltz, Jerry. "Ask an Art Critic." NYmag.com, September 30.

Sandler, Irving. "Deborah Kass." Bombsite.com, September.

Wells, Nicholas. "Deborah Kass: More Feel Good Paintings for Feel Bad Times." Cityarts.com, October 14.

Wolin, Joseph R. "Deborah Kass, 'More Feel Good Paintings for Feel Bad Times.'" *Time Out New York*, October 21–27.

2009
Beg Borrow and Steal, exhibition catalogue. Rubell Family Collection, Miami, FL.

Laster, Paul. "The Female Gaze." TheDailyBeast.com, July 30.

Radcliffe, Allan. "sh[OUT]: Contemporary Art and Human Rights." *The List*, April 2.

sh[OUT], exhibition catalogue. Glasgow Museums Gallery of Modern Art, Glasgow, Scotland.

2008
Abrams, Nathan, ed. *Jews and Sex.* Five Leaves Publications: Nottingham, England.

Batalion, Judy. "Seeing Shlock: Jewish Humour and Visual Art." *Jewish Quarterly*, Autumn, cover.

Leffingwell, Edward. "Review of Exhibitions, Deborah Kass." *Art in America*, January.

Shandler, Jeffrey. "What is American Jewish Culture?" *The Columbia History of Jews & Judaism in America*. Marc Lee Raphael, ed. Columbia University Press: New York.

Wagner, Frank. *Just Different!*, exhibition catalogue. Cobra Museum of Modern Art: Amstelveen, Netherlands, cover.

typisch! Stereotypes of Jews and Others, exhibition catalogue. Jewish Museum Berlin.

2007
Baigell, Matthew. *Jewish Art in America: An Introduction*. Rowman & Littlefield: Lanham, MD.

Colman, David. "A Place to Park the Imagination." *New York Times*, February 18.

Cotter, Holland. "That Sanitation Truck Parked on the Pier? It's Part of the Show." *New York Times*, February 23.

Douglas, Sarah. "Go Solo." *Art + Auction*, February 7.

Duponchelle, Valerie. "New York fait son grand Armory Show." *Le Figaro*, February 23.

Finch, Charlie. "Another Opening, Another Show." Artnet.com, September 10.

Galloway, David. "Reviews, The Eighth Square." *Artnews*, March.

Kass, Deborah. "The Seventies." *The Brooklyn Rail*, September.

Klein, Sheri. *Art & Laughter*. I. B. Tauris: London, England.

Maine, Stephen. "Poles of the Feminist Spectrum." *New York Sun*, October 4.

McClemont, Doug. "Last Chance." Saatchi-gallery.co.uk, October 8.

Orenstein, Gloria Feman. "Torah Study, Feminism and Spiritual Quest in the Work of Five American Jewish Women Artists." *Nashim, A Journal of Jewish Women's Studies & Gender Issues*, Fall.

Patel, Samir, ed. *Kori Newkirk 1997–2007*, exhibition catalogue. Fellows of Contemporary Art, Los Angeles and The Studio Museum in Harlem.

Pollack, Barbara. "Reviews, Deborah Kass." *Artnews*, November.

2006
Amato, Micaela Amateau, and Joyce Henri Robinson. *Couples Discourse*, exhibition catalogue. Palmer Museum of Art, Pennsylvania State University, University Park, PA.

Ault, Julie, ed. *Felix Gonzalez-Torres*. Steidldangin: Gottingen, Germany.

Bloom, Lisa. *Jewish Identities in American Feminist Art*. Routledge: New York, cover.

Danicke, Sandra. "Androgyne Kunst." *Frankfurter Rundschau*, August 26.

Douglas, Sarah. "Staying Power," *Art + Auction*, November.

Eichler, Dominic. "The Eighth Square." *Frieze*, November/December.

Mirzoeff, Nick. "'That's All Folks': Contemporary Art and Popular Culture," *A Companion to Contemporary Art Since 1945*. Amelia Jones, ed. Blackwell Publishing: Oxford, England.

Smith, Roberta. "The Name of This Show Is Not: Gay Art Now," *New York Times*, July 7.

Stremmel, Kerstin. "La vie en rose?" *Neue Züricher Zeitung*, October 17.

Wagner, Frank, Kasper Konig, Julia Freidrich, eds. *The Eighth Square, Gender, Life, and Desire in the Arts since 1960*, exhibition catalogue. Museum Ludwig, Cologne. Hatje Cantz Verlag: Germany.

2005
Cotter, Holland. "Trade." *New York Times*, February 25.

Goodbody, Bridget L. "Opportunity Knocks." *Art Review*, September/October.

Temin, Christine. "Here's Looking at You." *The Boston Globe*, January 23.

2004
Halberstam, Judith. "Hidden Worlds: Photography and Subcultural Lives," *Art Becomes You! Parody, Pastiche*

and the Politics of Art. Henry Rogers and Aaron Williamson, eds. Article Press, UCE Birmingham Institute of Art and Design: Birmingham, England.

Higgs, Matthew. Likeness: Portraits of Artists by Other Artists, exhibition catalogue. CAA Wattis Institute for Contemporary Art and Independent Curators International: San Francisco, CA.

Rubenstein, Raphael. "Independent and International: Highlights of the Cottrell-Lovett Collection," Co-Conspirators: Artist and Collector, exhibition catalogue. Orlando Museum of Art: Orlando, FL.

Scott, Sue. "Co-Conspirators: Artist and Collector, the Making of a Collection," Co-Conspirators: Artist and Collector, exhibition catalogue. Orlando Museum of Art, Orlando, FL.

Solomon, Julie. "At 100, Still Asking 'Why Should It Be Easy?'" New York Times, January 21.

Wilkin, Karen. "Open House: Working in Brooklyn." The Wall Street Journal, August 4.

Williams, Karla. "American Art: Lesbian, Post-Stonewall," The Queer Encyclopedia of the Visual Arts. Claude J. Summers, ed. Cleis Press: San Francisco, CA.

2003
Boyarin, Daniel, Daniel Itzkovitz, Ann Pellegrini, eds. Queer Theory and the Jewish Question. Columbia University Press: New York, cover.

McQuaid, Cate. "Something Borrowed." The Boston Globe, May 30.

Saltz, Jerry. Seeing Out Loud. The Figures Press: Great Barrington, MA.

Slotes, Oriz. Fixing the World: Jewish American Painters in the 20th Century. Brandeis University Press: Lebanon, NH.

Yablonsky, Linda. "To Thine Own Selves Be True." Artnews, November.

2002
Apel, Dora. Memory Effects: The Holocaust and the Art of Secondary Witnessing. Rutgers University Press: New Brunswick, NJ.

Braff, Phyllis. "Looking at Those Images Again and Again." New York Times, November 24.

Dannatt, Adrian. "Enough About Me." The Art Newspaper, May.

Leavy, Jane. Sandy Koufax, A Lefty's Legacy. Harper Collins: New York.

Ramirez, Ana Maria. Queer Visualities: Reframing Sexuality in a Post-Warhol World, exhibition catalogue. University Art Gallery, Staller Center for the Arts, Stony Brook University, Stony Brook, NY.

Wolf, Stacy. A Problem Like Maria: Gender and Sexuality in the American Musical. The University of Michigan Press: Ann Arbor, MI.

2001
D'Souza, Aruna, ed. Self and History, A Tribute to Linda Nochlin. Thames and Hudson: London, cover.

Goeser, Caroline. "Deborah Kass: The Warhol Project." ArtLies, Number 29.

Halpern, Max. "Warhol at UNCG." What's Up, March 23.

Johnson, Ken. "Wry Skepticism About What Jewishness Means." New York Times, July 27.

Liebmann, Lisa. "A Warholian Trifecta." Artforum, December.

Schneider, Rebecca. "Hello Dolly Well Hello Dolly: The Theatre and Its Double," Psychoanalysis and Performance. Adrian Kear and Patrick Campbell, eds. Routledge: London.

Welchman, John. Art After Appropriation: Essays on Art in the 1990's. Routledge: London.

"Hot property." parallax, Issue 19, cover.

2000
Cottingham, Laura. Seeing Through the Seventies: Essays on Feminism and Art, G + B Arts International: London.

Cronin, Patricia. "A Conversation on Lesbian Subjectivity and Painting," M/E/A/N/I/N/G/ An Anthology of Artists' Writings, Theory, and Criticism. Susan Bee and Mira Schor, eds. Duke University Press: Durham, NC.

Gilbert, Barbara C. "Introduction," Revealing and Concealing, Portraits and Identity, exhibition catalogue. Skirball Cultural Center, Los Angeles, CA.

Hammond, Harmony. "Deborah Kass," Lesbian Art in America: A Contemporary History. Rizzoli: New York.

Johnson, Patricia C. "Art Review Deborah Kass," Houston Chronicle, November 7.

Marcus, Greil. Double Trouble: Bill Clinton and Elvis Presley in the Land of No Alternatives. Picador USA: New York.

Weiss, Marion Wolberg. "Art Commentary," Dan's Papers, October 13.

Will, Barbara. Gertrude Stein, Modernism, and the Problem of 'Genius.' Edinburgh University Press: Edinburgh, Scotland.

Wilson, William. "Deborah Kass Packs Along Personal Politics As She Ventures Into Andy Warhol Territory." Los Angeles Times, August 4.

1999
Berger, Maurice. "Seeing Myself Seeing Myself," Deborah Kass, The Warhol Project, exhibition catalogue. Newcomb Art Gallery, Tulane University, New Orleans, LA. Newcomb Art Gallery and D.A.P.: New York.

Gilman, Sander. Making the Body Beautiful, A Cultural History of Aesthetic Surgery. Princeton University Press: Princeton, NJ.

Hill, Diane. "The 'Real Realm': Value and Values in Recent Feminist Art,"

Interpreting Visual Culture: Explorations in the Hermeneutics of the Visual. Ian Heywood and Barry Sandywell, eds. Routledge: New York.

Nochlin, Linda. "Deborah Kass: Portrait of the Artist as Appropriator," *Deborah Kass, The Warhol Project*, exhibition catalogue. Newcomb Art Gallery, Tulane University, New Orleans, LA. Newcomb Art Gallery and D.A.P.: New York.

Plante, Michael. "Screened Identities, Multiple Repetitions and Missed Kisses," *Deborah Kass, The Warhol Project*, exhibition catalogue. Newcomb Art Gallery, Tulane University, New Orleans, LA. Newcomb Art Gallery and D.A.P.: New York.

Rosenblum, Robert, "Cards of Identity," *Deborah Kass, The Warhol Project*, exhibition catalogue, Newcomb Art Gallery, Tulane University, New Orleans, LA. Newcomb Art Gallery and D.A.P.: New York.

Saslow, James M. *Pictures and Passions, A History of Homosexuality in the Visual Arts.* Viking: New York.

Staniszewski, Mary Anne. "First Person Plural: The Paintings of Deborah Kass," *Deborah Kass, The Warhol Project*, exhibition catalogue, Newcomb Art Gallery, Tulane University, New Orleans, LA. Newcomb Art Gallery and D.A.P.: New York.

1998
Antler, Joyce, ed. *Talking Back, Images of Jewish Women in American Popular Culture.* Brandeis University Press: Hanover, NH.

Bright, Deborah, ed. *The Passionate Camera, Photography and Bodies of Desire.* Routledge: New York.

Cameron, Dan. *Dancing at the Louvre: Faith Ringold's French Collection and Other Story Quilts.* University of California Press: Berkeley.

Cotter, Holland. "Patricia Cronin and Deborah Kass." *New York Times*, April 17.

Gilman, Sander L. "R. B. Kitaj's 'Good Bad' Diasporism and the Body in American Jewish Postmodern Art," *Love + Marriage = Death*. Stanford University Press: Stanford, CA.

Gould, Claudia and Valerie Smith. *5000 Artists Return to Artists Space: 25 Years.* Artists Space: New York.

Kaplan, Caren. "Beyond the Pale: Rearticulating U.S. Jewish Whiteness," *Talking Visions, Multiculural Feminism in a Transnational Age.* Ella Shohat, ed. The MIT Press: Cambridge MA.

Marcus, Greil. "Pop Gun." *World Art*, issue 19.

Schlager, Neil, ed. *Gay and Lesbian Almanac.* St. James Press: Detroit, MI.

Sherlock, Maureen P. *Face Forward: Self-Portraiture in Contemporary Art*, exhibition catalogue. The John Michael Kohler Arts Center, Sheboygan, WI.

1997
Ackerman, Marc J. "Identity Crisis Expressed as Art," *Identity Crisis: Self-Portraiture at the End of the Century*, exhibition catalogue. Milwaukee Art Museum.

Antler, Joyce. *The Journey Home: Jewish Women and the American Century.* Free Press: New York.

Auerbach, Lisa Anne & Weissman, Benjamin. "Two Jews on 'Too Jewish?'" *LA Weekly*, March 21–27.

Becker, Robin. "I'm Telling." *Prairie Schooner*, Spring, cover.

Blessing, Jennifer. "'Eros, C'est la Vie': Fetishism as Cultural Discourse (Surrealism, Fashion, and Photography)," *Art/Fashion; Biennale di Firenze*. Skira Editore: Milan.

Hyman, Paula, and Deborah Dash Moore, eds. *Jewish Women in America: A Historical Encyclopedia.* Routledge: New York.

Knight, Christopher. "Too Jewish?

Good Query," *Los Angeles Times*, February 4.

Schor, Mira. *Wet, On Painting, Feminism, and Art Culture.* Duke University Press: Durham, NC.

Sobel, Dean. "Deborah Kass," *Identity Crisis: Self-Portraiture at the End of the Century*, exhibition catalogue. Milwaukee Art Museum.

Ussher, Jane M. *Fantasies of Femininity: Reframing the Boundaries of Sex*, Rutgers University Press: New Brunswick, NJ.

1996
Baker, Kenneth. "Artful Look at Jewish Identity." *San Francisco Chronicle*, September 16.

Baynard, Ed. "My Barbra, Excerpts From A Conversation With Deborah Kass." *The Village Voice*, April 2.

Cottingham, Laura. "Consuming all Impediments," *Now Here Louisiana*, exhibition catalogue. Louisiana Museum of Modern Art, Humlebæk, Denmark.

Dellamora, Richard. "Absent Bodies/ Absent Subjects: The Political Unconscious Of Postmodernism," *Outlooks, Lesbian and Gay Sexualities and Visual Cultures.* Peter Horne and Regina Lewis, eds. Routledge: London.

Eggers, Dave. "Jews R Us." *SF Weekly*, December 4.

Fricke, Harald. "NowHere." *Artforum*, November.

Garber, Marjorie, ed. *Field Work: Sites in Literary and Cultural Studies (Culture Work: A Book from The Center for Literary and Cultural Studies at Harvard).* Routledge: London.

James, Jamie. *Pop Art Colour Library.* Phaidon Press: London.

Kaufman, Jason Edward. "Too Jewish?" *The Art Newspaper*, March.

Kimmelman, Michael. "Too Jewish? Jewish Artists Ponder," *New York Times*, March 8.

Kleeblatt, Norman L. "'Passing' Into Multiculturalism," *Too Jewish?: Challenging Traditional Identities*, exhibition catalogue. The Jewish Museum, New York. Rutgers University Press: New Brunswick, NJ.

Lord, Catherine. "Unanswered Crimes: Sex, Gender and Dykes," *Gender Fucked*, exhibition catalogue. Center on Contemporary Art, Seattle, WA.

McPhee, Martha. "Mae West, Our Little Chickadee," *New York Times Magazine*, November 24.

Nochlin, Linda. "Forward: The Couturier and the Hasid," *Too Jewish?: Challenging Traditional Identities*, exhibition catalogue. The Jewish Museum, New York. Rutgers University Press: New Brunswick, NJ.

Ockman, Carol. "Too Jewish? Challenging Traditional Identities." *Artforum*, September.

Rich, Frank. "The 'Too Jewish' Question." *New York Times*, March 16.

Self, Dana. "Deborah Kass, My Andy: a retrospective," exhibition brochure. The Kemper Museum of Contemporary Art, Kansas City, MO.

Smyth, Cherry. *Damn Fine Art By New Lesbian Artists*. Cassell Press: London, England.

Vine, Richard. "Report from Denmark Part 1: Louisiana Techno-Rave." *Art in America*, October.

1995
Blake, Nayland, Lawrence Rinder, Amy Scholder, eds. *In A Different Light; Visual Culture, Sexual Identity, Queer Practice*, exhibition catalogue. University Art Museum, University of California, Berkeley. City Lights Books: San Francisco, CA.

Bonetti, David. "Looking at Art 'In a Different Light.'" *The San Francisco Examiner*, January 11.

Cembalest, Robin. "Warhol Meets Streisand, Deborah Kass Makes Pop Art Ethnic." *Forward*, March 17.

Cotter, Holland. "Deborah Kass, 'My Andy: a retrospective' at Jose Freire." *New York Times*, March 24.

Duncan, Michael. "Report from Berkeley: Queering the Discourse." *Art in America*, July.

Gilbert-Rolphe, Jeremy, Norman Bryson, eds. *Beyond Piety: Critical Essays on the Visual Arts, 1986–1993*. Cambridge University Press: Cambridge, England.

Kearns, Jerry. *Imperfect*, exhibition catalogue. University of Massachusetts, Amherst, MA, and Tyler School of Art, Philadelphia, PA.

Kleeblatt, Norman. "Multivalent Voices." *Art in America*, December.

Knight, Christopher. "Shining a 'Different Light' on Both Artist and Viewer." *Los Angeles Times*, February 4.

Lord, Catherine. "Queering The Dead," *Pervert*, exhibition catalogue. University of California, Irvine, CA.

Smith Roberta. "Void, Self, Drag, Utopia (And 5 Other Gay Themes)." *New York Times*, March 26.

Staniszewski, Mary Anne. *Believing Is Seeing: Creating The Culture Of Art*. Penguin Books: New York.

Waldman, Allison, J. *The Barbra Streisand Scrapbook*. Citadel Press: New York.

Yablonsky, Linda. "Color Her Barbra." *Out*, April.

Zaya, Octavio. "Deborah Kass: The Jewish Jackies and My Elvis; A Project for AtlAnticA." *AtlAnticA*, Winter.

1994
Avigikos, Jan. "Ciphers of Identity at Ronald Feldman." *Artforum*, March.

Cotter, Holland. "Art After Stonewall,

12 Artists Interviewed." *Art in America*, June.

Cottingham, Laura. *The Power of Feminist Art*. Harry N. Abrams: New York.

DePaoli, Geri. *Elvis + Marilyn: 2 X Immortal*, exhibition catalogue. Rizzoli: New York.

Goldberg, Vicki. "A Pair of Saints Who Refuse to Stay Dead." *New York Times*, December 18.

Johnson, Ken. "Fiction, Non-fiction and Postmodern Ideology," *Democratic Vistas: 150 Years of American Art From Regional Collections*, exhibition catalogue. State University of New York at Albany: Albany, NY.

Rugoff, Ralph. "Beep Beep, Toot Toot: The Trouble with 'Bad Girls.'" *LA Weekly*, February 18–24.

Saltz, Jerry. "A Year in the Life: Tropic of Painting." *Art in America*, October.

Wise, Michael. "Double Yentls, Chanel Kippahs and P.C. Torahs." *Forward*, July 1.

1993
Berger, Maurice. "Displacements, Part One; Theory," *Ciphers of Identity*, exhibition catalogue. Fine Arts Gallery, University of Maryland, Cantonsville, MD.

Chernow, Barbara A. and George A. Vallasi, eds. "American Art," *The Columbia Encyclopedia, Fifth Edition*. Columbia University Press: New York, Houghton Mifflin Company: Boston.

Cotter, Holland. "Deborah Kass at fiction/nonfiction." *New York Times*, January 15.

Cronin, Patricia. "A Conversation on Lesbian Subjectivity and Painting (with Deborah Kass)." *M/E/A/N/I/N/G*, November.

Greenberg, Melinda. "The Art of Being Barbra." *Baltimore Jewish Times*, December 17.

Homes, A.M. "Deborah Kass at Fiction/Nonfiction," *Artforum*, March.

Langer, Cassandra. *Feminist Art Criticism, An Annotated Bibliography*. Macmillan: New York.

Smith, Roberta. "Jewish Museum as Sum of Its Past." *New York Times*, June 11.

1992
Cameron, Dan. "Don't Look Now." *Frieze*, January.

Cunningham, Michael. "After AIDS—Gay Art Aims At a New Reality." *New York Times*, April 26.

Curtis, Cathy. "Women's Work: Rich, Shocking." *Los Angeles Times*, October 16.

Liberio, Lydia. "What if Andy Warhol and Roy Lichtenstein Had Been Women?" *The Irvine World News*, October 15.

Liu, Catherine. "Diary of the Pop Body: Dandy Darlings and New Pop Strategies." *Flash Art International*, October.

Seigel, Judy, ed. *Mutiny and the Mainstream: Talk That Changed Art, 1975–1990*. Midmarch Arts Press: New York.

Smith, Roberta. "Women Artists Engage the Enemy." *New York Times*, August 16.

1991
Cameron, Dan. *Just What Makes Today's Homes So Different, So Appealing?*, exhibition catalogue. The Hyde Collection, Glens Falls, NY.

Cottingham, Laura. "Feminism and Painting," *Balcon* No.7.

Hess, Elizabeth. "Death to the Masters." *The Village Voice*, October 22.

Kimmelman, Michael. "Painting Culture at fiction/nonfiction," *New York Times*, November 1.

1990
Cottingham, Laura. "Subject Matters,

Too." Essay for *Deborah Kass*, Simon Watson Gallery, New York.

Shottenkirk, Dena. "Deborah Kass at Simon Watson." *Artforum*, December.

Westfall, Stephen. "Deborah Kass: Subject Matters." *Contemporanea*, November.

1989
Mooreman, Margaret. "Deborah Kass at Scott Hanson," Artnews, January.

Zimmer, William. "The Poetic and The Visual." *New York Times*, April 2.

1988
Cameron, Dan. "Ready Made Nature," *Deborah Kass*, exhibition catalogue. Scott Hanson Gallery, New York.

Morgan, Robert C. "Meaningful Geometry." *Flash Art*, May/June.

Nadelman, Cynthia. "New Editions," *Artnews*, October.

1987
Ostrow, Saul and Deborah Kass. "In Her Own Voice." *Bomb*, Fall.

Saltz, Jerry. *Beyond Boundaries: New York, New Art*. Alfred Van der Mark Editions: New York.

1986
Cameron, Dan. "Second Nature: New Paintings by Deborah Kass." *Arts Magazine*.

Cohen, Ronny. "Deborah Kass at Baskerville + Watson." *Artforum*, Summer.

Westfall, Stephen. "Deborah Kass at Baskerville + Watson." *Art in America*, July.

1985
Masheck, Joseph. "Observations on Harking Back." *New Observations* #28.

Sterling, William H. *The New Expressive Landscape*, exhibition catalogue. Sordoni Art Gallery, Wilkes University, PA.

1984
Brenson, Michael. "Deborah Kass at Baskerville + Watson." *New York Times*, January 20.

Liebmann, Lisa. "Deborah Kass at Baskerville + Watson." *Artforum*, April.

Wilson, William. "Deborah Kass at Turnball, Lutjeans, and Kogan." *The Los Angeles Times*, February 3.

1982
Frank, Peter. "Dark Thoughts." *Artnews*, March.

Henry, Gerrit. "The First Energist Drawing Show." *Artnews*, February.

Smith, Roberta. "Energism at Stefanatie." *The Village Voice*, May 25.

1980
Staniszewski, Mary Anne. "First Person singular: Recent Self-Portraiture at Pratt Institute." *Artnews*, May.

1979
Barry, Ann. "Arts and Leisure Guide." *New York Times*, October 21.

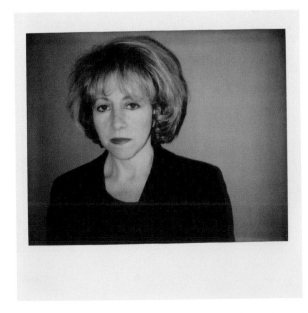

X

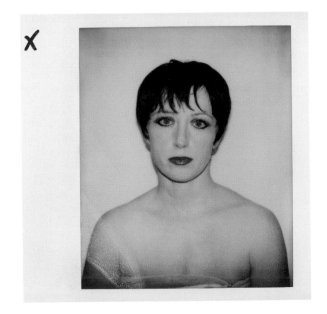

(top to bottom)
Trevor Fairbrother, 1998

Jose Freire, 1994

Lisa Dennison, 1998

(top to bottom)
Pat Steir, 1997

Paul Schimmel, 1998

Cindy Sherman, 1994

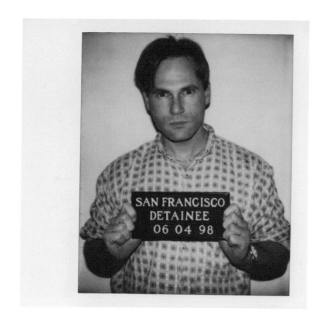

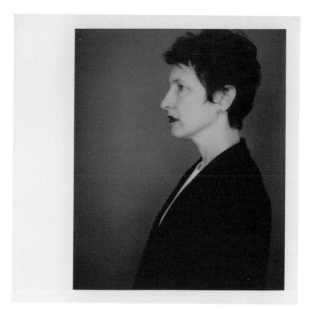

(top to bottom)
Jonathan Katz, 1998

Norman Kleeblatt, 1994

Thelma Golden, 1998

(top to bottom)
Terrie Sultan, 1998

Elizabeth Murray, 1994

Robert Storr, 1998

Published on the occasion of the exhibition **Deborah Kass: Before and Happily Ever After**, organized by The Andy Warhol Museum, Pittsburgh, Pennsylvania.

Exhibition itinerary:
The Andy Warhol Museum, Pittsburgh, Pennsylvania
October 27, 2012–January 6, 2013

Deborah Kass: Before and Happily Ever After is made possible through the generous support of PNC Financial Services.

Library of Congress Control Number: 2012941095

ISBN: 978-0-8478-3918-6 (hardcover)
ISBN: 978-0-9855350-1-8 (paperback)

First published in the United States of America in 2012 by

Skira Rizzoli Publications, Inc.
300 Park Avenue South
New York, NY 10010
www.rizzoliusa.com

Margaret Rennolds Chace, Associate Publisher
Holly La Due, Editor
Design: Beverly Joel, pulp, ink.

On the front cover: *Red Deb*, 2000
On the back cover: *Puff Piece*, 1992
Endpapers: *OY/YO*, 2011
2012 2013 2014 2015/ 10 9 8 7 6 5 4 3 2 1
Printed in China

Deborah Kass would like to thank:
Eric Shiner, The Andy Warhol Museum, Vincent Fremont, Paul Kasmin, Hayden Dunbar, the Paul Kasmin Gallery, Beverly Joel, Michael Plante, Jose Freire, Simon Watson, Arthur Roger, Brooks Adams, Lisa Liebmann, Griselda Pollock, Irving Sandler, Robert Storr, John Waters, and Patricia Cronin.

Contributors:

Lisa Liebmann and **Brooks Adams** are writers and art critics based in Paris and New York.

Griselda Pollock is director of the Centre for Cultural Analysis, Theory, and History, and Professor of Social and Critical Histories of Art at the University of Leeds.

Irving Sandler is an art critic and historian, contributing editor at *Art in America*, and professor emeritus at the State University of New York.

Eric C. Shiner is director of The Andy Warhol Museum in Pittsburgh.

Robert Storr is a curator, writer, and Dean of the Yale School of Art.

John Waters is an American film director, author, actor, and photographer.

Photo Credits:
All images are courtesy the artist and Paul Kasmin Gallery, New York, unless otherwise noted.

Réunion des Musées Nationaux/Art Resource, NY. Photo: Gérard Blot: 14(l)

© 2012 The Andy Warhol Foundation for the Visual Arts, Inc. / Artists Rights Society (ARS), New York. Digital Image © The Museum of Modern Art/Licensed by SCALA / Art Resource, NY: 17(t)

Courtesy Cheim & Read, New York: 19

© Ed Ruscha. Courtesy Gagosian Gallery. Digital Image © The Museum of Modern Art/Licensed by SCALA / Art Resource, NY: 20(t)

© Frank Stella/ARS, NY. Photo credit: Steven Sloman/Art Resource, NY: 36(b)

Courtesy Dallas Museum of Art, Foundation for the Arts Collection, anonymous gift: 40

The Frances Young Tang Teaching Museum and Art Gallery at Skidmore College, Saratoga Springs, New York: 62–63

Courtesy the Jewish Museum, New York, Photo by John Parnell: 115

© The Andy Warhol Foundation for the Visual Arts/ARS, NY. Image © The Metropolitan Museum of Art. Image source: Art Resource, NY: 128(l)

© Barbara Kruger, courtesy Mary Boone Gallery, New York: 177

© Mary Heilmann, photo: John Berens. Courtesy of the artist; 303 Gallery, New York; Hauser & Wirth: 178

(following page) **After Louise Bourgeois**, 2010

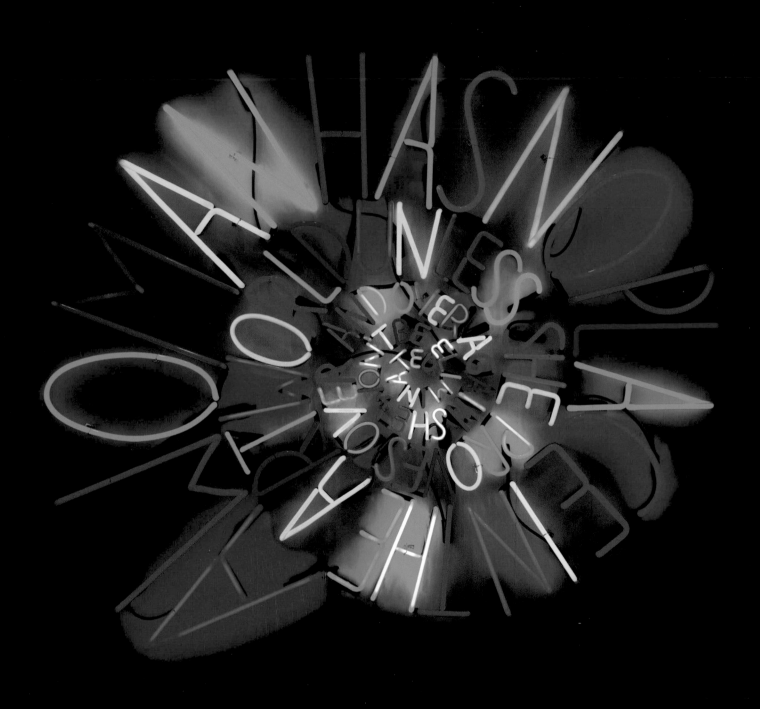